To

Chris & Sharon,

Hope you enjoy

the video &

Back Home.

Len WASS

NOVA SCOTIA
LANDMARKS

Photographs by Len Wagg

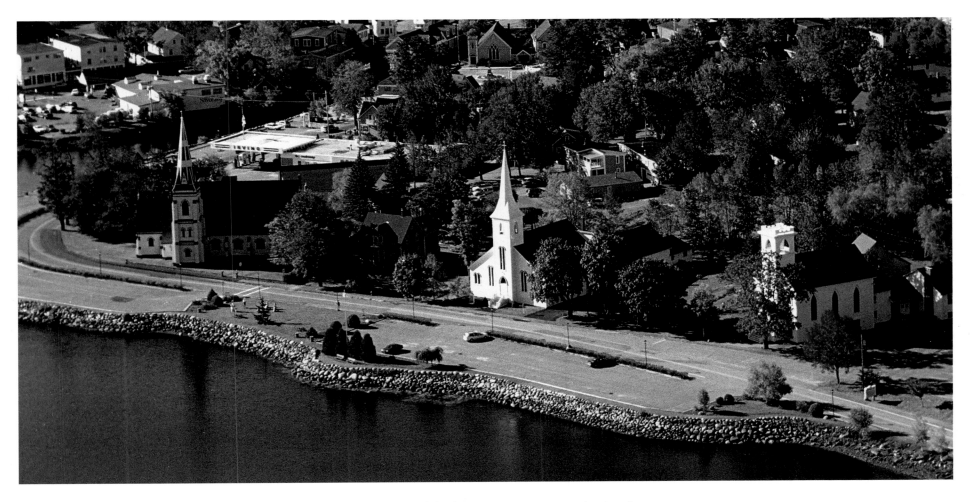

Formac Publishing Company Limited
Halifax, Nova Scotia

Formac Publishing Company Limited acknowledges the support of the Cultural Affairs Section, Nova Scotia Department of Tourism and Culture. We acknowledge the financial support of the Government of Canada through the Book Publishing Industry Development Program (BPIDP) for our publishing activities.

We acknowledge the support of the Canada Council for the Arts for our publishing program.

Library and Archives Canada Cataloguing in Publication

Wagg, Len
 Nova Scotia landmarks / photos and text by Len Wagg.

ISBN 0-88780-631-7

 1. Nova Scotia—Aerial photographs. I. Title.

FC2312.W33 2004 917.15'0022'2 C2004-904045-6

Formac Publishing Company Limited
5502 Atlantic Street
Halifax, Nova Scotia B3H 1G4
www.formac.ca

Printed and bound in Canada

Previous page:
A well photographed landmark on the South Shore, these three familiar churches are located at the eastern entrance to the town of Mahone Bay. From the left (southwest) they are: St. James' Anglican Church, St. John's Lutheran Church and Trinity United Church.

Table of CONTENTS

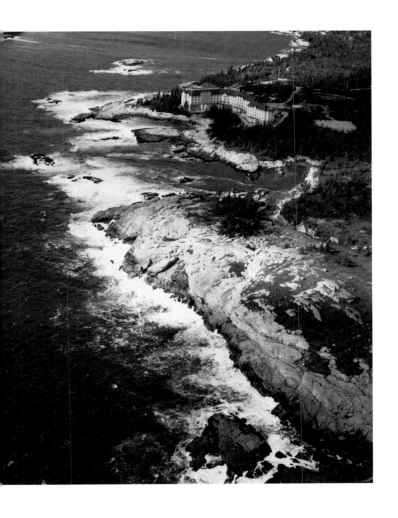

The meeting of the Shubenacadie and the Stewiacke rivers in the heart of Nova Scotia's richest farmland.

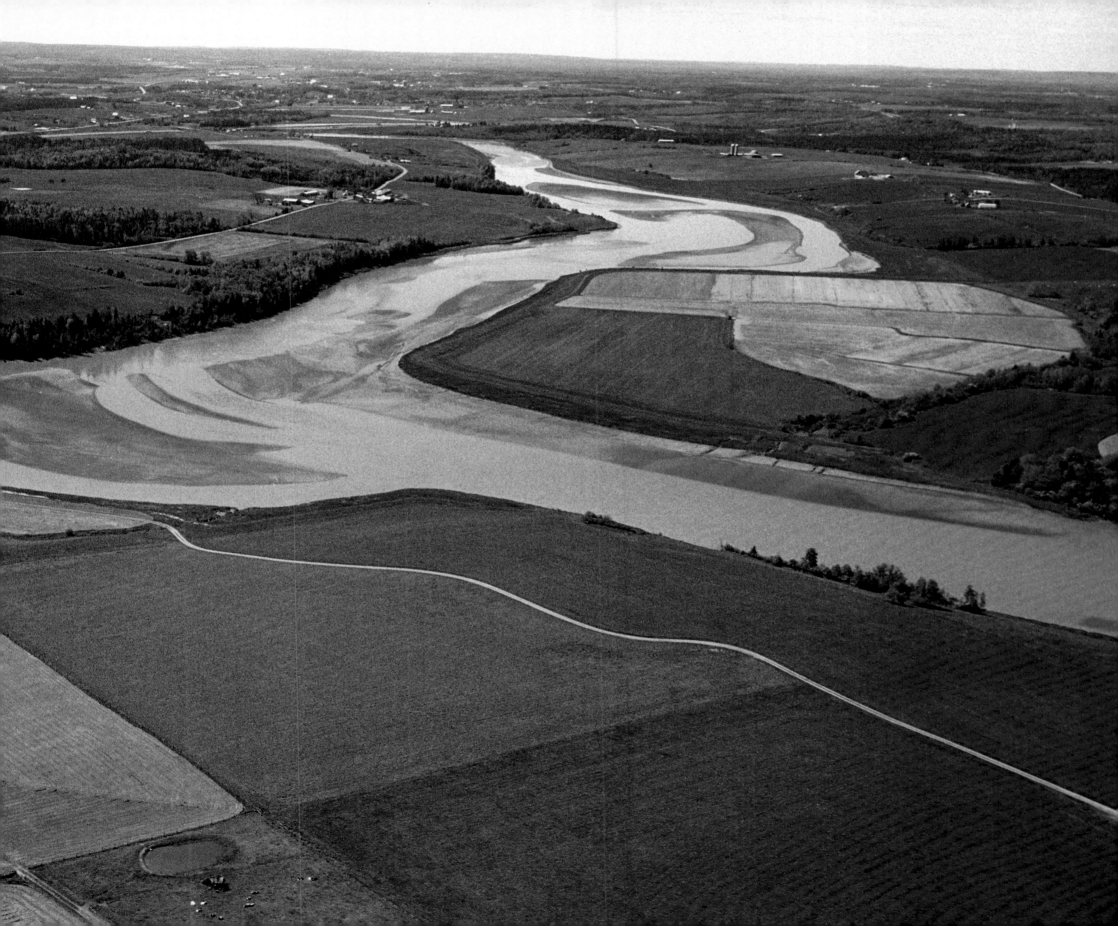

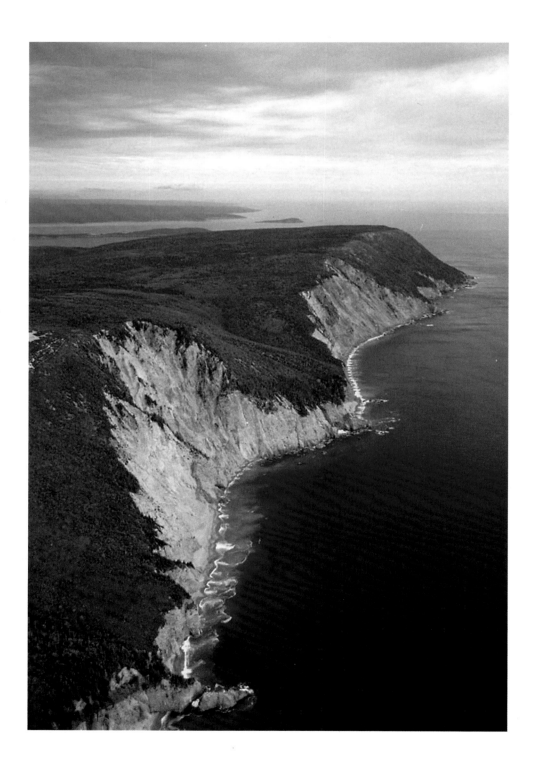

THIS BOOK IS dedicated to my wife Sandy and our children Brett, Kiya, and Jodi, who have endured my long absences while I have tried to capture the perfect image, as well as many hours spent in the digital darkroom.

INTRODUCTION

The long-range, "sub-hunter" Argus aircraft, pride of Canadian Forces Base Greenwood in the 1960s and 1970s, provided me with my first opportunity to view Nova Scotia's aerial landscape. I was a lucky twelve-year-old on an air-cadet field trip. The plane headed west (down the Annapolis Valley) and over Digby Gut, then turned and flew over the Bay of Fundy. I got a chance to crawl on my hands and knees under the cockpit to the observer's spot to watch the tiny coastal communities disappear beneath the plane.

The Argus, huge beasts that shook dishes and windows from one end of the Valley to the other, had been a part of my childhood. I remember thinking that there was a big lake with motorboats behind the forest that bordered our farm. It seemed the boats went all hours of the night and through the winter as well. Eventually I found out that there was no lake and that the motors were the airplanes taking off and landing.

Just a few months after that Argus flight, I took my first aerial picture, from a small Canadian Armed Forces Reserve aircraft. This flight was part of an air-cadet summer camp. My mother had given me a point-and-shoot camera and told me to take a picture of the house if we flew over it. I looked out the window, snapped the picture and captured my first aerial landscape—browned grass from another hot summer, apple trees in straight lines and a dirt road that went on over the mountain. This was my community in 1974.

The world from the air never ceases to surprise with its ever-changing views. A trickling stream in summer becomes a raging river tumbling over Economy Mountain the following spring. What looks like a mountain from the Canso Causeway becomes a hollowed-out

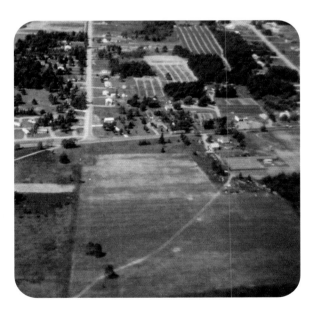

Annapolis Valley, 1974, first aerial photograph by Len Wagg.

mine from the air. Traffic confusion in the city assumes logical dimensions from above.

Later on, I learned to fly gliders and enjoyed soaring over Yarmouth, Greenwood, Liverpool, Debert, Summerside and communities in Cape Breton. It was my turn to give young cadets their first airplane ride. We would have the airplanes ready to fly before dawn at CFB Greenwood, waiting for official daylight or sometimes for the sun to melt the frost off the wings. On one of these flights to Yarmouth, I saw a disappearing lake. The shape was there but only the centre contained water; small trees and bushes were taking over. Years later, flying the same route, I couldn't find the lake at all. The landscape had changed, but unlike that dirt road with my house on it, I had not taken a picture, and it was gone forever.

I began to work as a newspaper photographer, and planes continued to be a part of my life. Aerobatic groups would take the press for rides to promote airshows, and after only six months on the job, I found myself strapped into the number eight plane in the Canadian Armed Forces' Snowbirds. It was an exciting 45 minutes of flying right side up and upside down, all the while less than two metres from the next plane. Looking out the top of the cockpit I could see the lighthouse at Peggy's Cove.

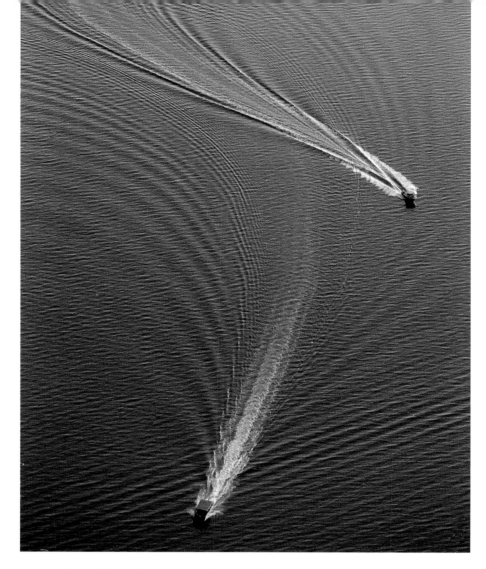

Boats out for an evening cruise pass each other in Tatamagouche Bay, on the Northumberland Strait.

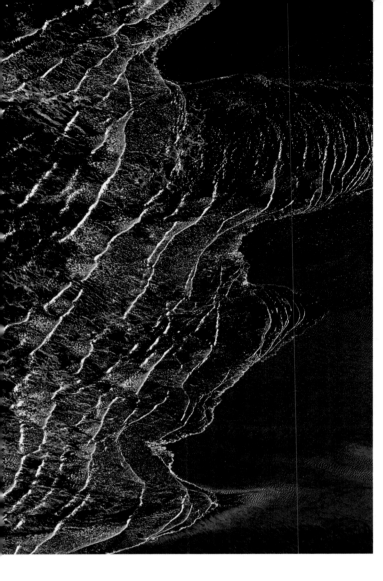

The waves on an incoming tide create intricate designs along a beach near Cape Chignecto Provincial Park.

Soon afterwards, the 75th anniversary of the Royal Canadian Navy gave me the chance to sit in the open door of a Huey helicopter, my feet on the skids, and secured by a "monkey tail" (a harness attached to the aircraft), as it flew in and out between the ships. The Coast Guard would sometimes invite the press on helicopter rides to lighthouses on islands or to greet tall ships. I once had a sideways hovering view of the Tall Ship USCGS *Eagle* as it sailed into Halifax Harbour.

During the late 1990s I witnessed the progress of the trench that was dug across the province to hold the natural-gas pipeline. On a number of occasions I flew the entire length of the trench and captured the work and its footprint on the landscape. I began to contemplate the unstoppability of so-called progress. The pipeline was complete: the lake near Yarmouth was gone. It was then that I decided to document the province from the air.

Since starting this project, a number of things I photographed are no longer the same: the coal mines, a way of life for so many, and the SYSCO steel mill, closed with the loss of hundreds of jobs; and Point Pleasant Park, the trees ravaged by a little beetle and then a hurricane.

Nova Scotia has thousands of great views for photography. But simply being there does not guarantee good pictures. The challenge is to be there when the light is perfect. The very first image for this project was Cape Split. I checked the tides and booked an aircraft and pilot through the Debert Flight Centre. We made it to Cape Split just as the sun was setting the light striking the cliffs with an orange glow. As the pilot adjusted the altitude and angle in accordance with my hand motions, the picture was obvious — the blue water boiling into waves as the tide receded and the currents collided. Through the open window and with my eye up to the viewfinder, I got my shot.

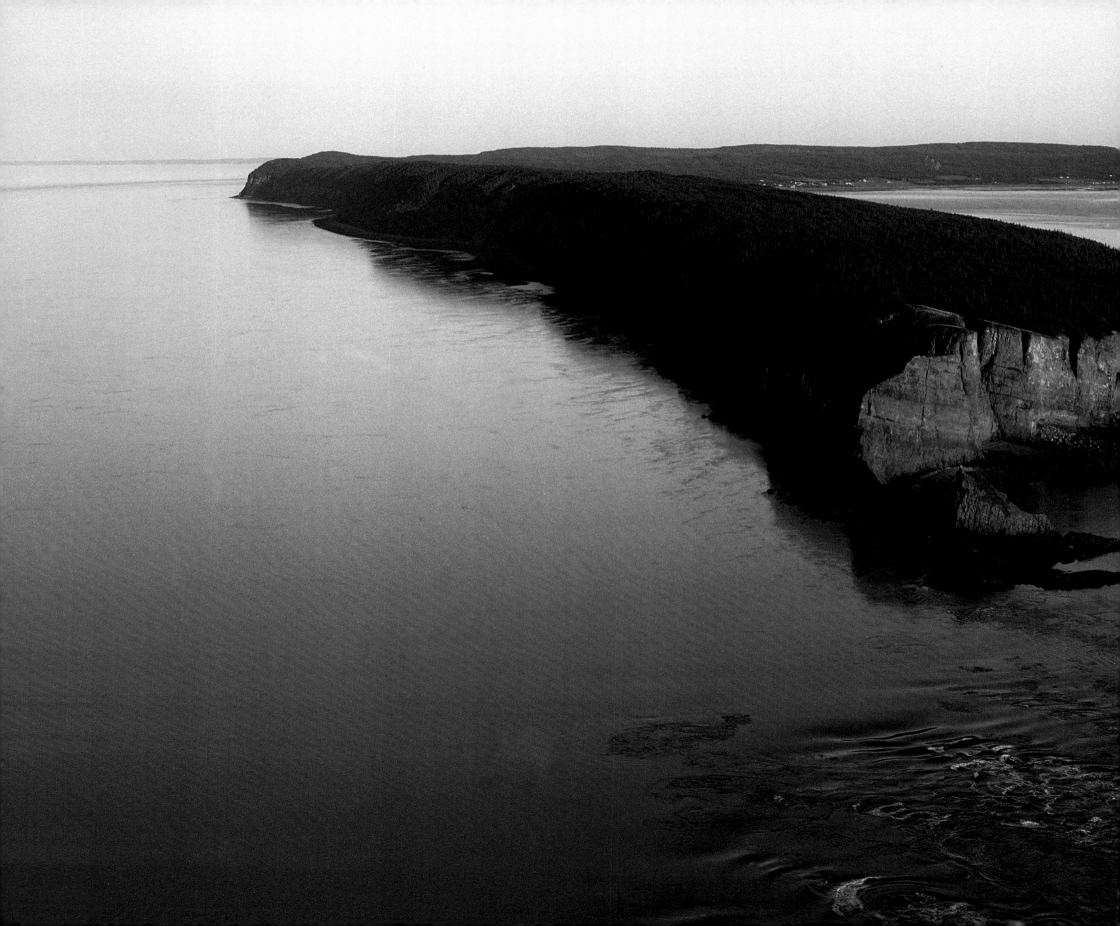

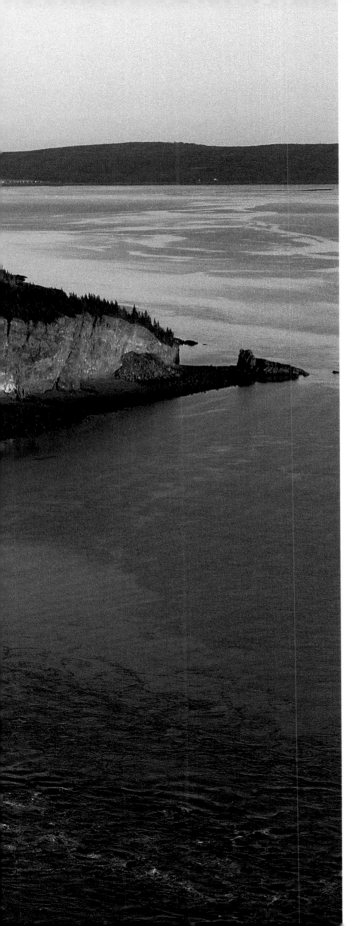

1 ANNAPOLIS VALLEY

FROM THE AIR over the Annapolis Valley the Bay of Fundy dominates the scenery on the northern coast. The tides, among the highest in the world, have shaped the geography of the land and the communities that are sustained along this 100-kilometre stretch.

North Mountain is crisscrossed with dirt roads, and the patchwork of fields and orchards on the valley floor forms a colourful mosaic that shifts with the seasons. Lower down, there are overgrown fields and abandoned farm buildings, as well as new houses beginning to march across the rural landscape.

The spire of the memorial church at the Grand Pré National Historic Site rises above a rectangle of green trees and manicured lawns. This site memorializes the Acadians who settled this area almost four hundred years ago, building dykes along the shoreline.

The Cornwallis and Annapolis rivers meander through the Valley to empty into the Bay of Fundy, one flowing east, the other west. Towns cluster along the riverbanks — Wolfville, New Minas, Kentville, Berwick, Kingston, Lawrencetown, Bridgetown and, finally, Annapolis Royal.

Left: In September, the evening light paints the great cliffs of Cape Split an orange hue. This Nova Scotian landmark has long been a popular hiking and camping destination. The powerful currents of the Bay of Fundy turn the waters around Cape Split into a maelstrom as billions of gallons flow by during the twice-daily tide change.

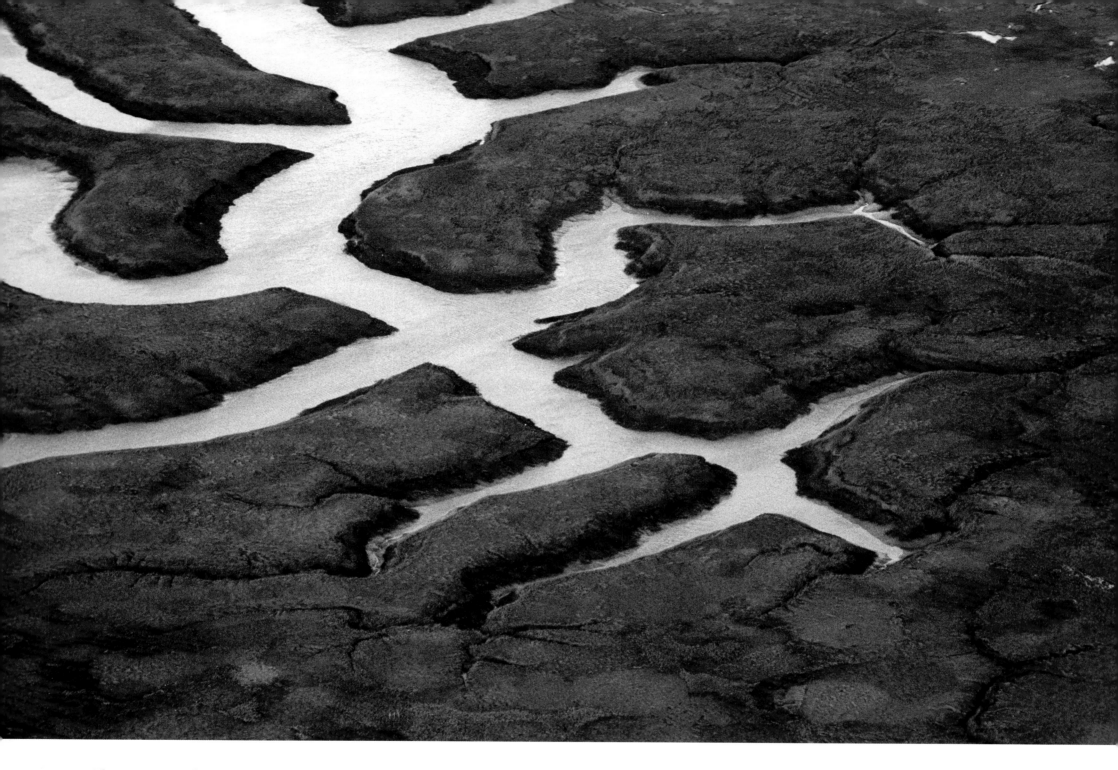

The arteries of the tidal flats of the Minas Basin are ever changing, with the sediment churned up from the seabed by the tidal flow of the Bay of Fundy.

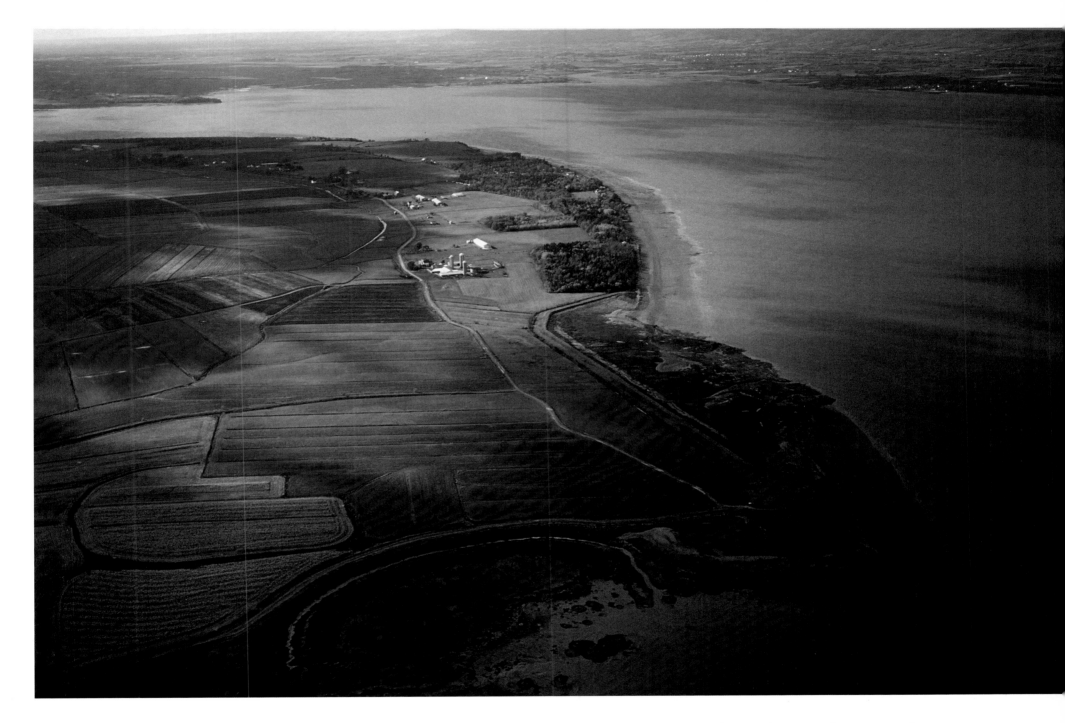

Evangeline Beach lies on the edge of Minas Basin, a few miles north of Grand Pré National Historic Site. The shores of Long Island are also visible in this photograph.

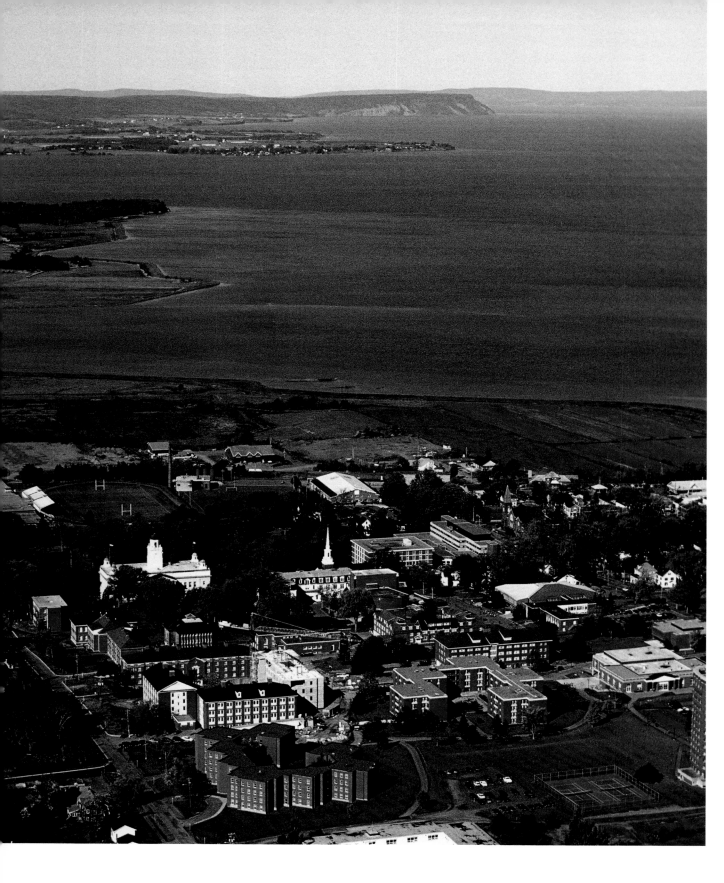

Wolfville is home to Acadia University, established in 1838. In the distance are the red sandstone cliffs of Cape Blomidon, home to the legendary Mi'kmaq hero, Glooscap.

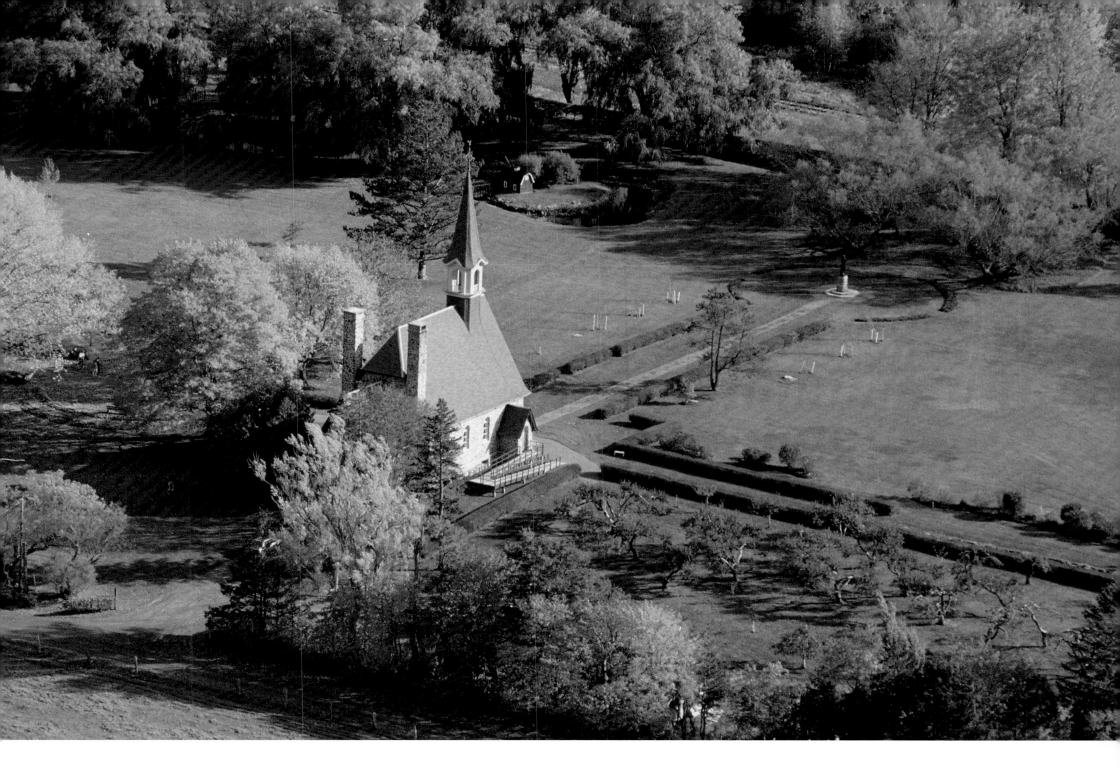

The spire of the Church of St. Charles Museum rises above the surrounding trees at the Grand Pré National Historic Site. The area holds a picnic park and gardens, a blacksmith shop and an interpretive centre, which depicts the life and deportation of the Acadian people.

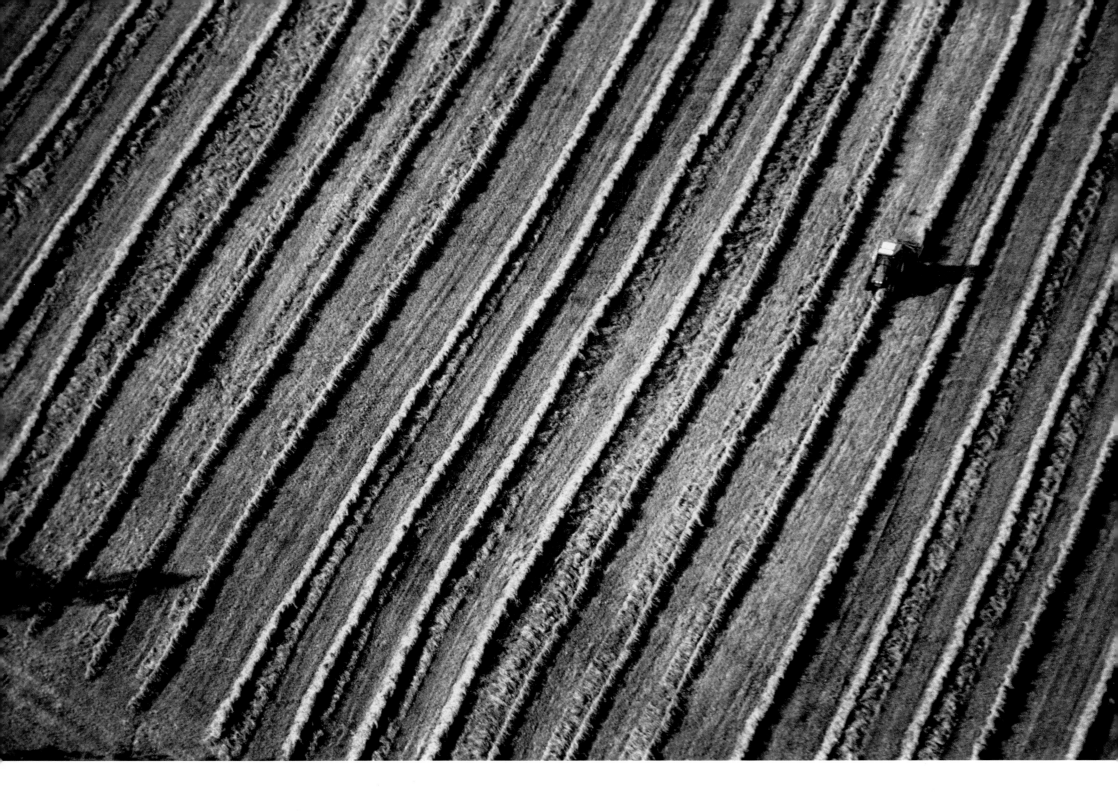

Parallel lines are touched by the late afternoon
sun while a farmer turns the hay.

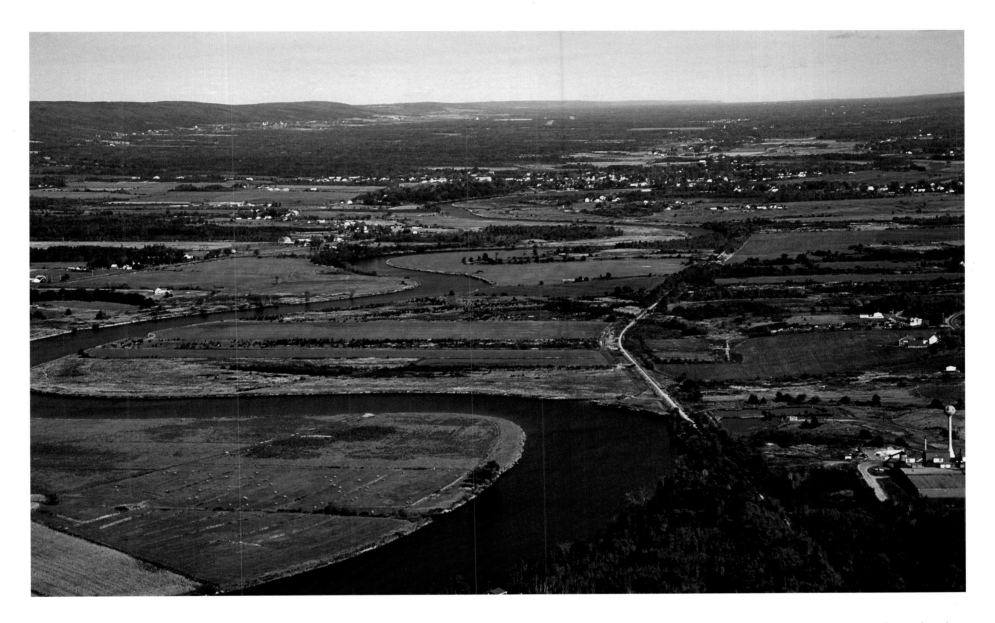

The rich soil of the Annapolis Valley extends for 100 kilometres between Windsor and Digby and makes up 20 percent of Nova Scotia's farmland. Formed 11,000 years ago by retreating glaciers, the Valley is bordered by the North and South mountains, which rise 200 metres above sea level. Once a hunting area of nomadic tribes and later settled by the Mi'kmaq, the Valley's rivers provided a source of food, transportation and fresh water. In 1604, the French settled near present-day Granville Ferry and spread out along the riverbanks, dyking the shoreline of the Bay of Fundy to create fertile farmlands.

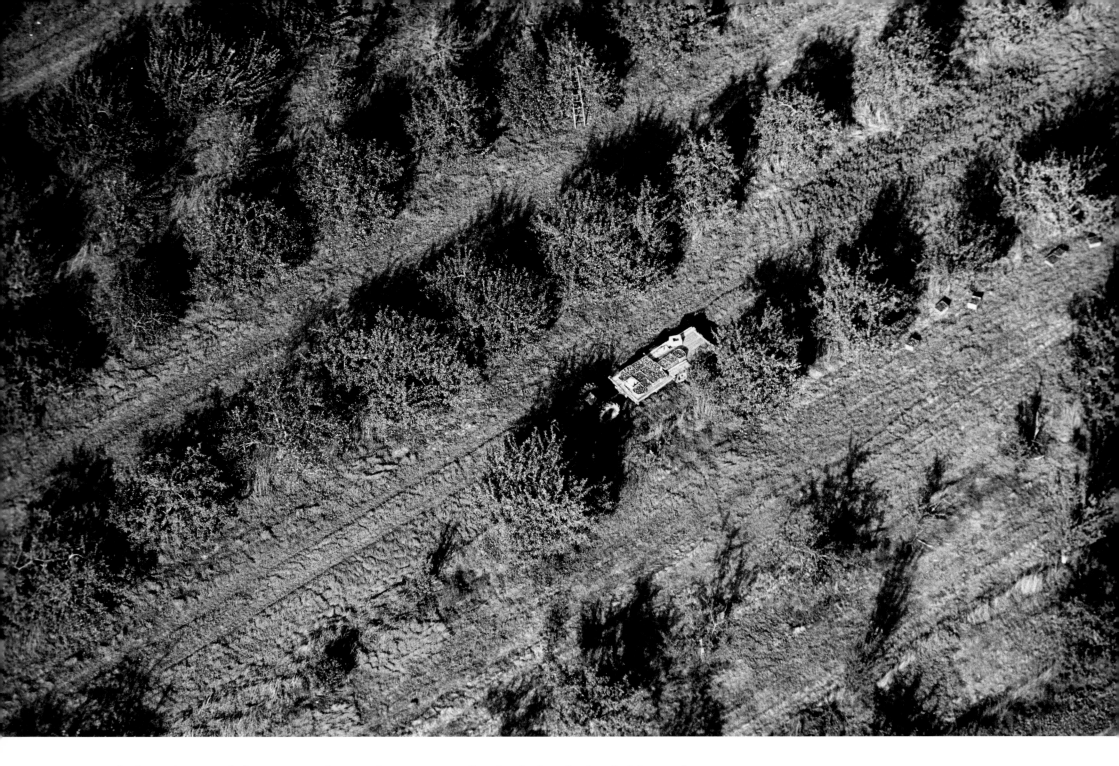

In the late afternoon light near Grand Pré, a farm tractor pulls a load of apples headed for market. Apples were first introduced by French settlers in the early 1600s. Today, orchards dot the landscape, and apples have become an important part of Annapolis Valley culture, celebrated with the Apple Blossom Festival every spring.

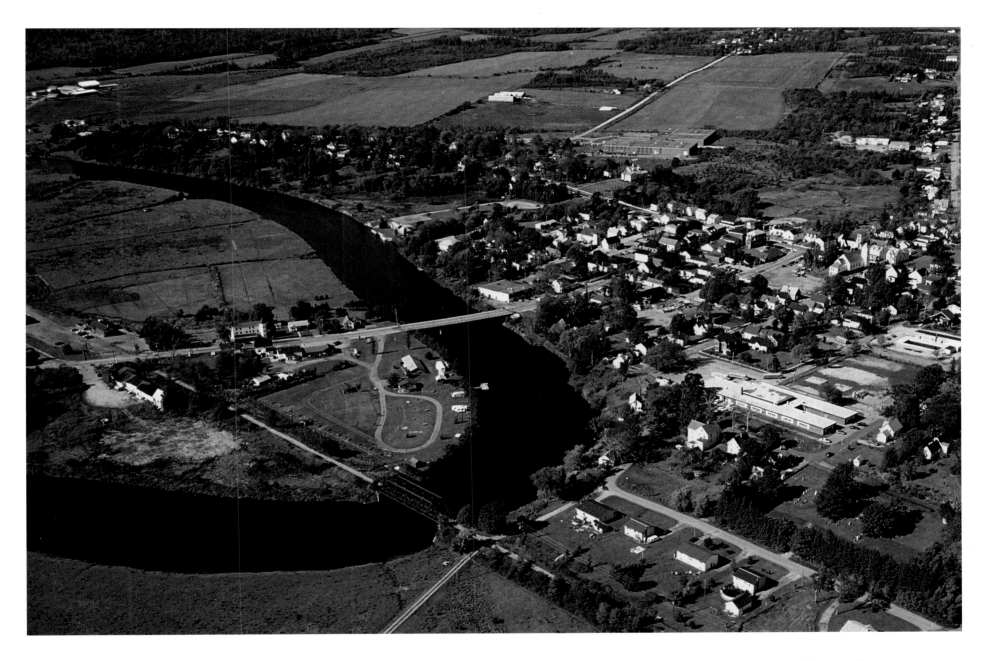

Bridgetown, on the banks of the Annapolis River, was settled by Loyalists following the American War of Independence. The first bridge, after which the town is named, was built in 1803. Bridgetown was a thriving shipbuilding centre in the early part of the nineteenth century.

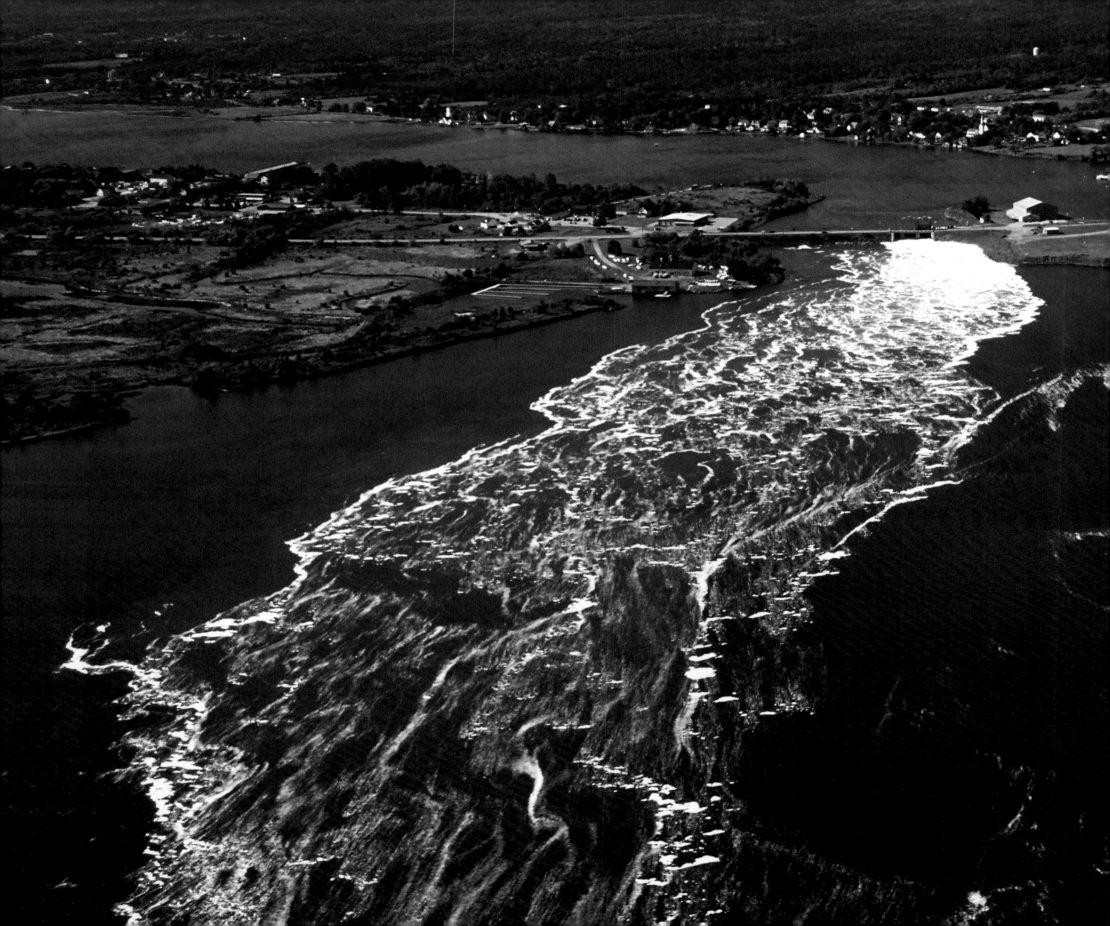

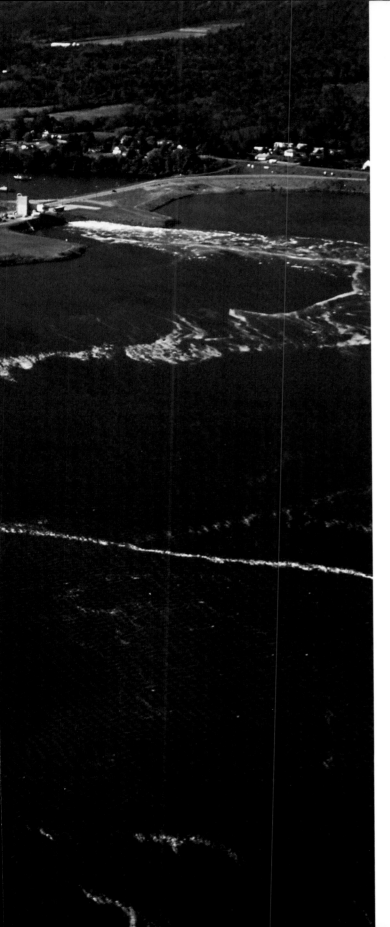

Waters churn through the Annapolis Tidal Generating Station beneath the causeway linking the town of Annapolis Royal with Granville Ferry. The station, completed in 1984, has a capacity of 20 megawatts. It uses the largest straight-flow turbine in the world to produce more than 30 million kilowatt hours per year, enough, according to Nova Scotia Power, to supply 4000 homes.

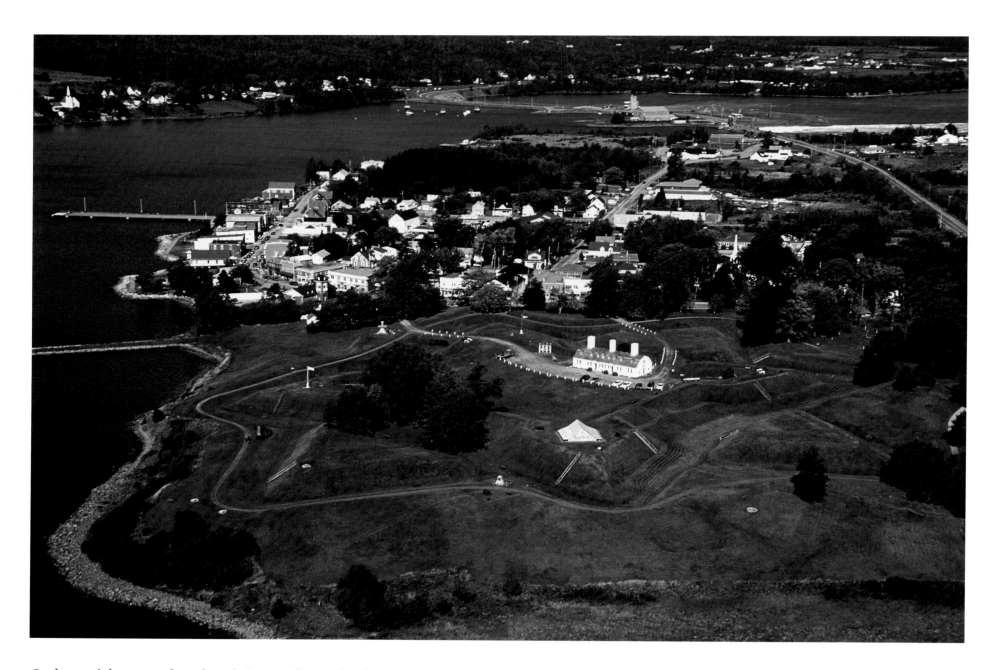

Outlines of the original earthen defence walls are clearly seen at Fort Anne, the first capital of Nova Scotia and Canada's first National Historic Site. Originally named Fort Charles, it was built in 1629 and was controlled alternately by French and British soldiers during the on-going battle for control of Nova Scotia. Final victory went to Britain in 1710.

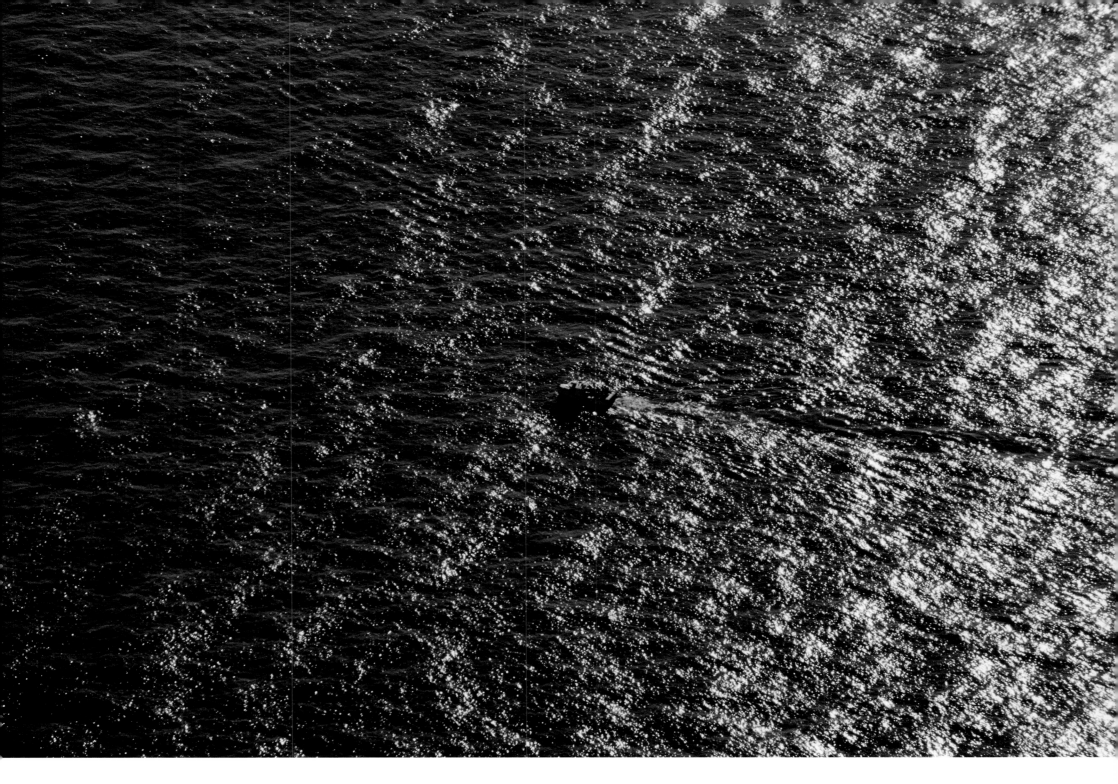

A lobster boat heads out from Digby Gut to the rich fishing grounds of the Bay of Fundy.

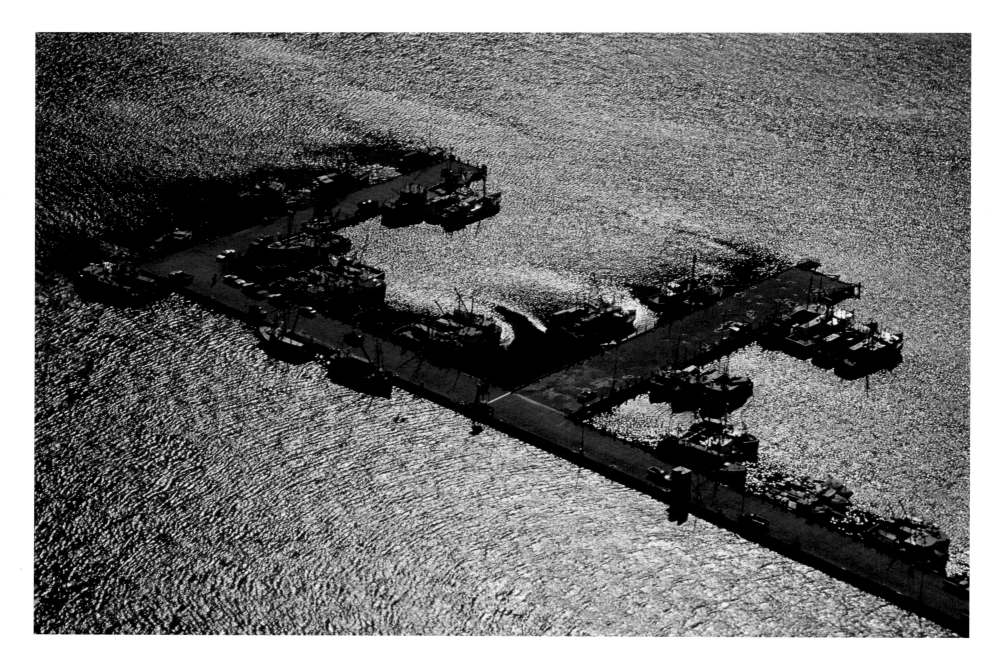

Afternoon light silhouettes fishing boats tied up along the main wharf in Digby, on the Annapolis Basin. Home to one of the largest scallop fishing fleets in North America, Digby has been called the Scallop Capital of the World.

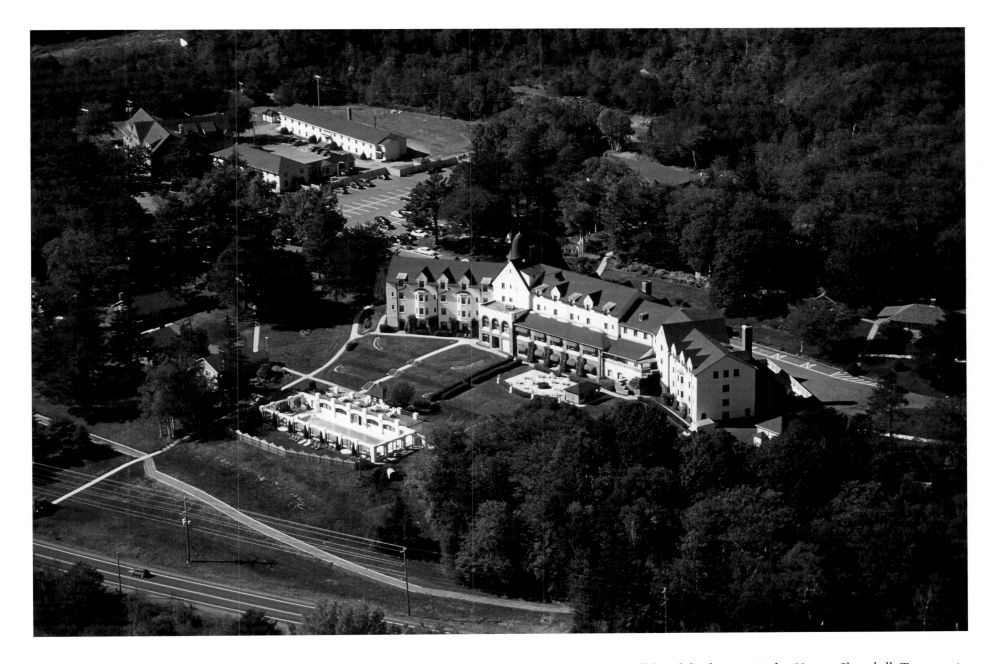

The Pines Resort, Digby, started out as a small hotel, built in 1903 by Henry Churchill. Twenty-six years later it was expanded to include a Norman-style chateau, cottages, a swimming pool, and an 18-hole golf course. The Government of Nova Scotia purchased it in 1956 and made it a "Signature Resort", in company with Liscombe Lodge and Keltic Lodge.

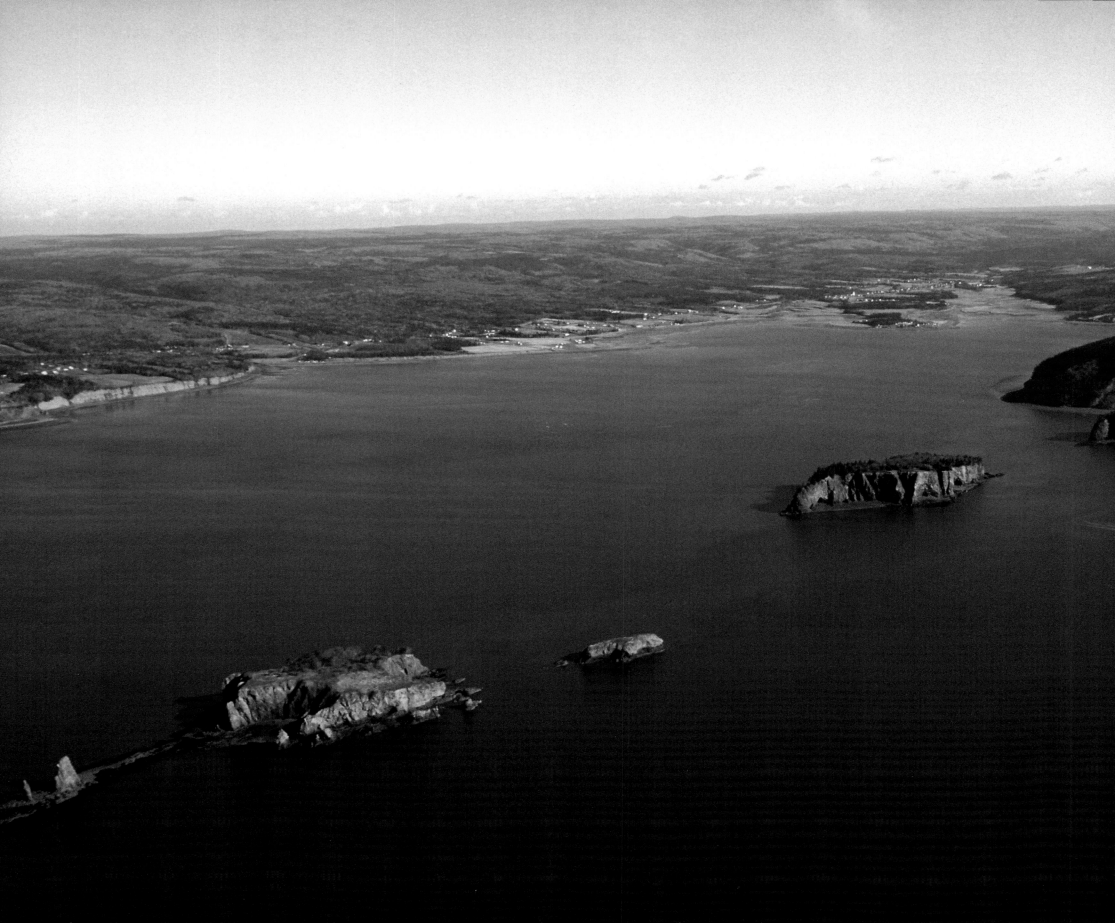

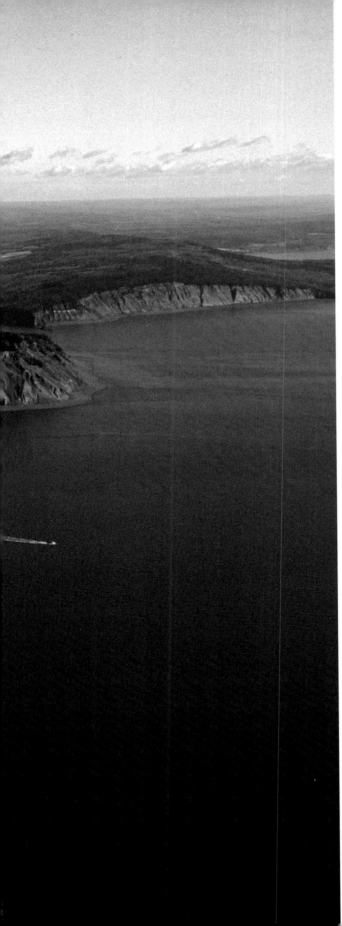

2 COBEQUID MOUNTAINS AND MINAS BASIN

FLYING OVER CENTRAL Nova Scotia is a geology lesson from the air. From the ancient lakebeds that are stirred by the tidal action of Cobequid Bay to the world's largest open-pit gypsum mine in Milford, the topology of the area is as diverse as the people who settled here. In the northwest the Cobequid Mountains gradually give way shores of Minas Basin at the head of the Bay of Fundy. Travelling south along the coast, there are spectacular beaches, many of them strewn with piles of driftwood.

At the tip of the peninsula is Cape Chignecto Provincial Park, where wilderness hiking trails have been developed for outdoor enthusiasts. East towards Truro, layers of time are recorded in the sedimentary cliffs of Red Head at Five Islands.

Near Truro, Cobequid Bay narrows, welcoming silty-brown rivers, including the Shubenacadie that rises in Shubenacadie Lake. Twice-daily the tidal bore can be enjoyed by river rafters, their rubber boats ploughing through the red-brown whirlpools made where the tide and river current meet.

Left: According to Mi'kmaw lore, Glooscap created Five Islands in the Minas Basin when he threw mud at his enemy, Beaver. The islands are, from left to right: Pinnacle, Egg, Long, Diamond and Moose.

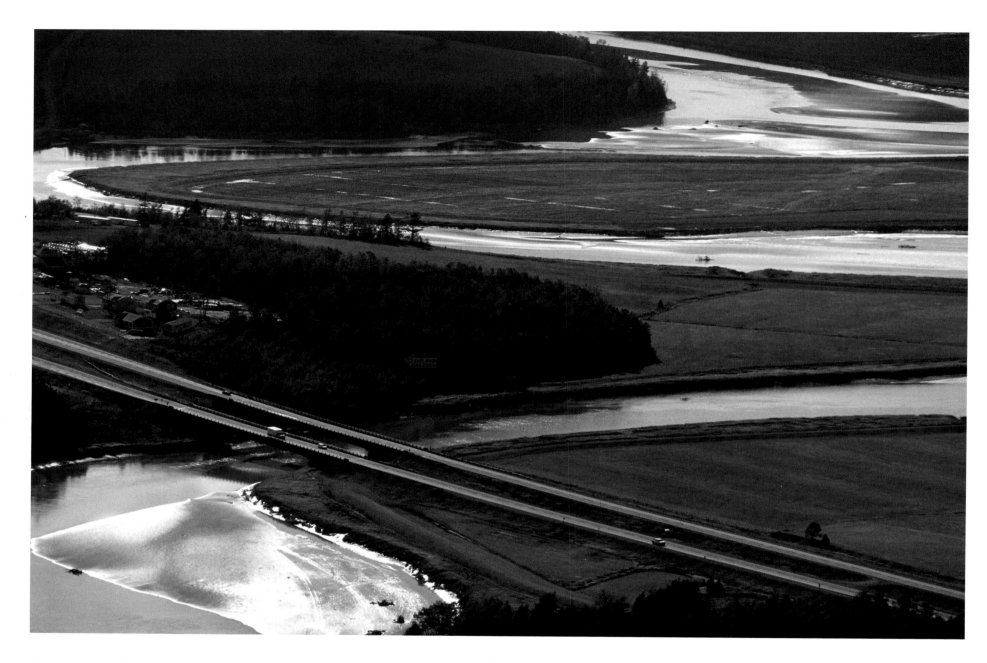

The Stewiacke River meanders through farmland in central Nova Scotia.

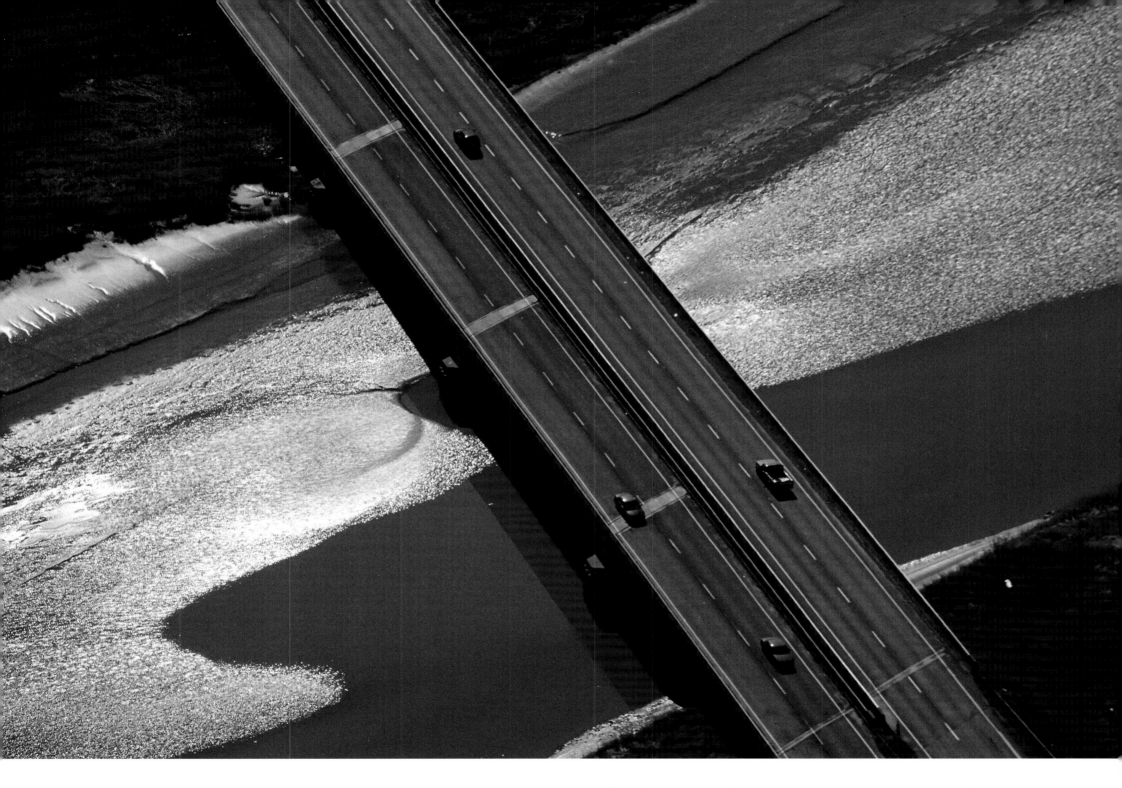

Designated as Veterans Memorial Highway in November 2000, the portion of Highway 102 that joins Truro with Miller Lake, just outside Halifax, passes over the Stewiacke River.

Five Mile River flows by gypsum cliffs and Hayes Cave in South Maitland. The cave, home to hibernating bats in winter, was sculpted by water seeping through the minerals.

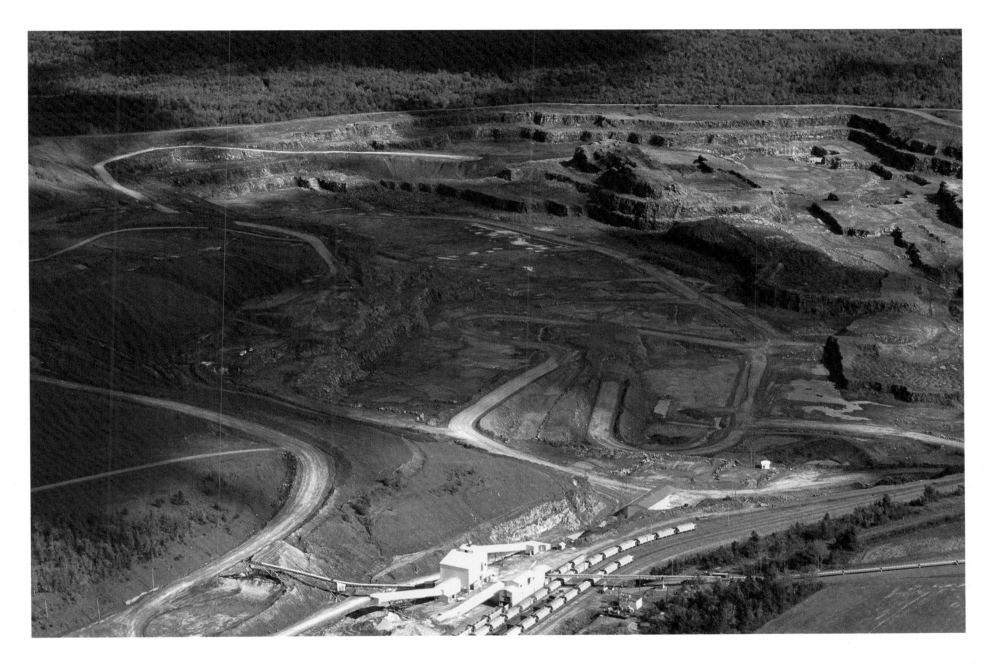

National Gypsum's mine at Milford Station, opened in 1954, is the largest open-pit gypsum mine in the world. Giant trucks seem like toys as the equipment crushes nearly a thousand tonnes of rock every hour. The gypsum is taken by train to Dartmouth, where it is loaded onto bulk carriers. The 570-acre mine has enough gypsum for another 50 years.

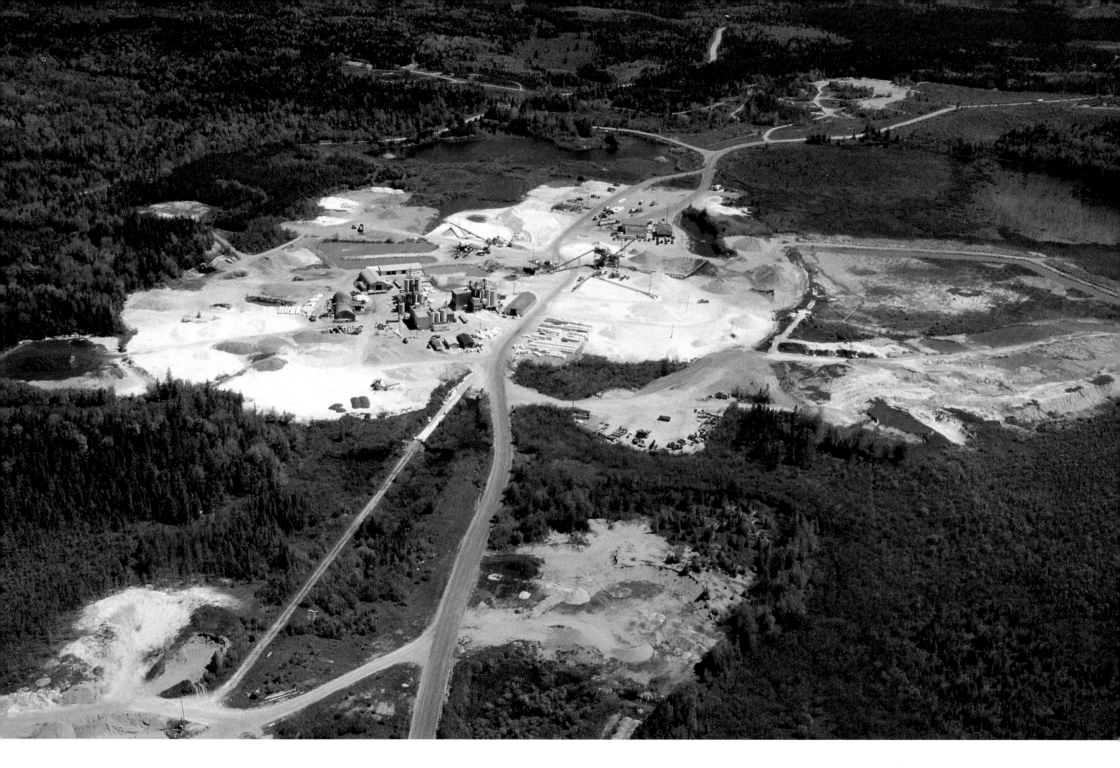

Piles of white and brown sand are screened, washed and packaged at the Nova Scotia Sand and Gravel quarry in Hardwoodlands, Hants County.

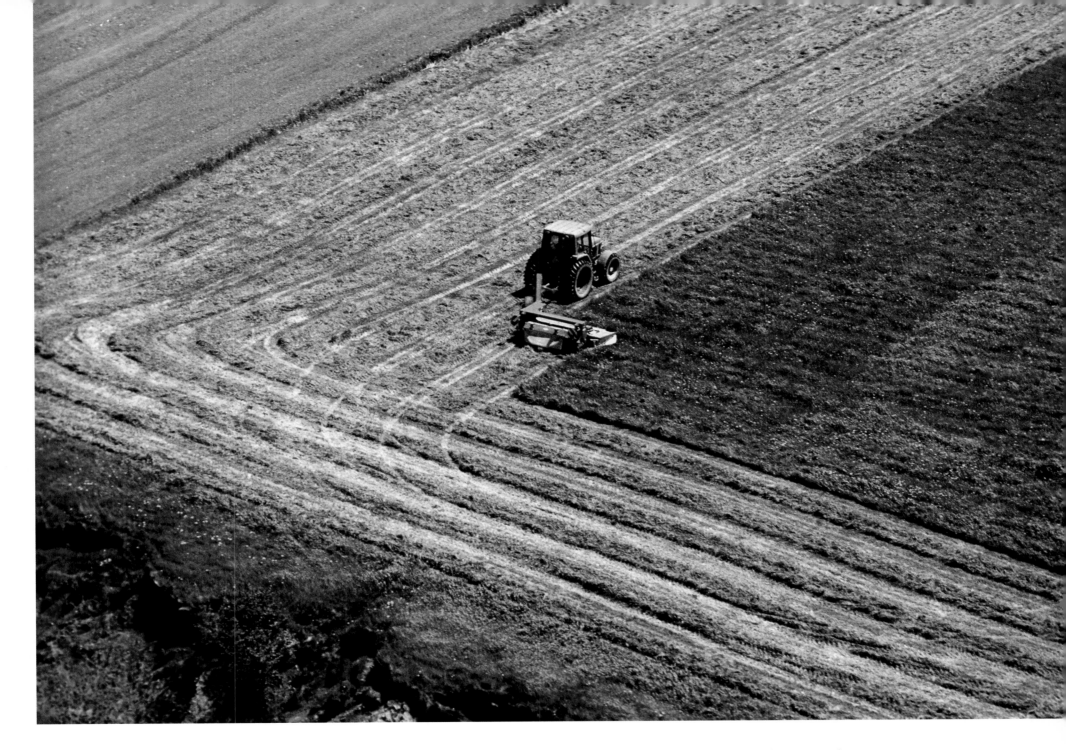

A Noel-shore farmer turns a corner while cutting hay during an early summer harvest.

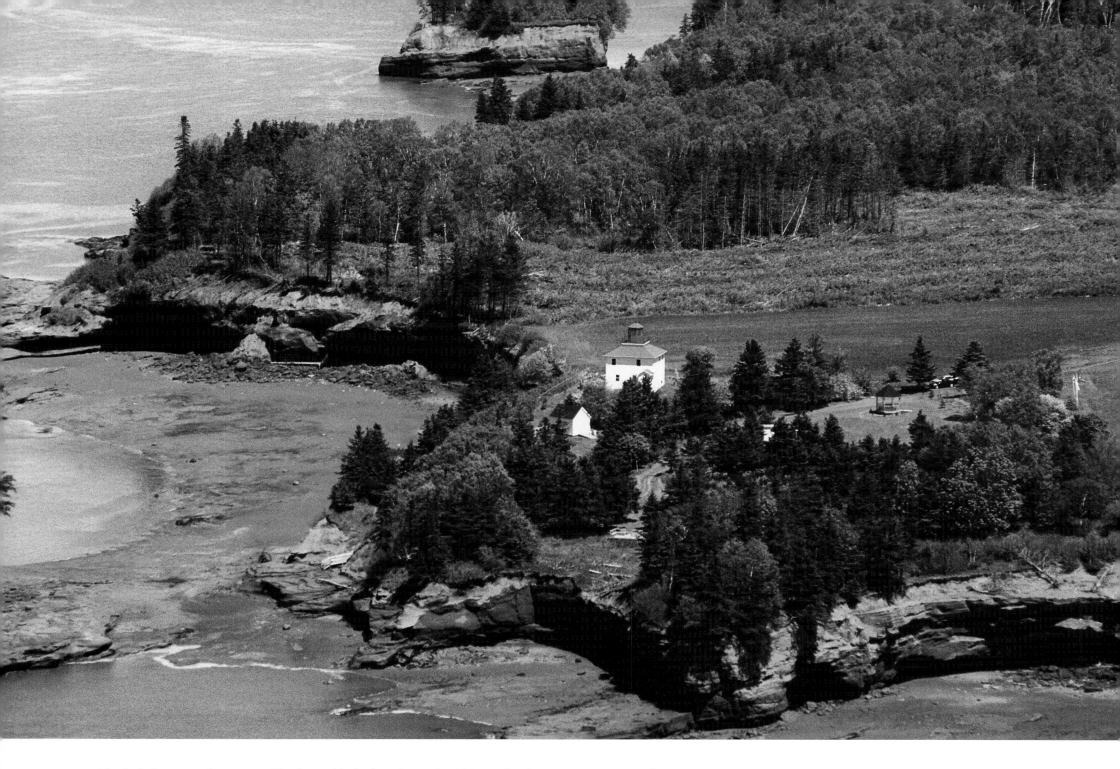

The lighthouse at Burntcoat Head, established in the mid-1800s and today a community park, sits on the Noel Shore, overlooking Minas Basin. The lighthouse was moved back due to the erosion of the shoreline caused by the Bay of Fundy tides. The greatest difference between high and low tides, 16.27 metres, was recorded at Burntcoat Head.

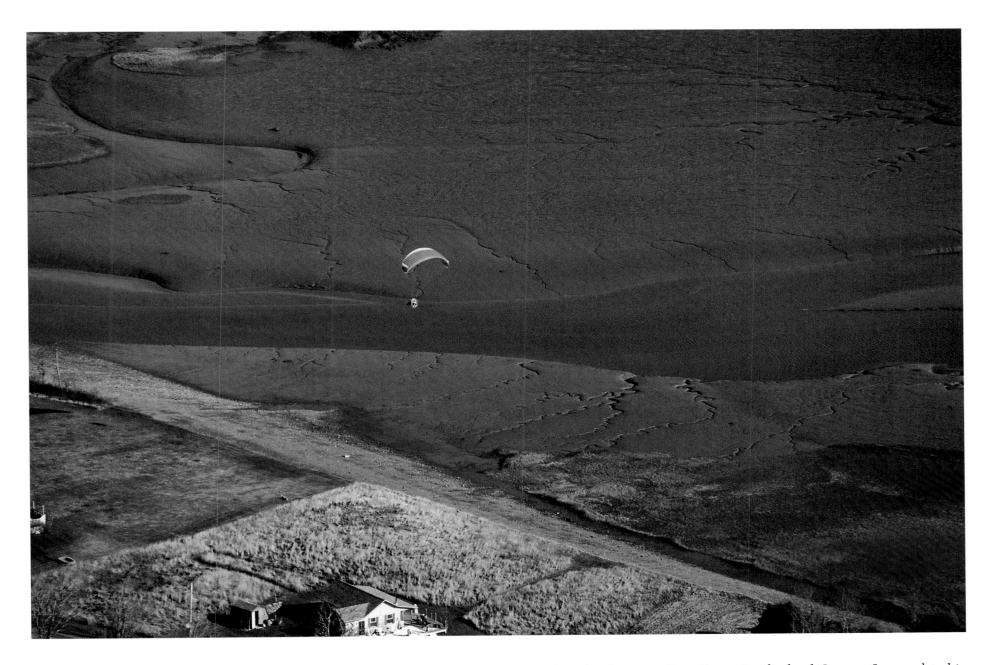

Para-glider Dan Yorke prepares for a landing near Bass River, Cumberland County. Strapped to his body is a motorized fan, which he powers up to aid in take off. The fan propels him forward once he is in the air, and he steers using the directional controls on the parachute. Yorke has flown as high as 700 metres and thinks he could go higher.

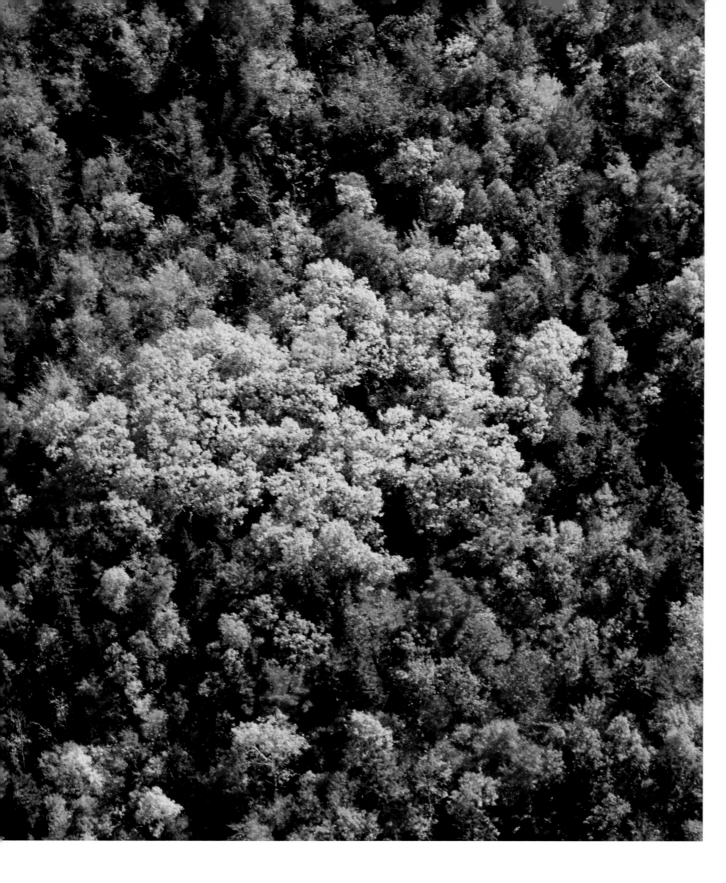

The fall colours of spruce, maple, birch and aspen are captured in this image of Wilson Mountain, near Harmony in Colchester County.

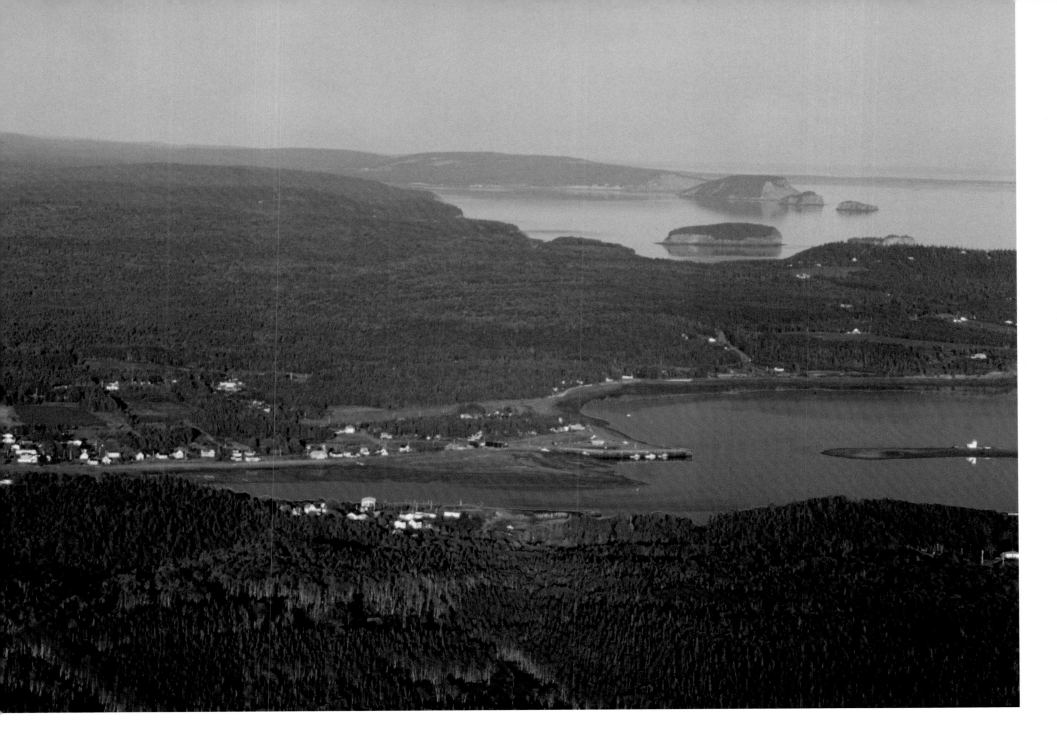

The mouth of Parrsboro Harbour opens into Minas Basin near Riverside Beach. In the distance are the Brothers and Five Islands. The Brothers, owned by the Nova Scotia Nature Trust, are two steep-sided basalt islands harbouring an old growth hardwood forest, rare plants and shorebird nesting sites.

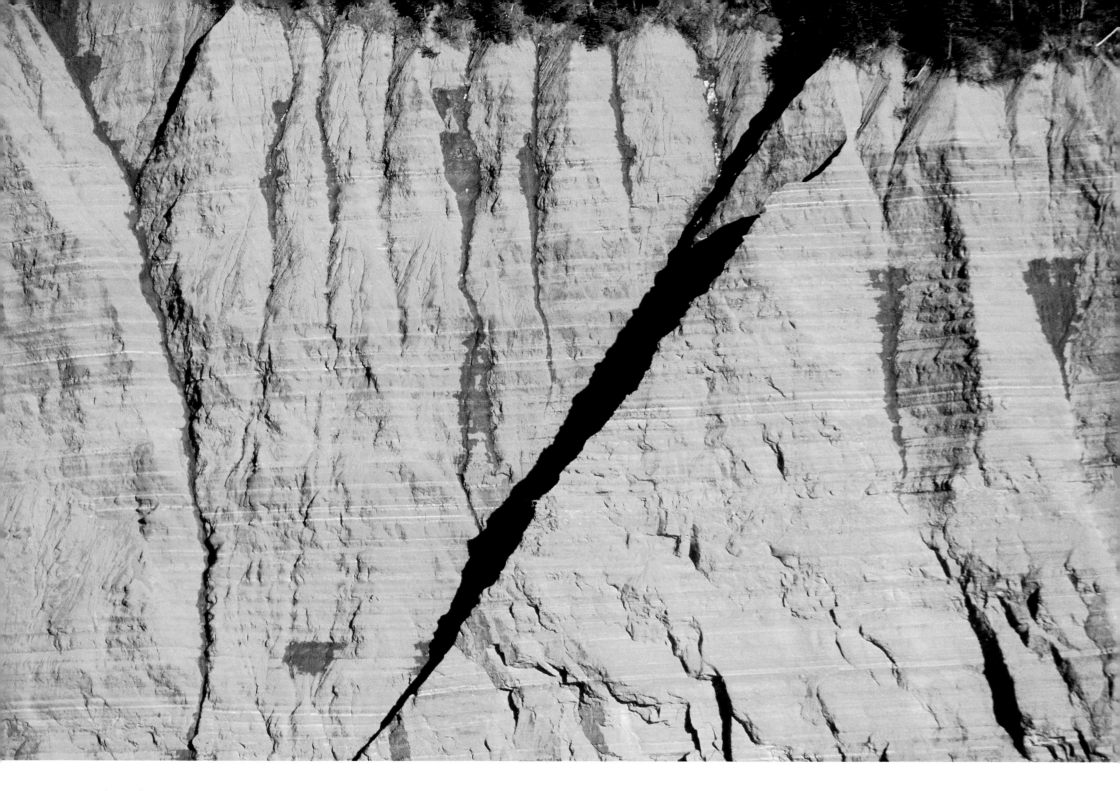

The sedimentary rocks of Red Head are the result of millions of years of settling of ancient seabeds.

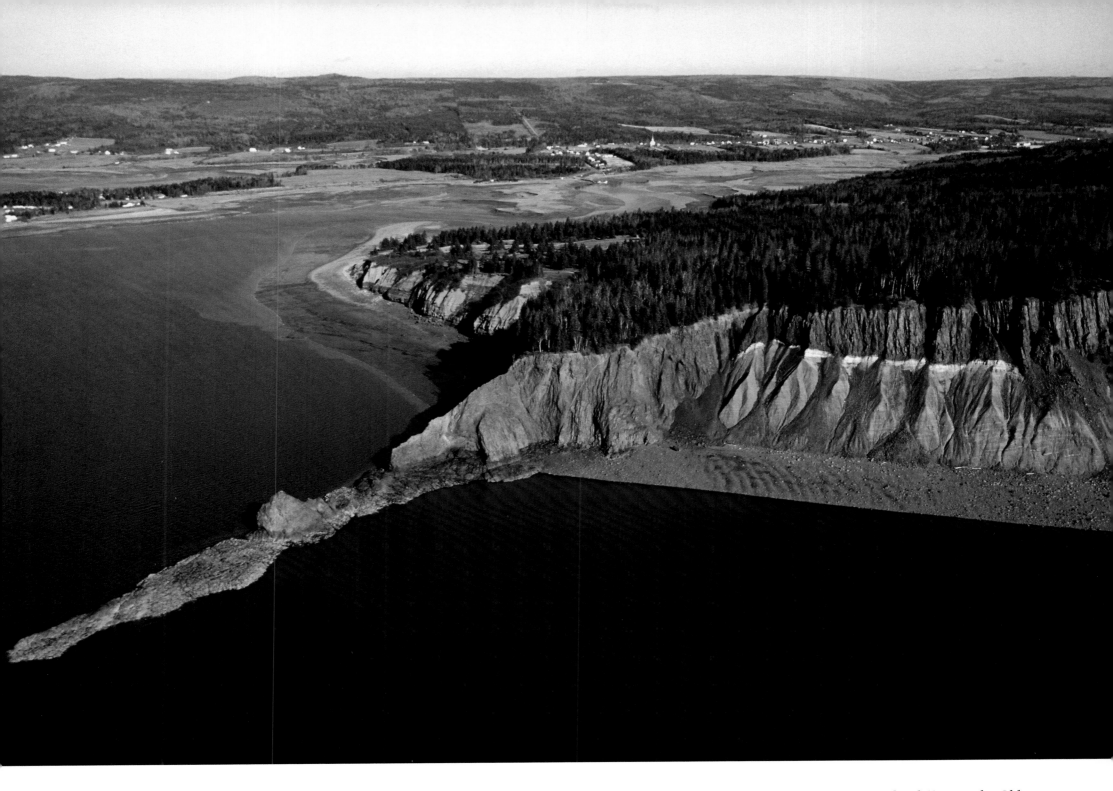

The geological strata of Five Islands Provincial Park are exposed by erosion on the cliffs near the Old Wife point. The bottom layer of red sandstone is 225 million years old. The white layer dates to the demise of the dinosaurs, around 60 million years ago. On top is a layer of basalt from an ancient lava flow.

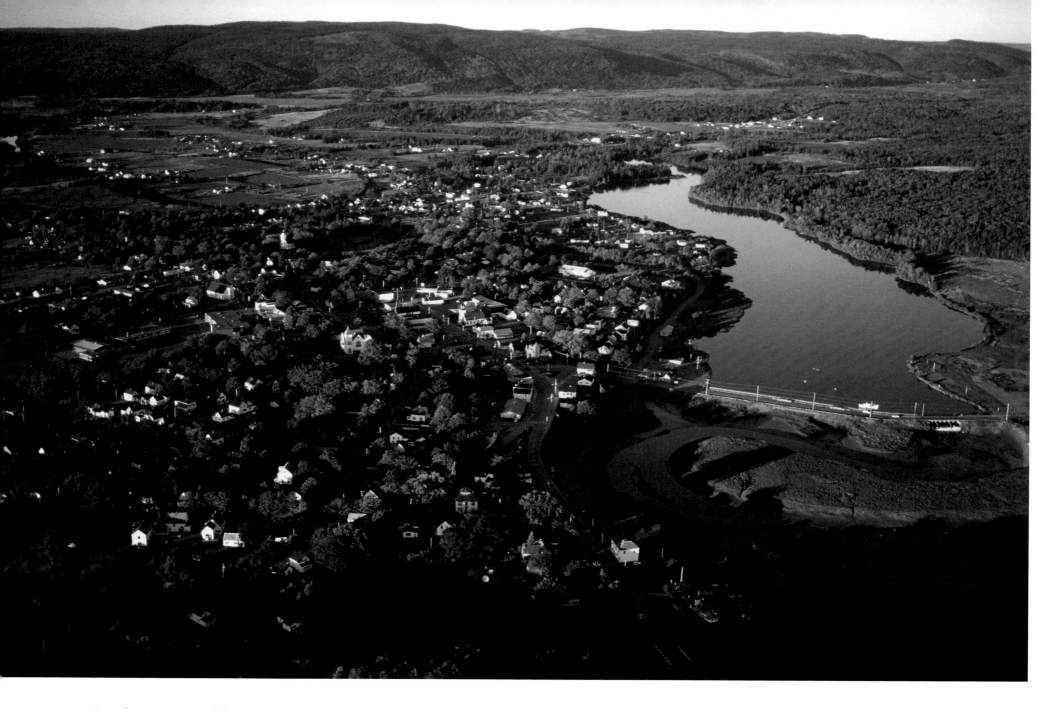

Parrsboro prospered during Nova Scotia's Age of Sail when shipbuilding and trade were the backbone of the economy. This quiet town lies on the banks of the river that rises in the Cobequid Mountains, in the background.

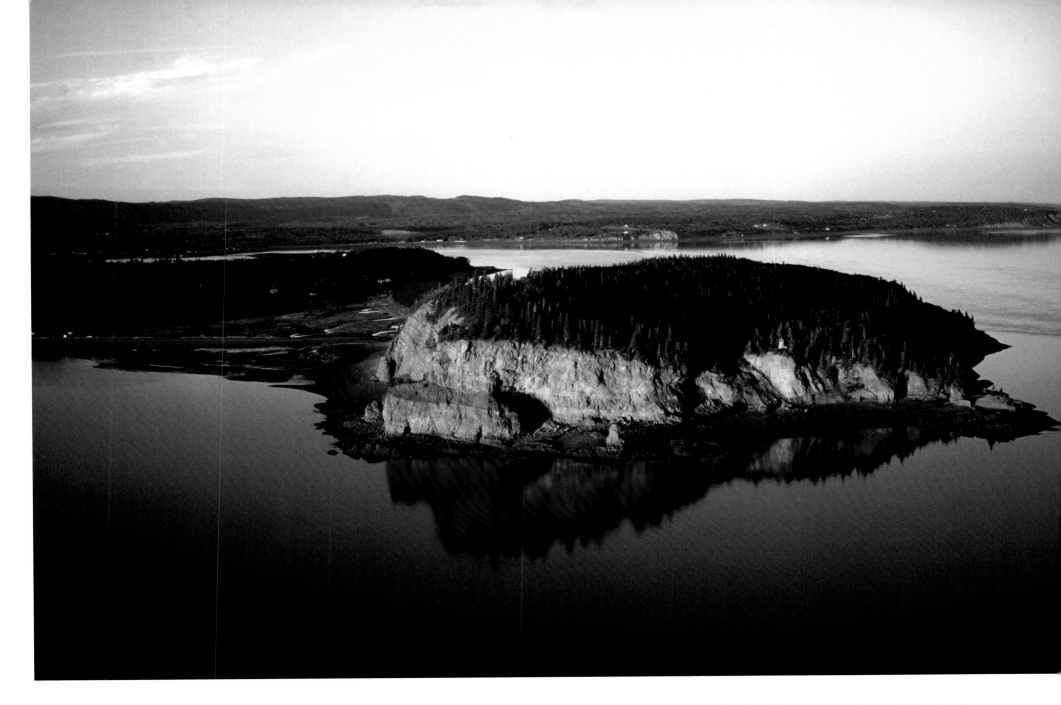

The late evening sun reflects off the cliffs of Partridge Island and into Minas Basin. The island, connected to the mainland near Parrsboro by an isthmus, is popular with hikers and fossil hunters. In 1607, Champlain discovered an iron cross here, perhaps indicating that other Europeans had previously been to the area.

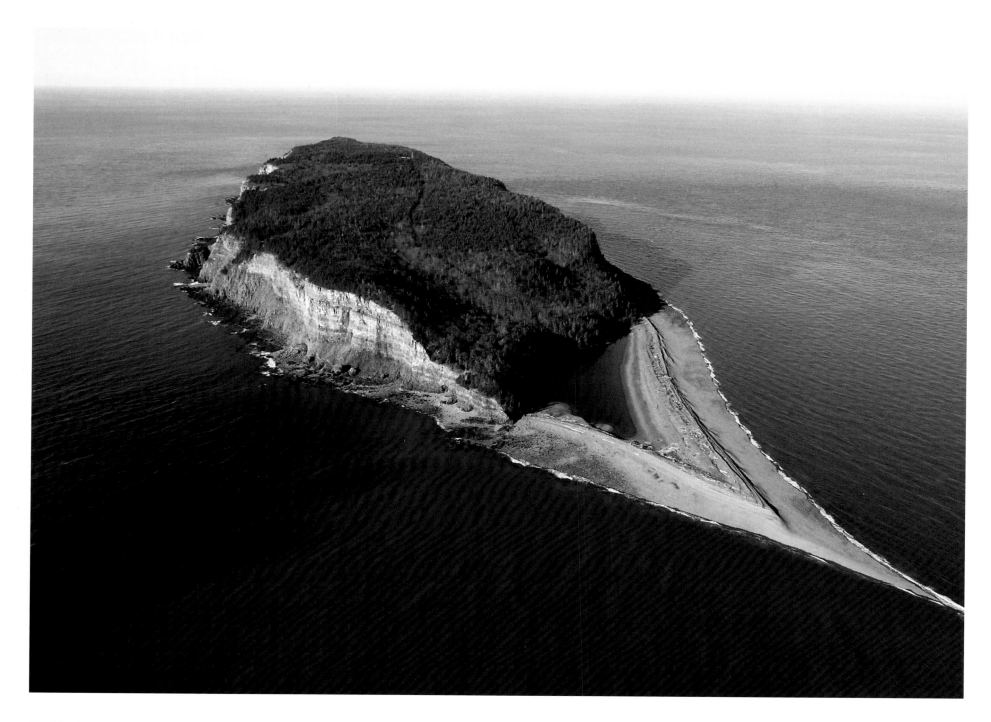

Visible from New Brunswick and Nova Scotia, Isle Haute rises 100 metres above sea level in the Bay of Fundy, five miles off Cape Chignecto. The island was part of a migration route for Aboriginal peoples thousands of years ago as evidenced by early tools found on the beach.

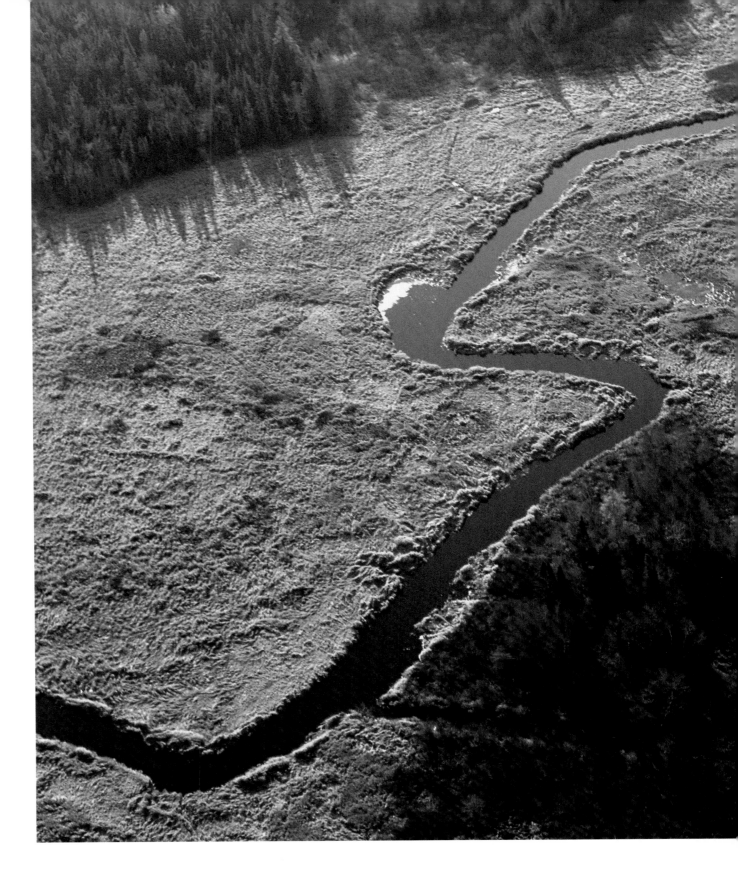

A slow-moving brook runs through a bog off the Maccan River in Cumberland County.

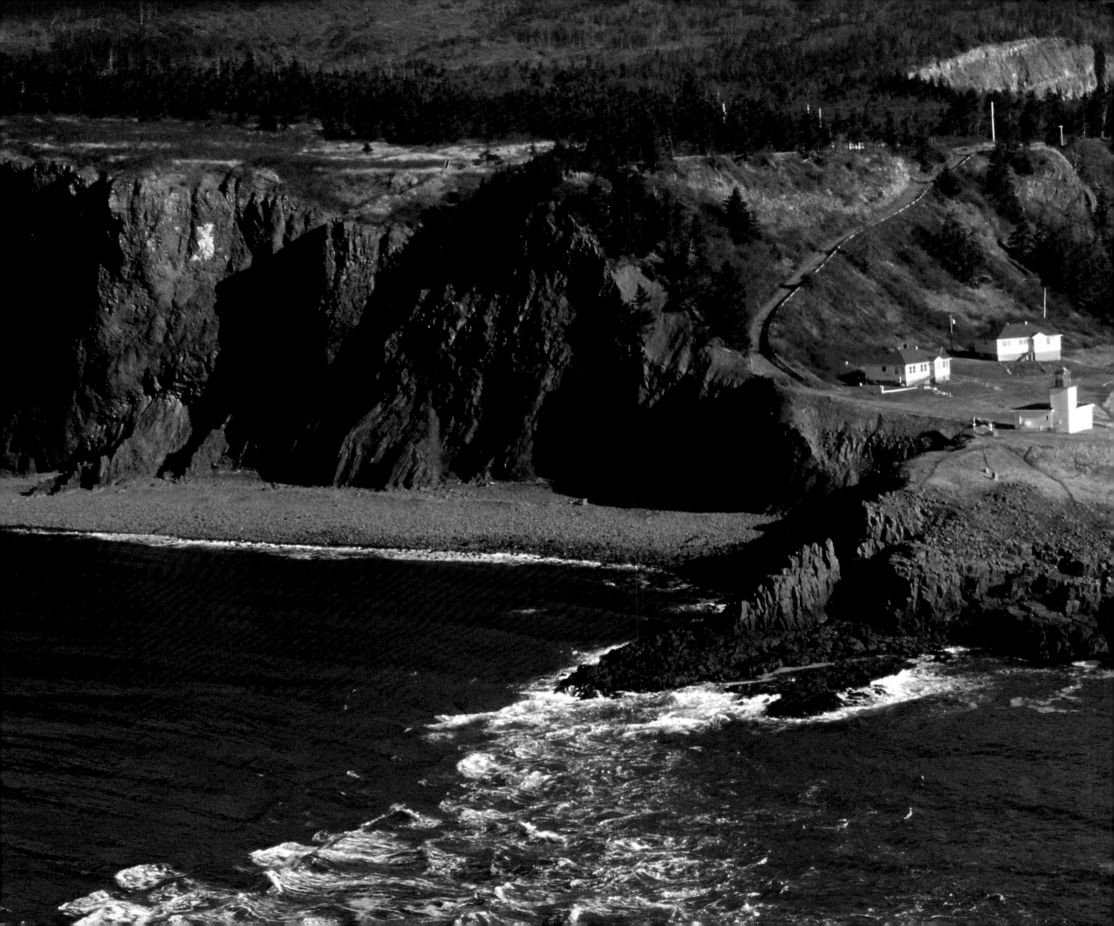

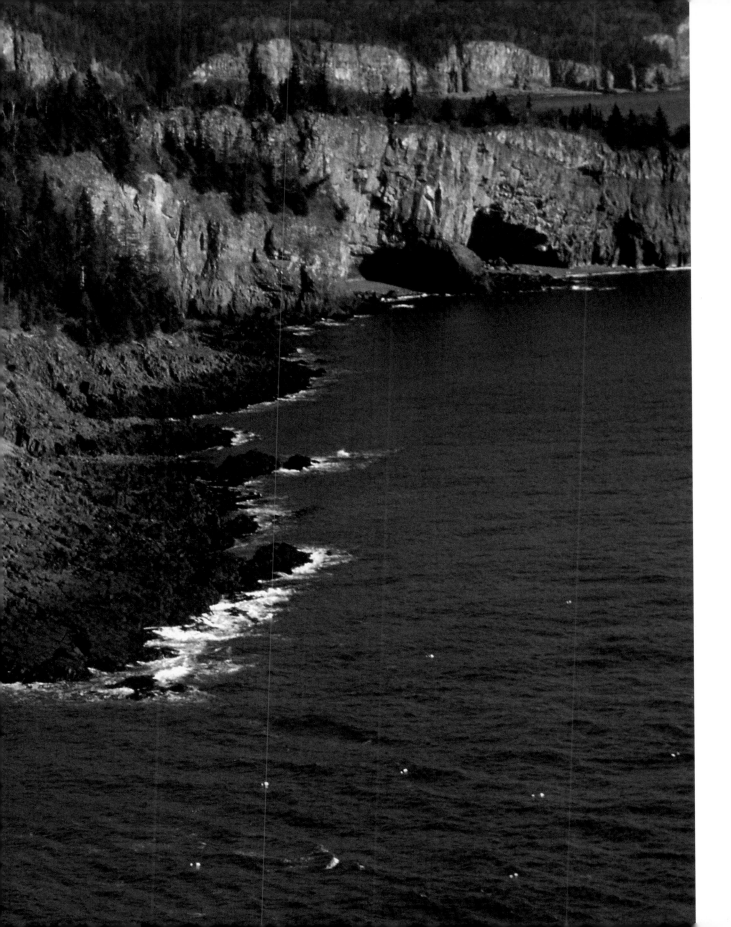

Churning waters of the retreating tide rip through Minas Channel at Cape d'Or, supposedly named by Champlain when he saw the copper-rich cape glinting like gold. The Colonial Copper Company mined the ore during the late nineteenth and early twentieth centuries. The lighthouse has been turned into a restaurant, and the keeper's cottage is a guesthouse.

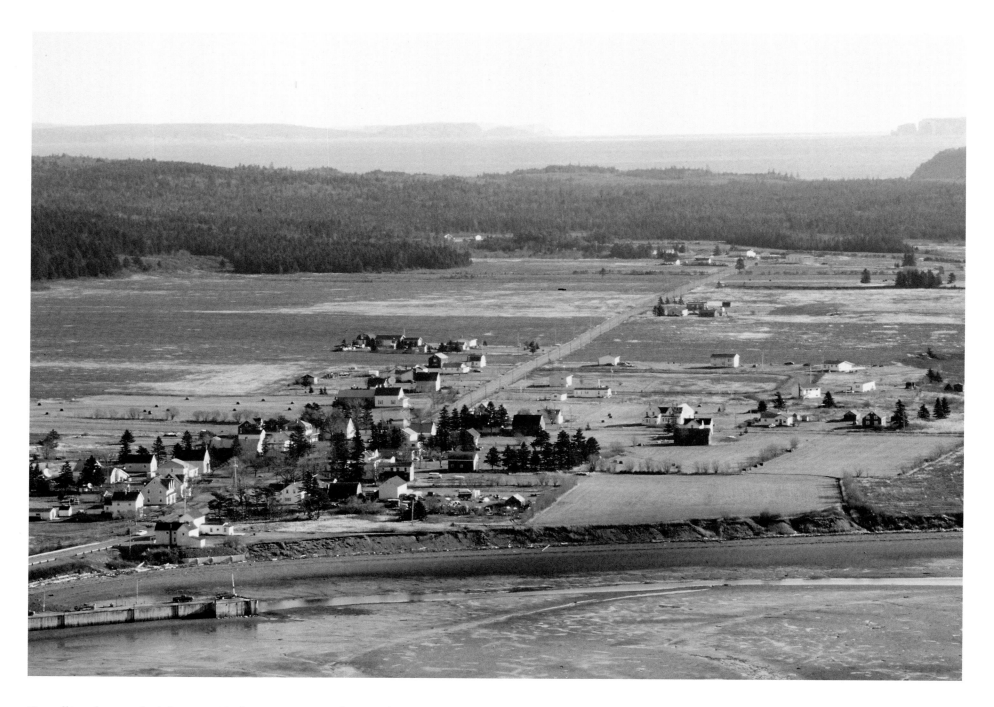

Travelling by road, Advocate Harbour seems to be at the end of everything. Once a thriving shipbuilding area, the harbour basin, seen here at low tide, shelters lobster fishing boats from the turbulence of the Bay of Fundy. On the horizon (centre), across Minas Channel, is Cape Split. On the right is Spencer's Island.

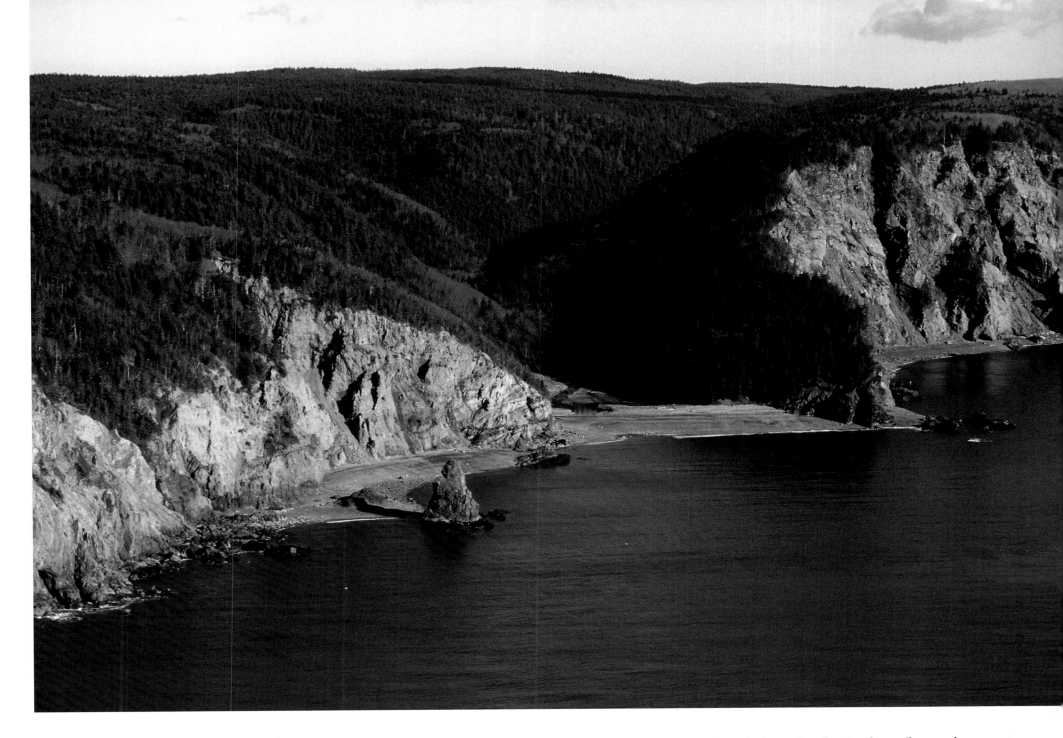

Within the cliffs of Cape Chignecto is Refugee Cove, used as a hiding place by Acadians fleeing the British expulsion order of 1755. Today it is part of Cape Chignecto Provincial Park, a spectacular hiking and camping area.

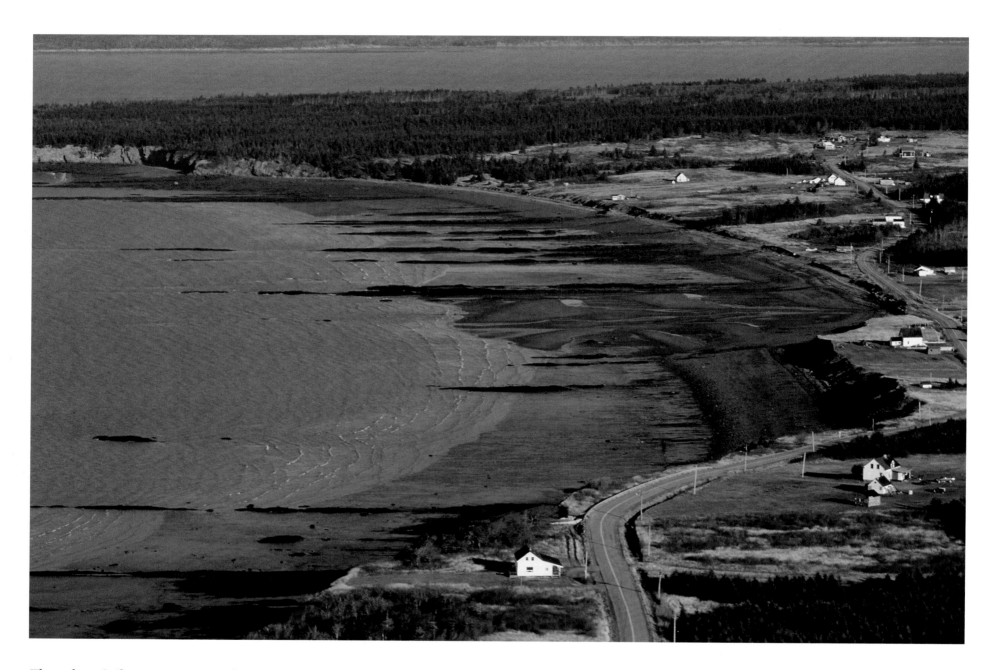

The tides of Chignecto Bay recede at Lower Cove, near Joggins, where some of the world's oldest fossils have been found. Visitors enjoy the Joggins Fossil Centre and search the beach for fossils near the constantly eroding cliffs.

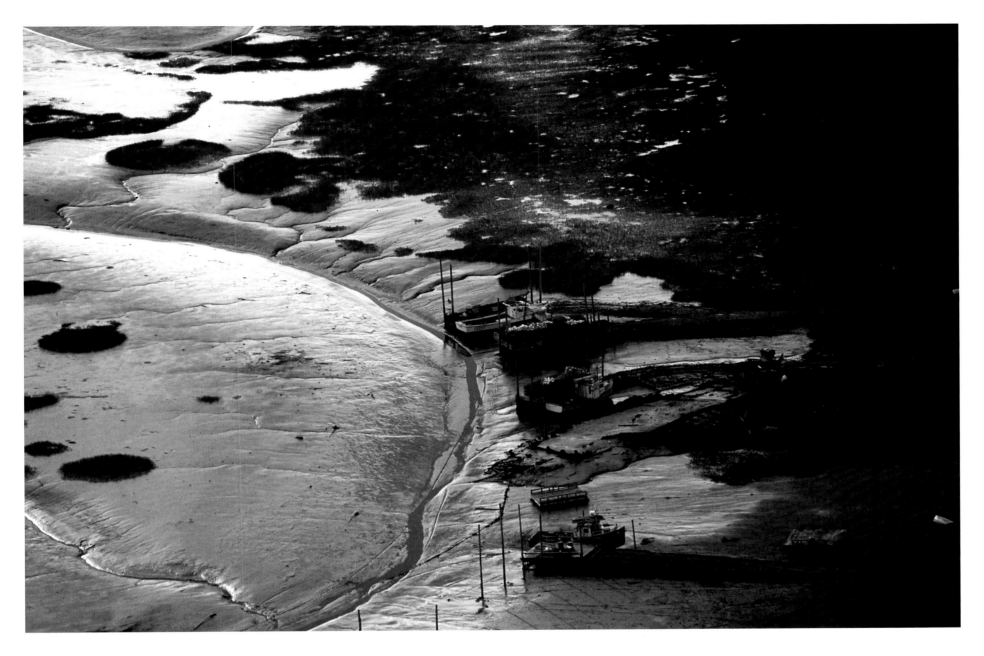

Fishing boats at low tide rest on the sea floor near West Apple River on Chignecto Bay.

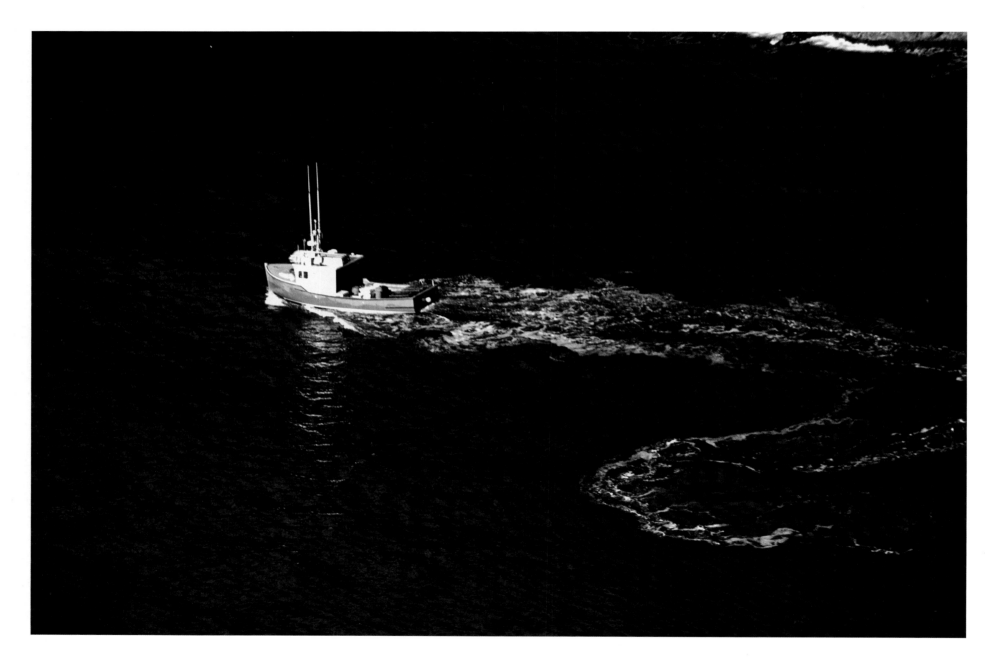

A lobster fisher heads onto the waters of Advocate Bay to check traps in early November.

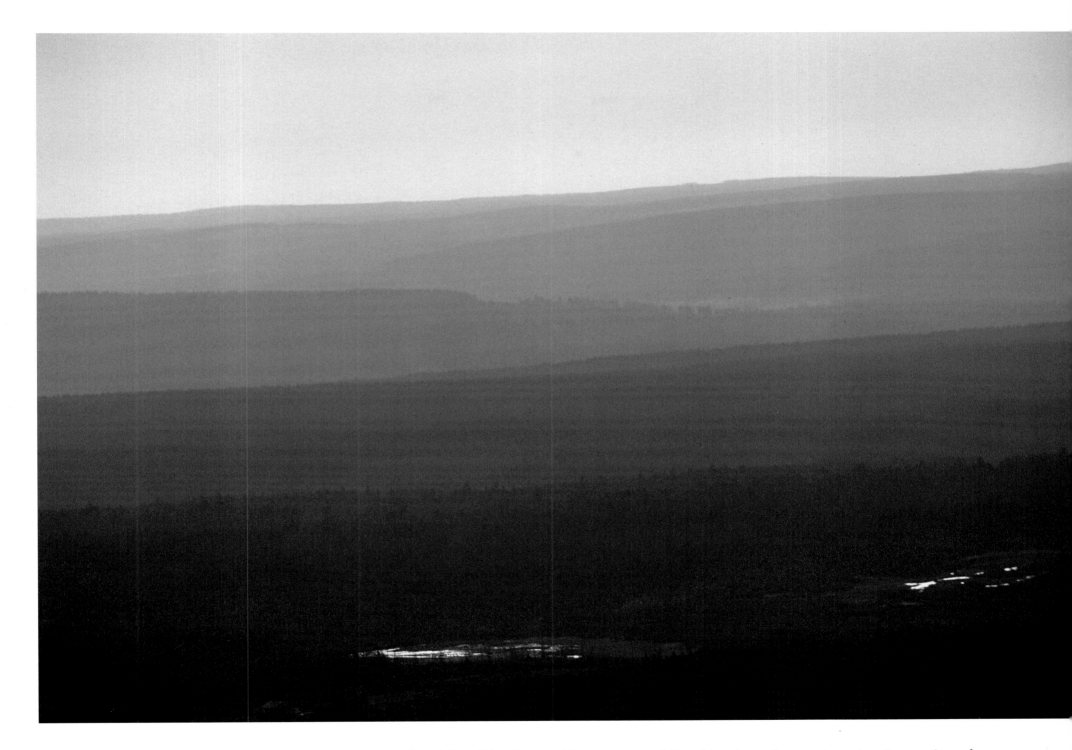

The rolling hills of the Canaan Mountains are diffused by the early morning mist. Spruce, fir and maple forests provide homes for deer, bear and moose.

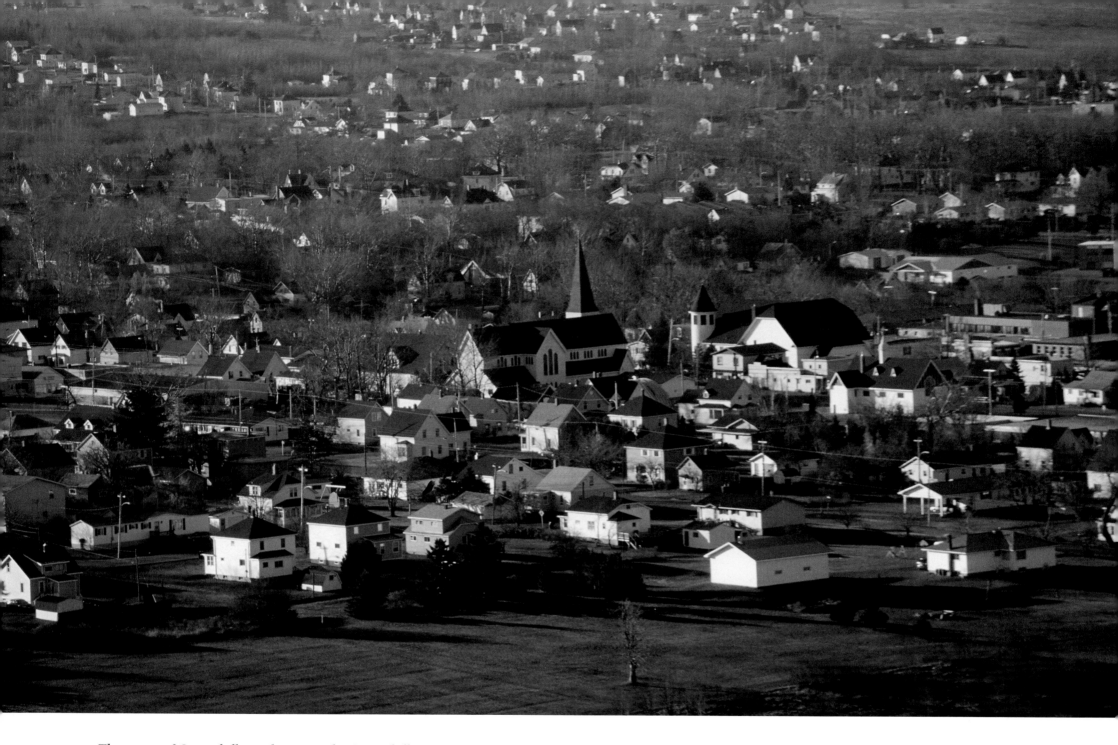

The town of Springhill was home to the Springhill Mining Company, formed in 1873. Coal mining continued to be a major local industry until 1971. Over the century there were three major mining disasters, in 1891, 1956 and 1958. Rescue efforts during the 1958 "bump" (caused by a land shift that trapped miners underground) were broadcast live around the world.

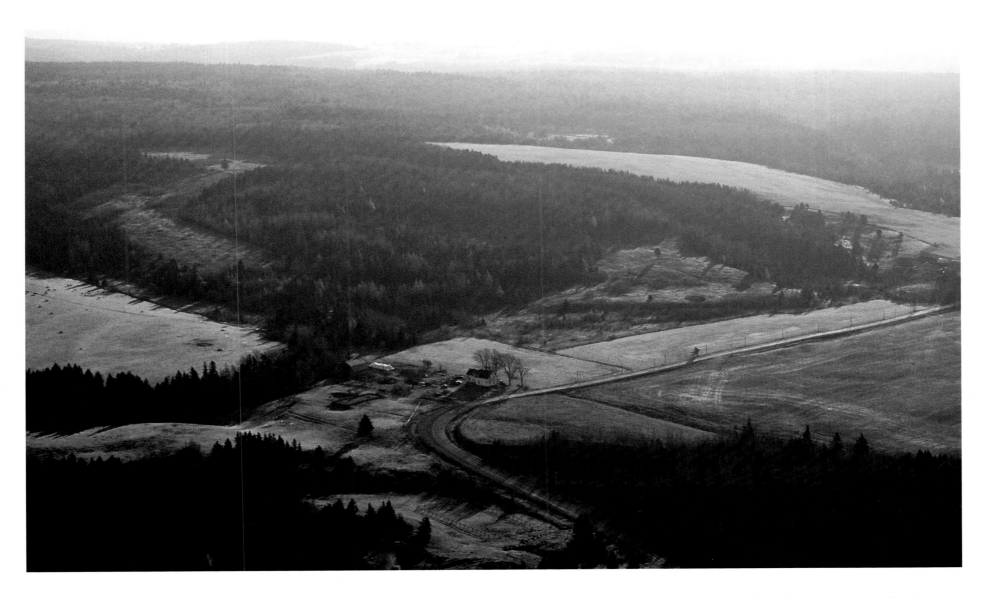

A single farm dots the countryside west of Springhill, with the Cobequid Mountains in the distance. The province of Nova Scotia has a total of 23,000 kilometres of road, including this stretch of gravel road in Cumberland County.

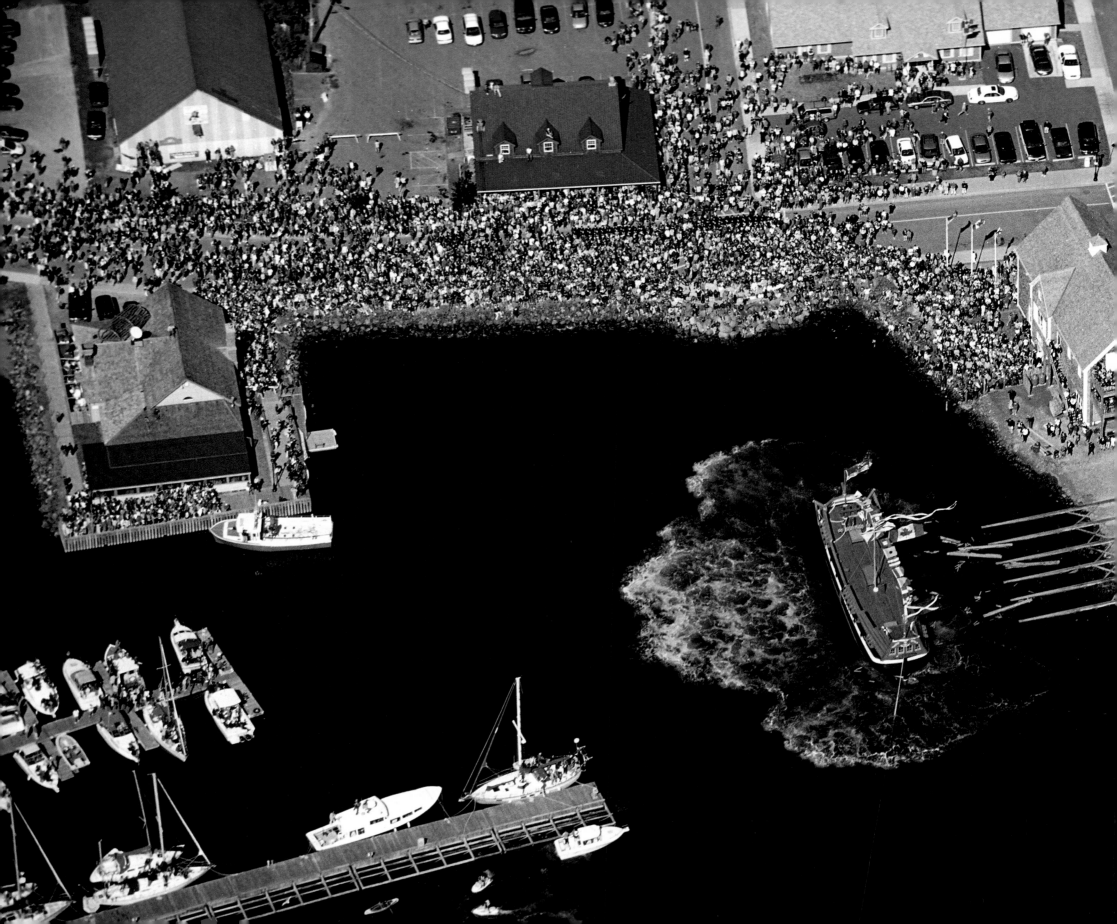

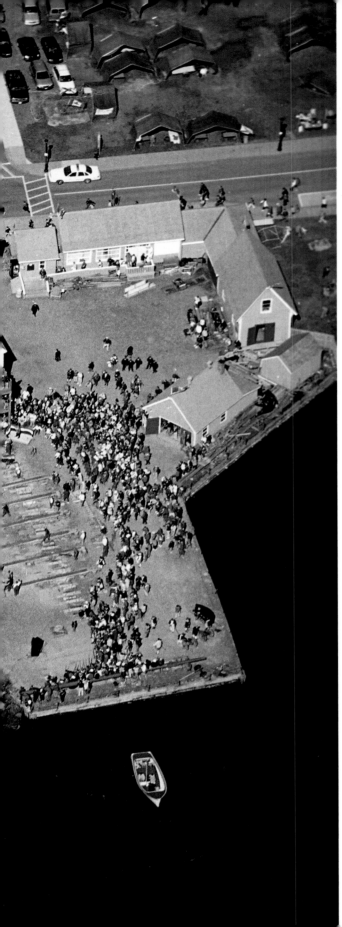

3 NORTHUMBERLAND SHORE

THE DRIVE ACROSS the Cobequid Mountains feels like traversing a valley, not ascending a gentle slope. So it's a surprise to realize, when your ears pop at Folly Lake, that this is one of the highest points of land on mainland Nova Scotia. From the air, the mountains show their colours. In fall, there is a mosaic of reds and yellows; in summer, a green canopy is spread below; in winter, the white snow contrasts with the grey leafless trees and green conifers. And in spring, lakes are still clogged with ice long after it has melted at lower elevations.

The mountains gradually level out and Prince Edward Island appears across the Northumberland Strait. Turning east, fly over the giant salt mine near Pugwash and, on a good day, catch sight of basking seals on sun-warmed rocks off Malagash Point.

Farther east is the town of Pictou, where Scottish settlers landed in 1773. The remains of surface and underground coal mines at New Glasgow and Stellarton are clearly seen from the air. Follow a ribbon of road towards Antigonish, with the sprawling campus of St. Francis Xavier University, and on past the old monastery at Monastery to the Canso Causeway, which connects the mainland with Cape Breton Island.

Left: On Sunday, September 17, 2000, thousands of people lined the shores of Pictou Harbour to watch the launch of *Ship Hector*, a replica of the ship that brought Scottish settlers to Nova Scotia in 1773. A floating museum, *Ship Hector* had a close call in September 2003, when Hurricane Juan tore it from its mooring and tossed it onto nearby rocks.

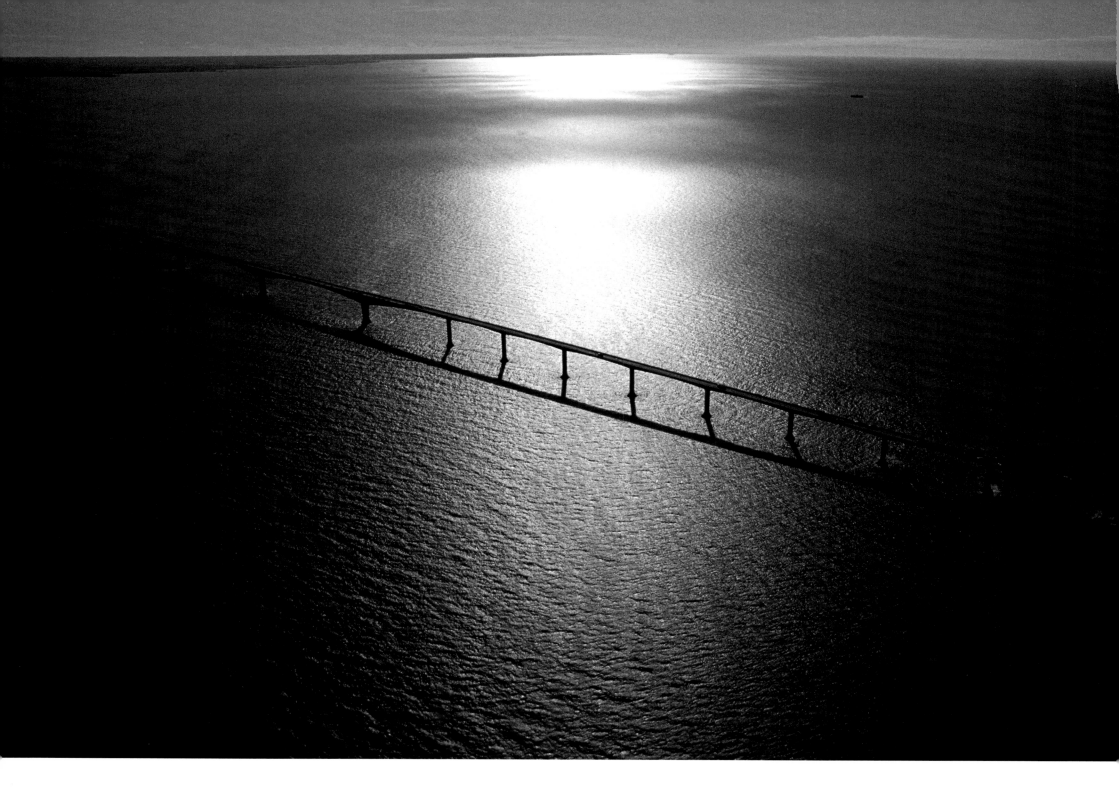

Opened May 1, 1997, Confederation Bridge, joining New Brunswick and Prince Edward Island, stretches 12.9 kilometres across the Northumberland Strait. The bridge is a vital link for all the Maritime provinces–Nova Scotia, New Brunswick and Prince Edward Island.

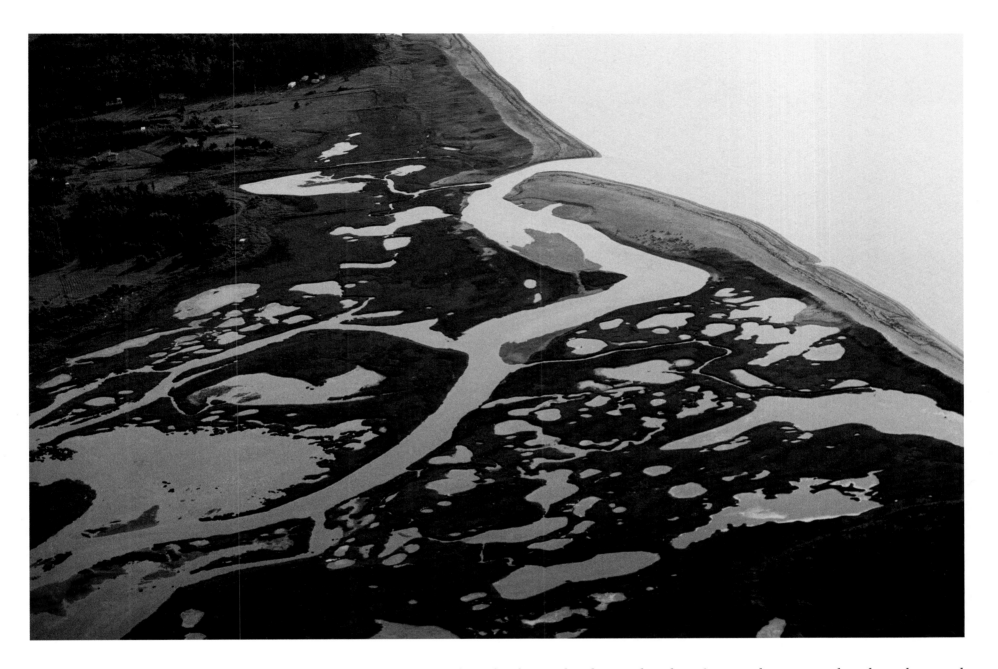

The ocean cuts through a barrier beach at Malagash to form a saltwater marsh, rich in plants and waterfowl. The red sandstone shores of the Northumberland coast were formed 290 million years ago.

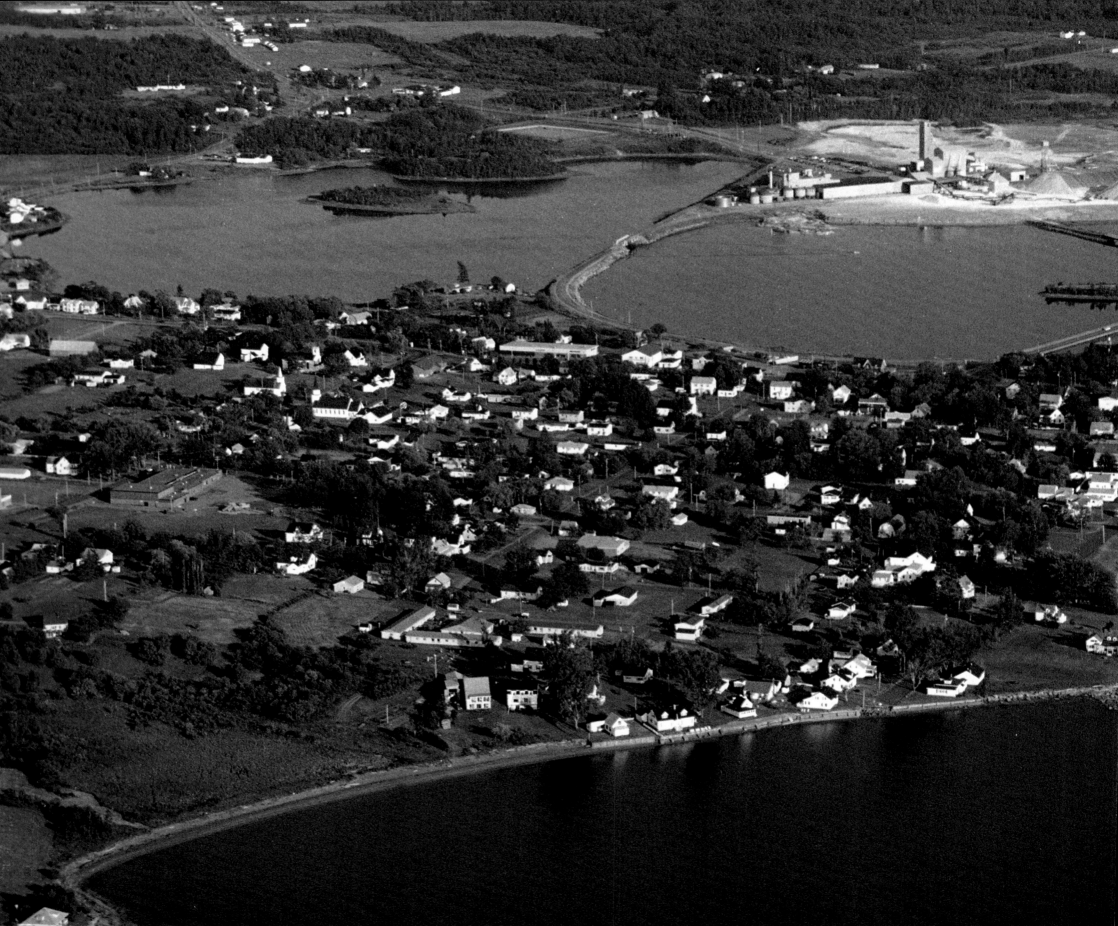

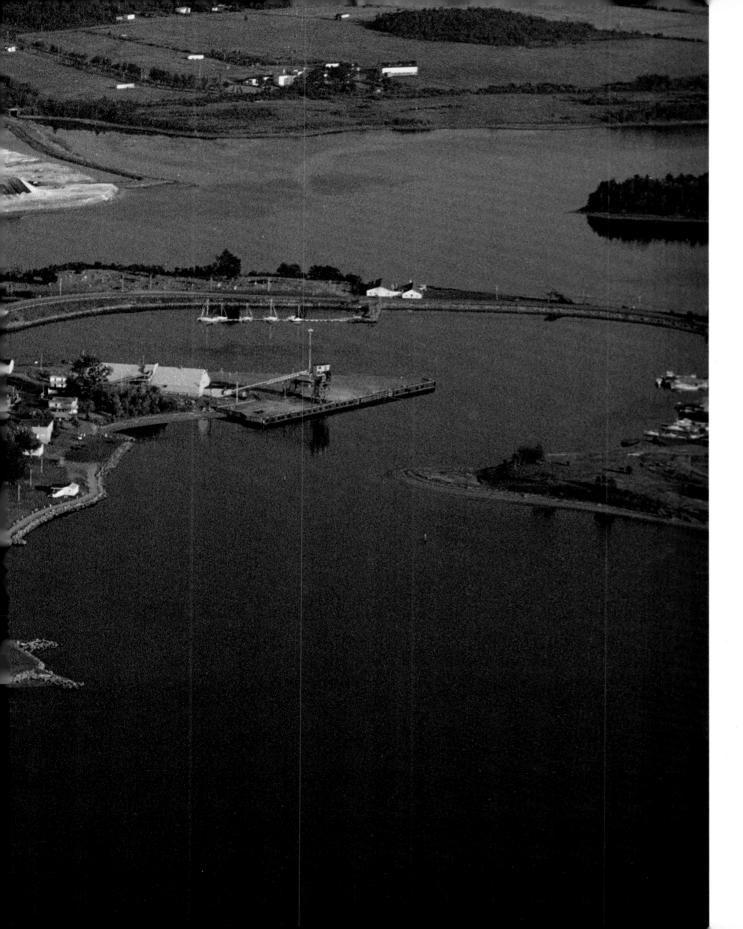

The Canadian Salt Mine, opened in 1963, dominates the landscape around the Pugwash Basin. The village of Pugwash gets its name from a Mi'kmaw word for deep water. Pugwash is world famous for the annual Conference on Science and World Affairs, which attract peace activists and philosophers. The first conference, held in 1957 and organized by Cyrus Eaton, included Albert Einstein among its delegates. In 1995, the conference and its secretary-general, Joseph Rotblat, were awarded the Nobel Peace Prize.

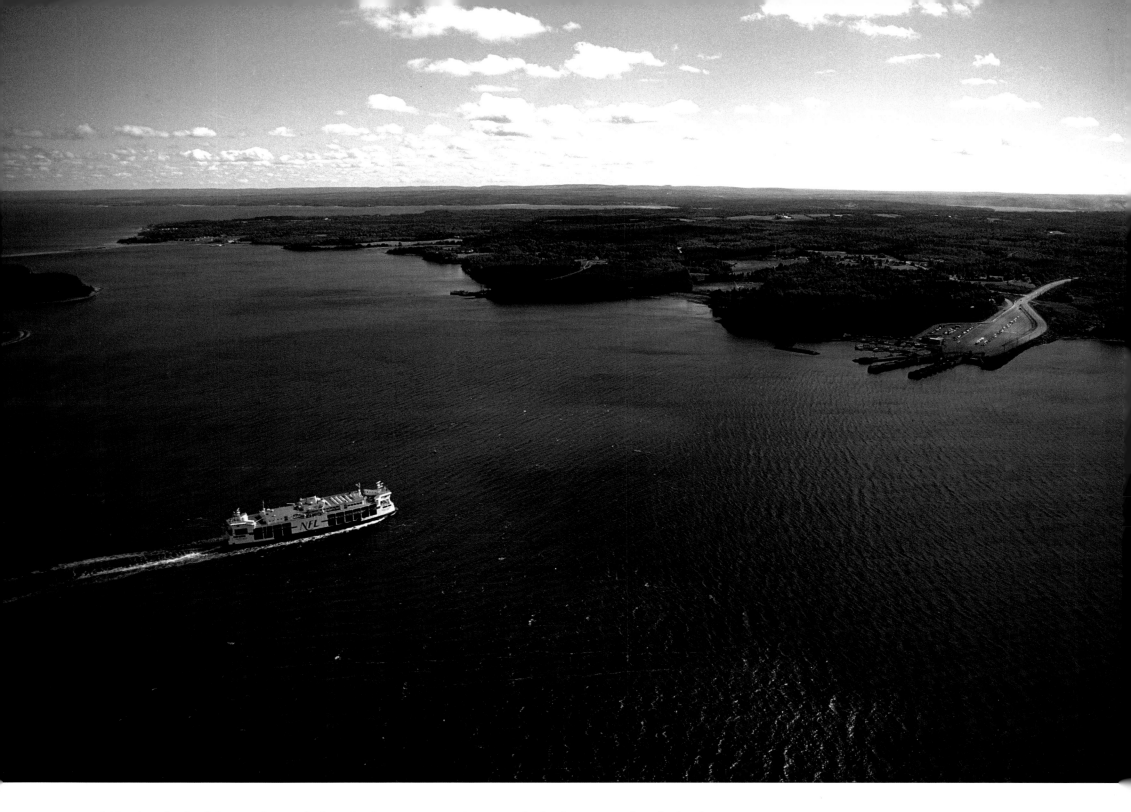

A Northumberland ferry sails into dock at Caribou, returning from Wood Islands, Prince Edward Island.

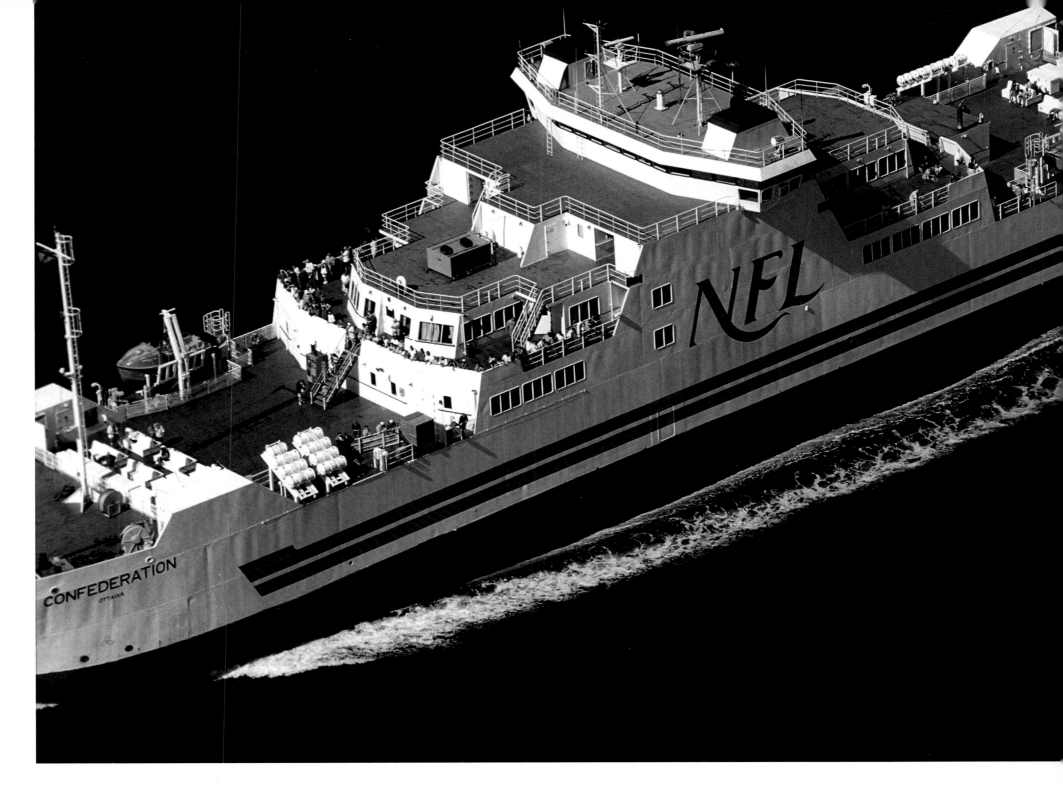

The ferry, *Confederation*, heads to Wood Islands. The 45-minute ride across the Northumberland Strait is still popular, despite the opening in 1997 of Confederation Bridge, linking Prince Edward Island and New Brunswick.

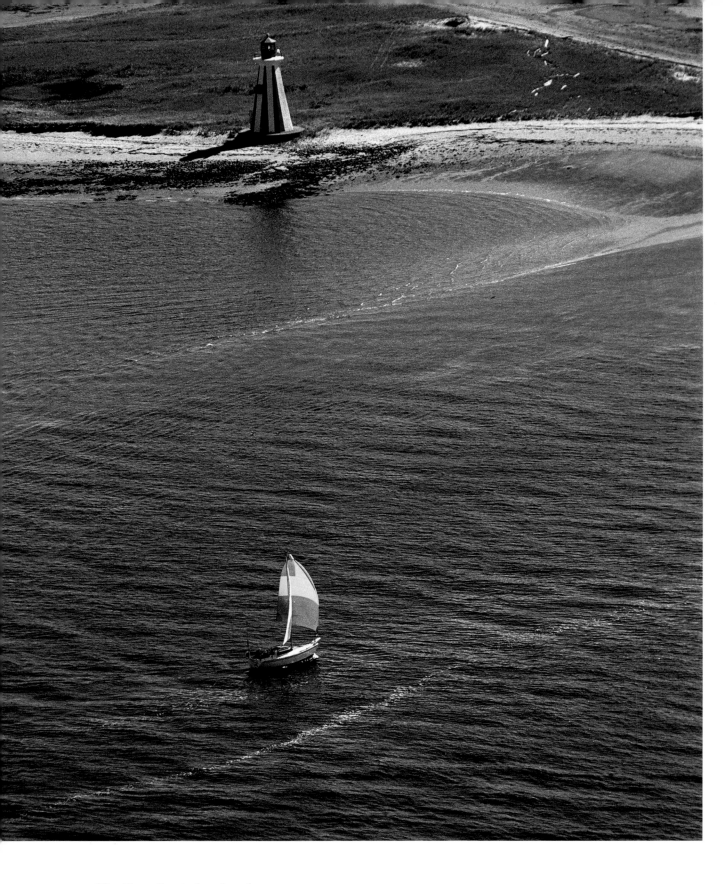

A sailboat passes Pictou Bar Lighthouse, at the south entrance to Pictou Harbour. The original lighthouse, built in 1834, was replaced in 1904 by this 15-metre structure, which operates today with an automated light.

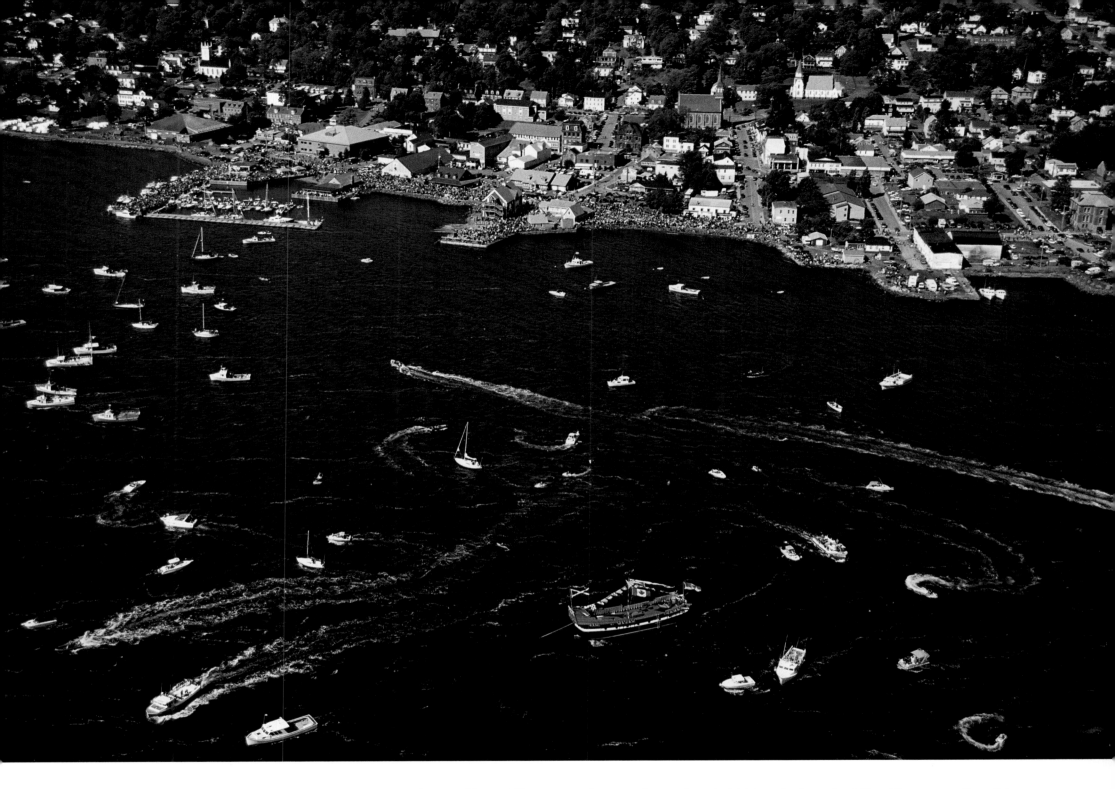

Ships and boats fill Pictou Harbour on September 17, 2000, at the launch of *Ship Hector*, a replica of the ship that brought settlers from Ullapool, Scotland, to the Pictou area, landing on September 15, 1773.

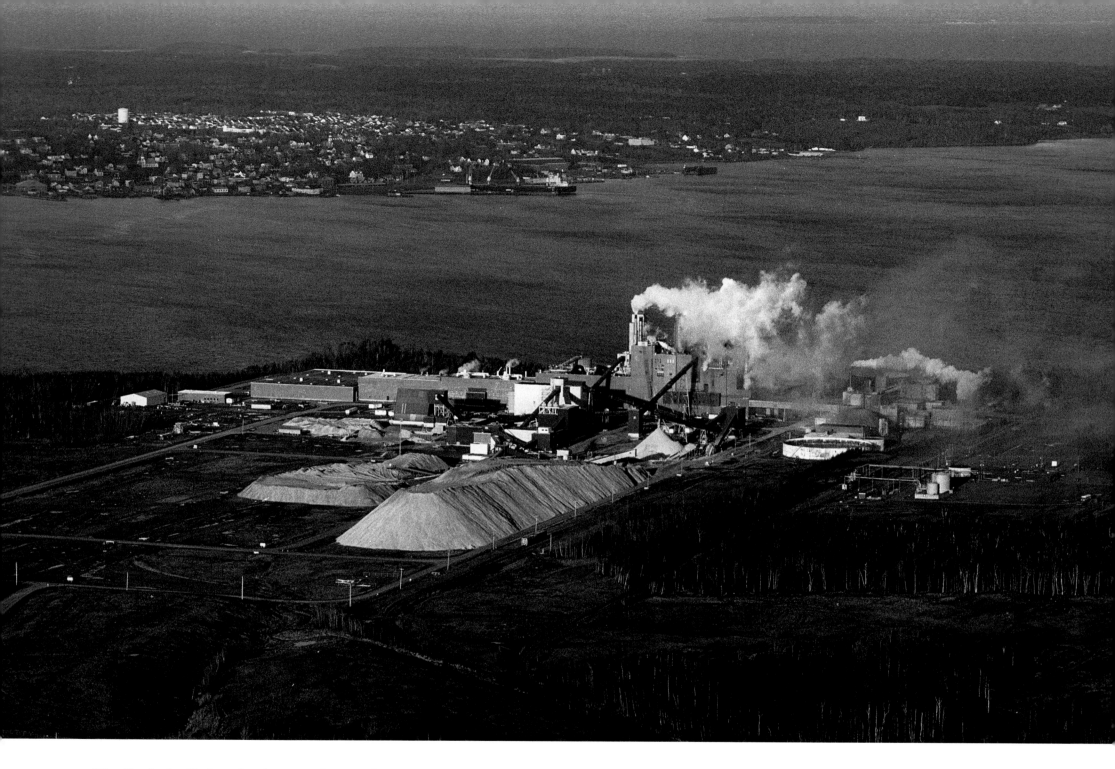

The Kimberly-Clark pulp plant at Abercrombie Point manufactures paper products and employs around 400 people from the Pictou area.

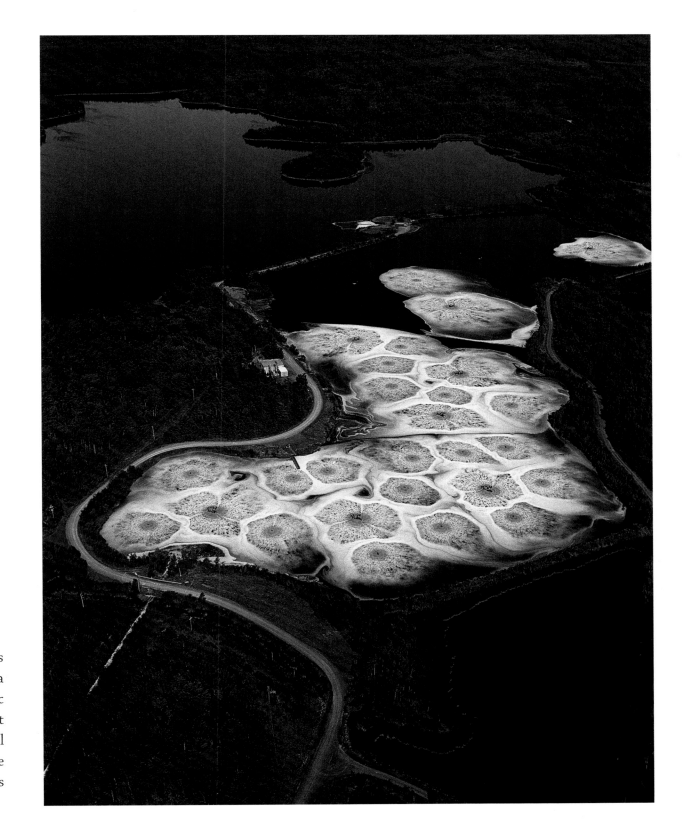

The Boat Harbour Project, in Pictou County, is an undertaking by the Nova Scotia Department of Transportation and Public Works to turn a wastewater effluent stabilization lagoon back into a natural tidal estuary. The lagoon is being used as part of the Boat Harbour Treatment Facility to process effluent from Kimberly Clark.

A family enjoys a day on the beach at Caribou/Munroes Island Provincial Park, near Widow Point on the Northumberland Strait. The waters of the Strait provide the warmest salt-water swimming in Nova Scotia.

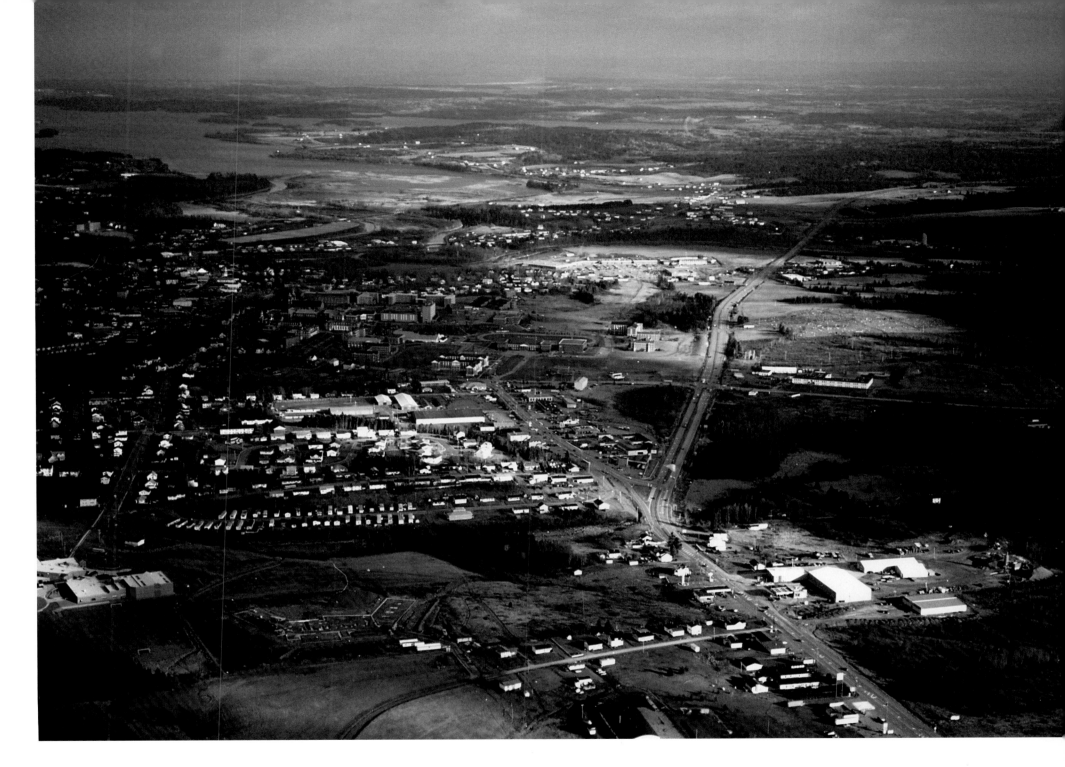

Antigonish, considered the heart of New Scotland, traces its roots to the Mi'kmaw settlements around St. Georges Bay. The town is known worldwide for highland games, St. Francis-Xavier University and for the Coady International Institute, named in honour of Rev. Dr. Moses Coady, a founder of the Antigonish Movement.

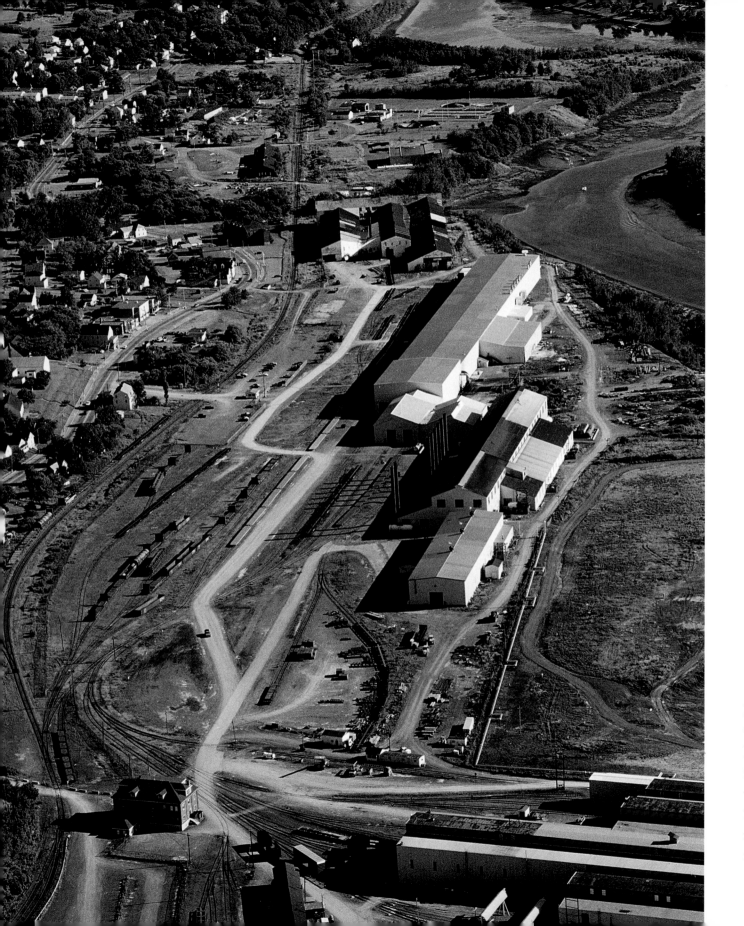

More than 16 kilometres of railway connect the various production facilities at Trentonworks Ltd., at Trenton, Nova Scotia. The original ironworks was founded in 1872 and through various owners has expanded to the present 160-acre facility. In addition to railcar manufacturing, the company is capable of making steel forgings up to 100 tons.

The Maritimes and Northeast Pipeline carries natural gas from Goldboro, Nova Scotia, to the United States. It was built in 1998–99 by a consortium of companies involved in delivering offshore gas to U.S. and Atlantic Canadian markets.

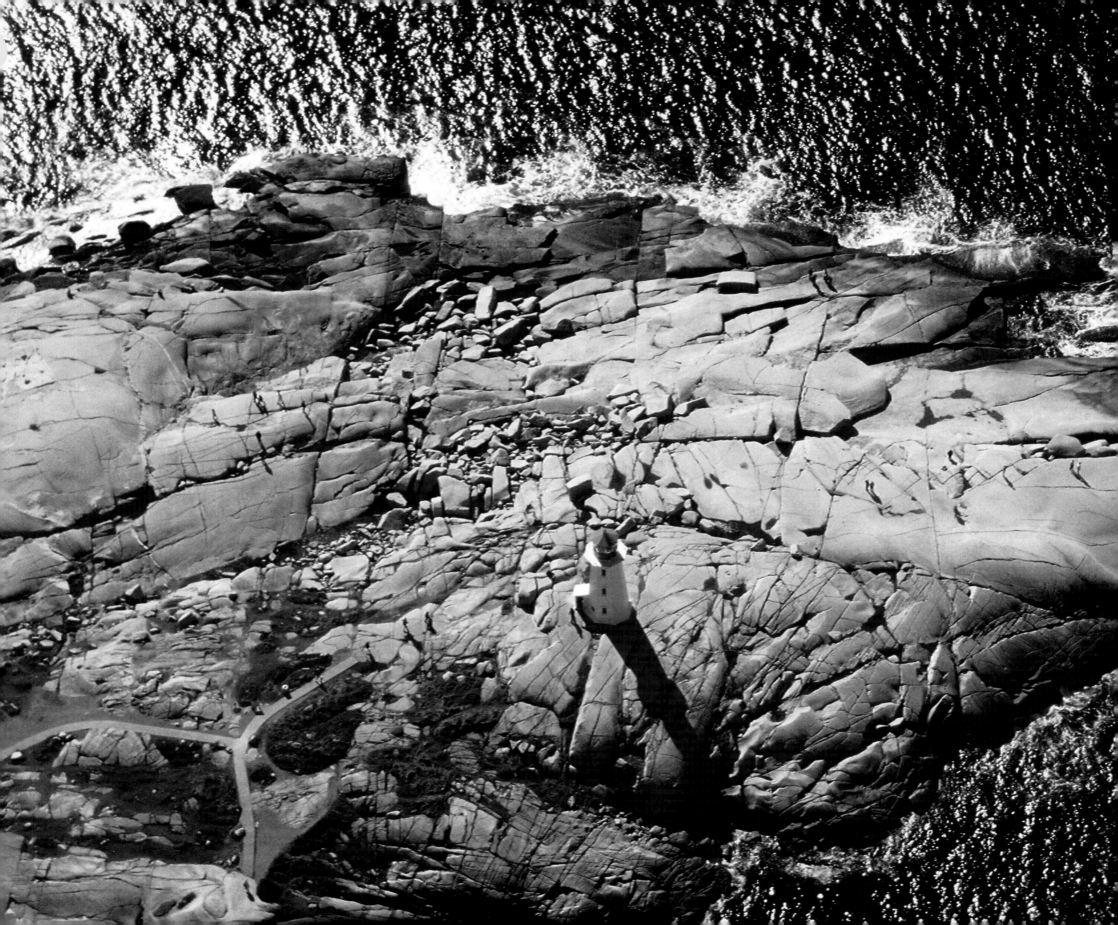

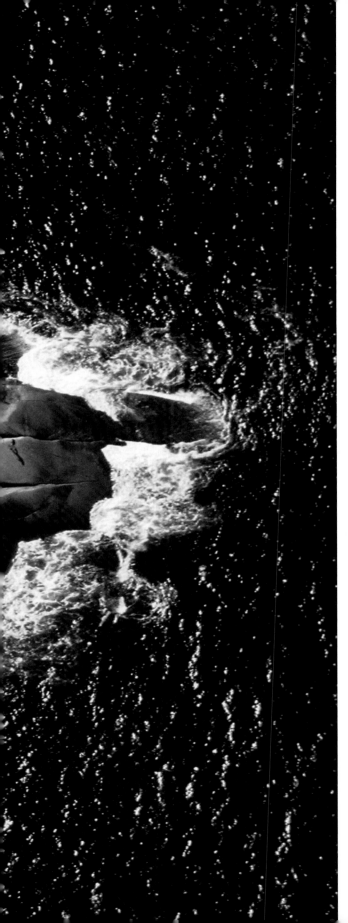

4 SOUTH SHORE

FLYING FROM HALIFAX to Yarmouth means heading southwest along the coast. Crossing the Aspotogan Peninsula it is not hard to believe the tales of pirate treasure buried on some of the hundreds of islands scattered over Mahone Bay. Here, fishing is a way of life and tiny communities line the coast around the numerous coves. They are sheltered from the ocean that pounds the tips of the peninsula. Near Lunenburg, it is not unusual to glimpse trawlers returning with their catches or bulk carriers steaming towards Halifax.

Drive along the South Shore route and it seems that the forests go on forever. Not so from the air, where logging roads and clear-cutting scars provide evidence that the seemingly endless forests are just fringes of trees lining the highways.

Flying inland across the centre of the province reveals hundreds of lakes, which, with the rivers that connect them to the sea, once fuelled the economy, providing passage for logs headed towards the mills. But for a few roads between the South Shore and Annapolis Valley communities, the area is sparsely populated. One such road, from Liverpool to Annapolis Royal, runs past Kejimkujik National Park, a protected wilderness area.

Left: One of the most photographed and recognized Canadian landmarks is the Peggy's Cove Lighthouse, located at the eastern entrance to St. Margarets Bay. Established officially as Peggy's Point Lighthouse in 1868, the new tower, erected in 1915, sits atop vast granite rocks that are pounded by the waves of the Atlantic Ocean. Located at one of the most popular tourist destinations in Nova Scotia, the lighthouse's own post office provides visitors a place to mail their postcards.

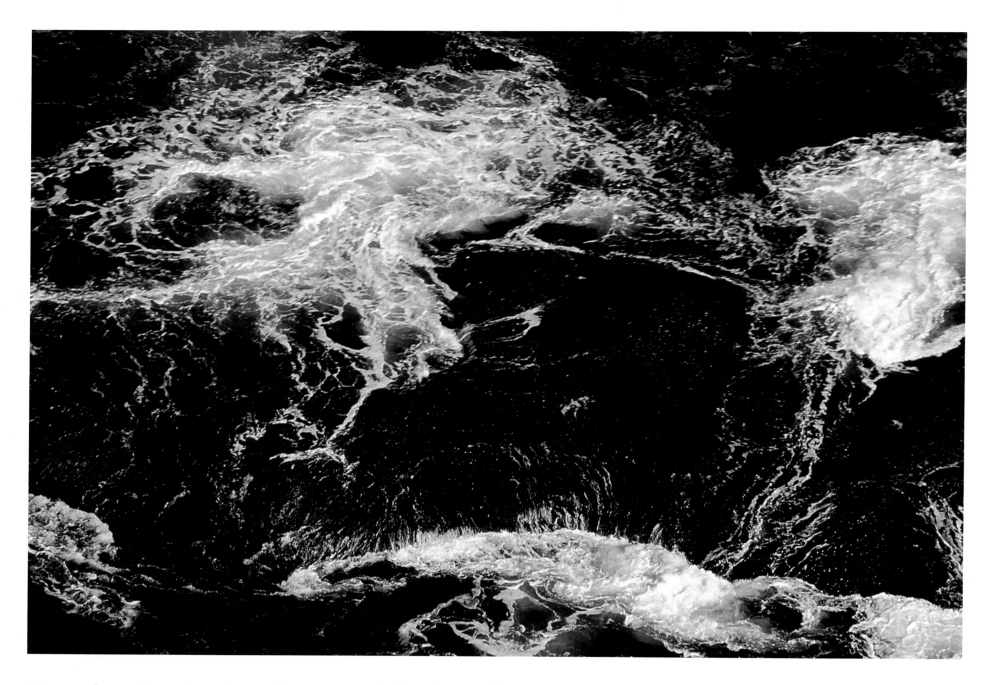

Waves crash over the granite rocks near West Dover, not far from the site of the Swissair Flight 111 crash in 1998. The father of one victim was so taken with the kindness of Nova Scotians in the aftermath of the tragedy that he emigrated from his home in Switzerland and opened a seaside restaurant in this tiny village.

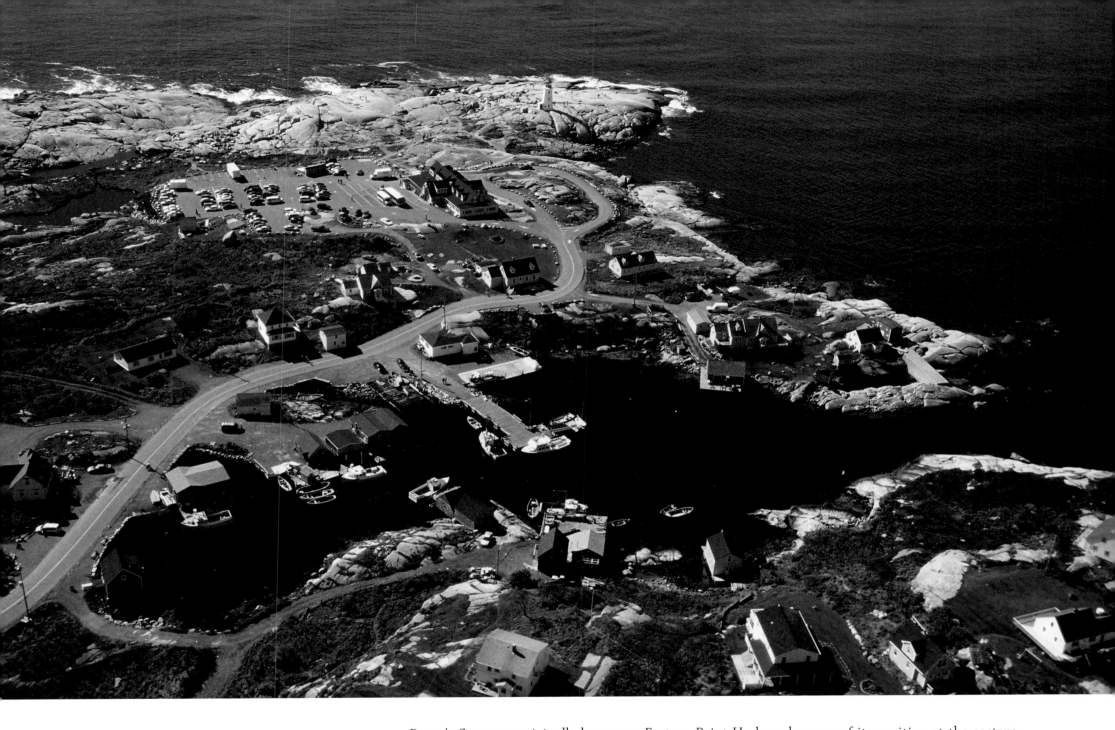

Peggy's Cove was originally known as Eastern Point Harbour because of its position at the eastern side of St. Margarets Bay. Since Peggy is a nickname for Margaret, this may explain its current name. A more romantic tale has it that a girl named Peggy, travelling to meet her fiancé, was the sole survivor of a shipwreck on the treacherous rocks.

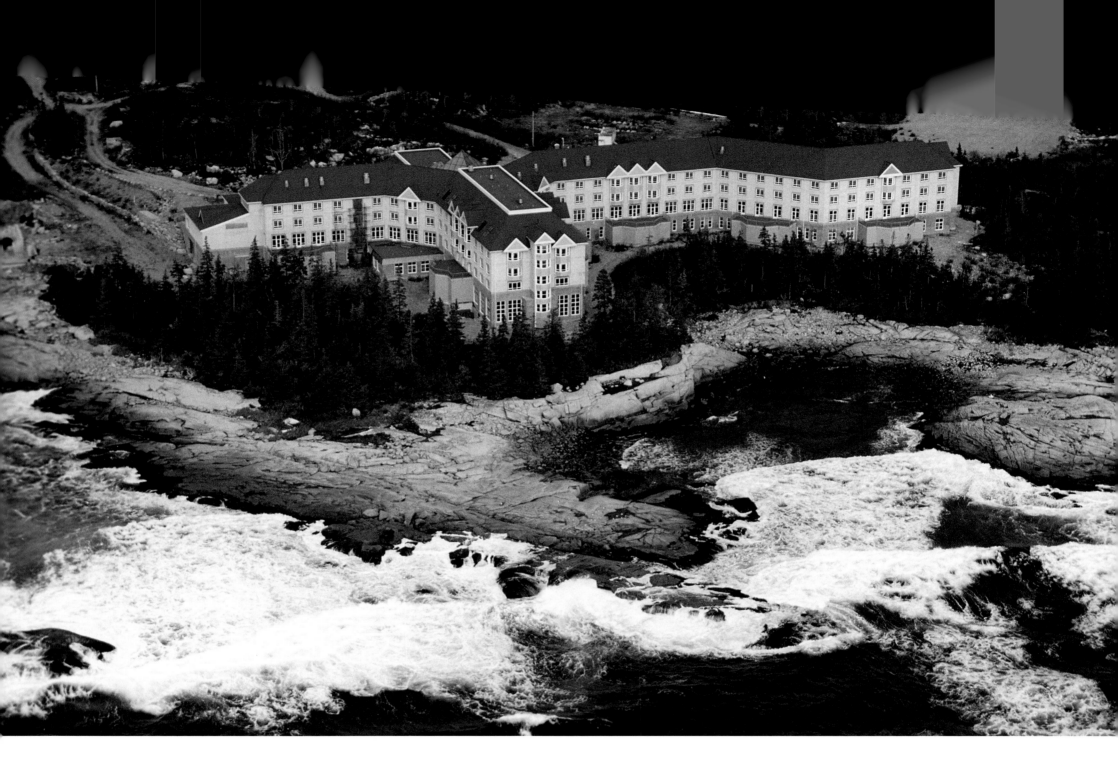

The surf along the Aspotogan Peninsula washes ashore near the unfinished Sea Spa at Coleman's Cove, on the western side of St. Margarets Bay. Construction of the European-style luxury spa, with its five-story structure, halted in 1994, when the original investors ran out of money. It was sold to a Nova Scotian company at a tax sale in 1997.

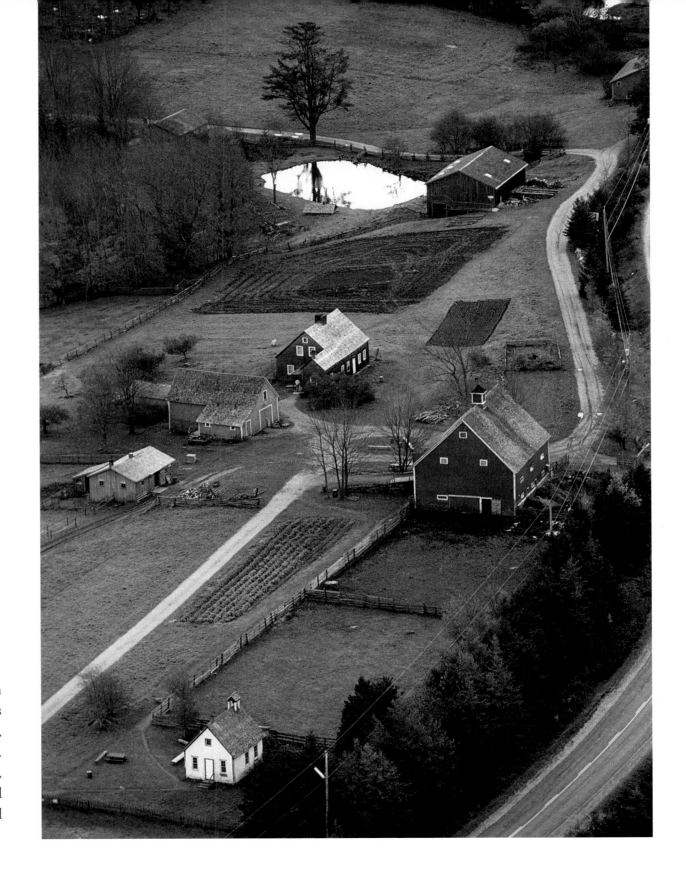

Ross Farm, settled by Captain William Ross in 1816 and home to five generations of his family until 1970, is located on Highway 12, about halfway between Chester and Kentville. The 60-acre farm, now a living museum, includes a schoolhouse, barn, smithy and cooperage, as well as oxen, Canadian horses and heritage poultry breeds.

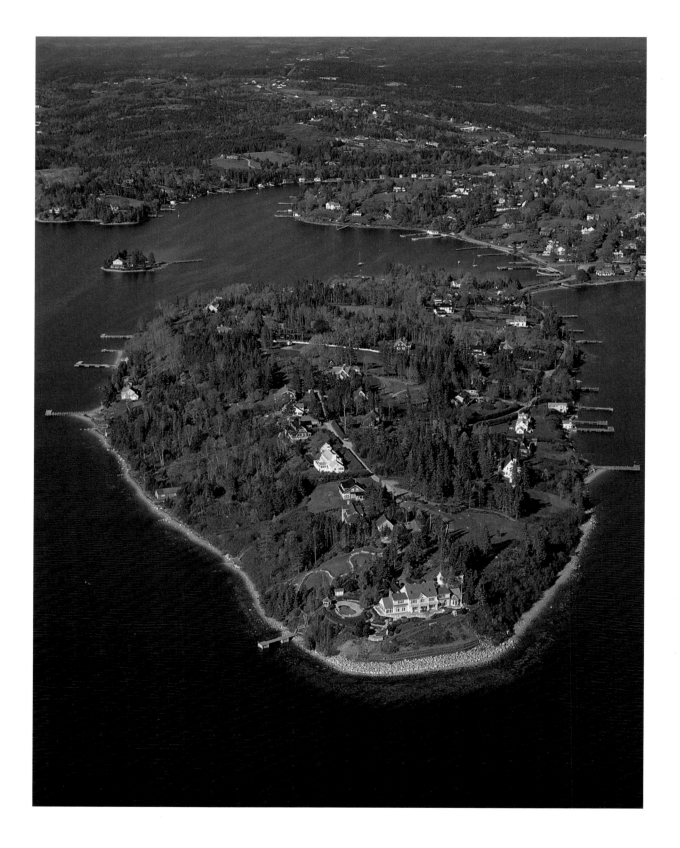

The Peninsula, connected to Chester by a small causeway, is an area of attractive waterfront homes along the South Shore of Nova Scotia.

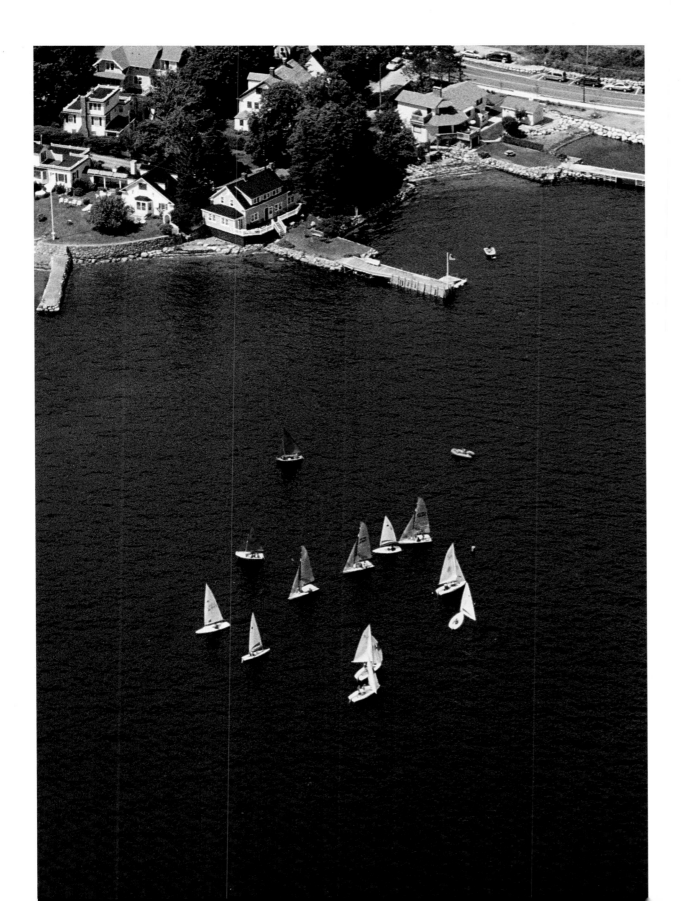

A squadron of boats tack and turn in Chester harbour during a morning sailing class. Chester hosts a race week each year that draws hundreds of sailors and boats for competition and companionship.

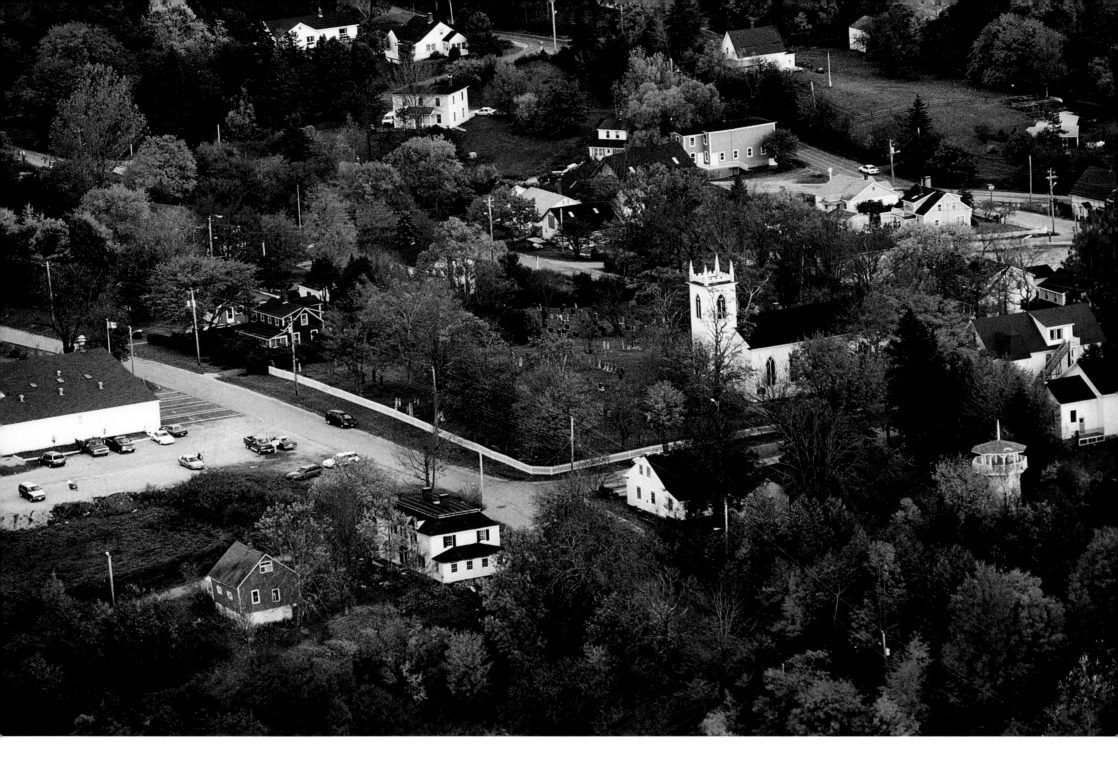

Golden leaves cling to the branches of trees in Chester. A white picket fence surrounds St. Stephen's Anglican Church. To the right is the Lightfoot Tower atop the Zoe Valle Library.

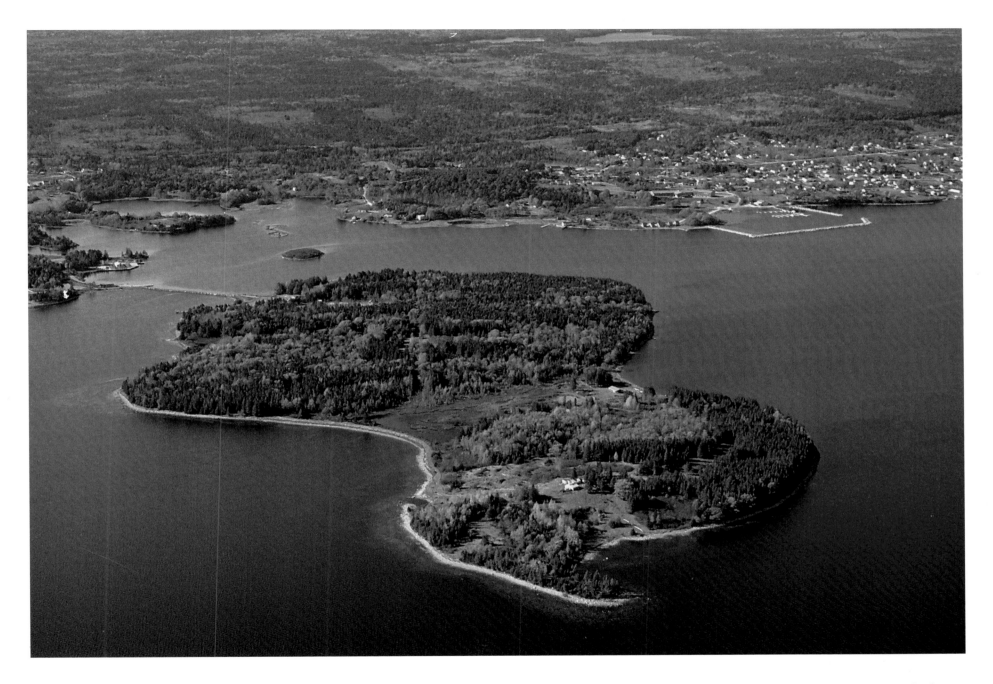

In the 1790s, two boys discovered a mysterious pit on Oak Island in Mahone Bay. The pit, which was soon called the "money pit", was supposed to contain treasure — anything from Captain Kidd's ill-gotten gains to the Holy Grail, to Shakespeare's original portfolios, to the French crown jewels. For over 200 years, treasure seekers have poured their money and energy, and in some cases given their lives, into the struggle to unravel the mystery of the pit.

The replica HMS *Rose*, built in Lunenburg in 1970, is tied up alongside the Fisheries Museum of the Atlantic. The ship's design is based on drawings of a Royal Navy frigate, built in Hull, England, in 1757. Other famous Lunenburg-built ships include the original *Bluenose*, the replica *Bluenose II*, built in 1963, and a replica of the infamous HMS *Bounty*.

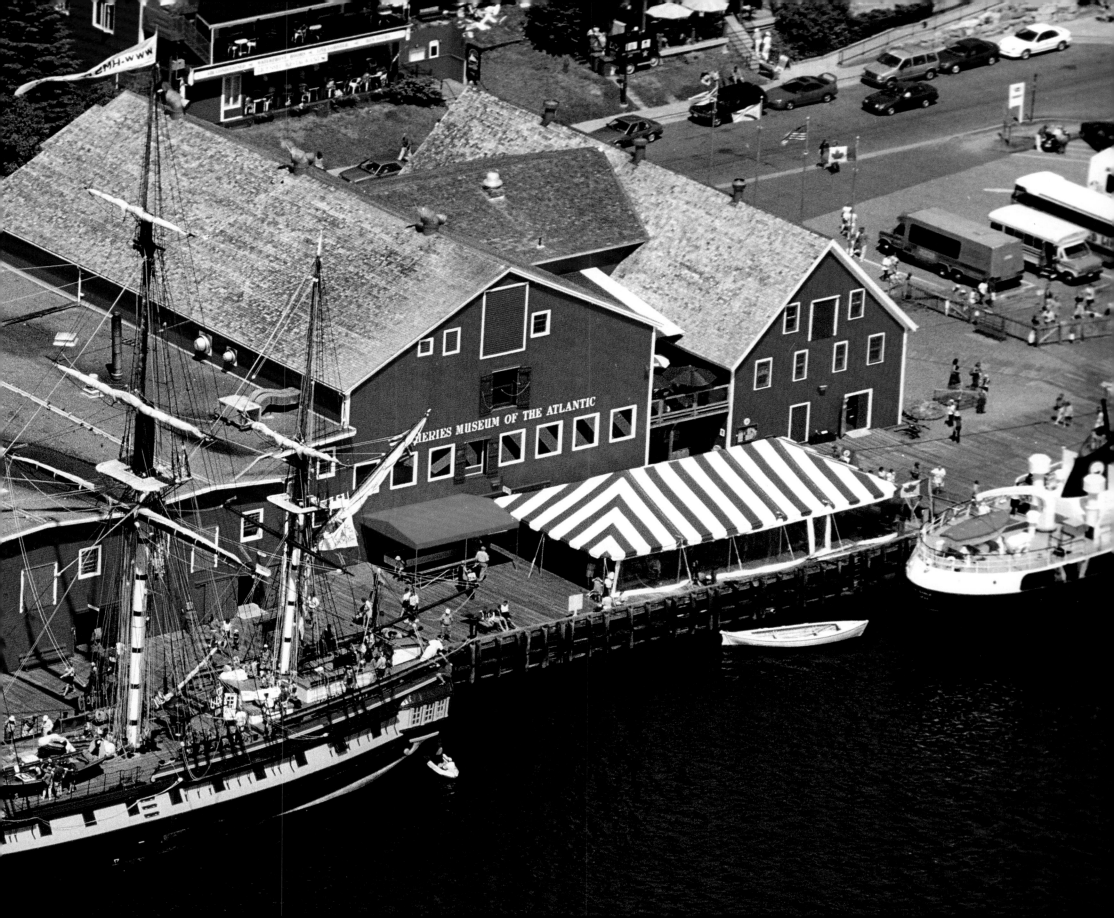

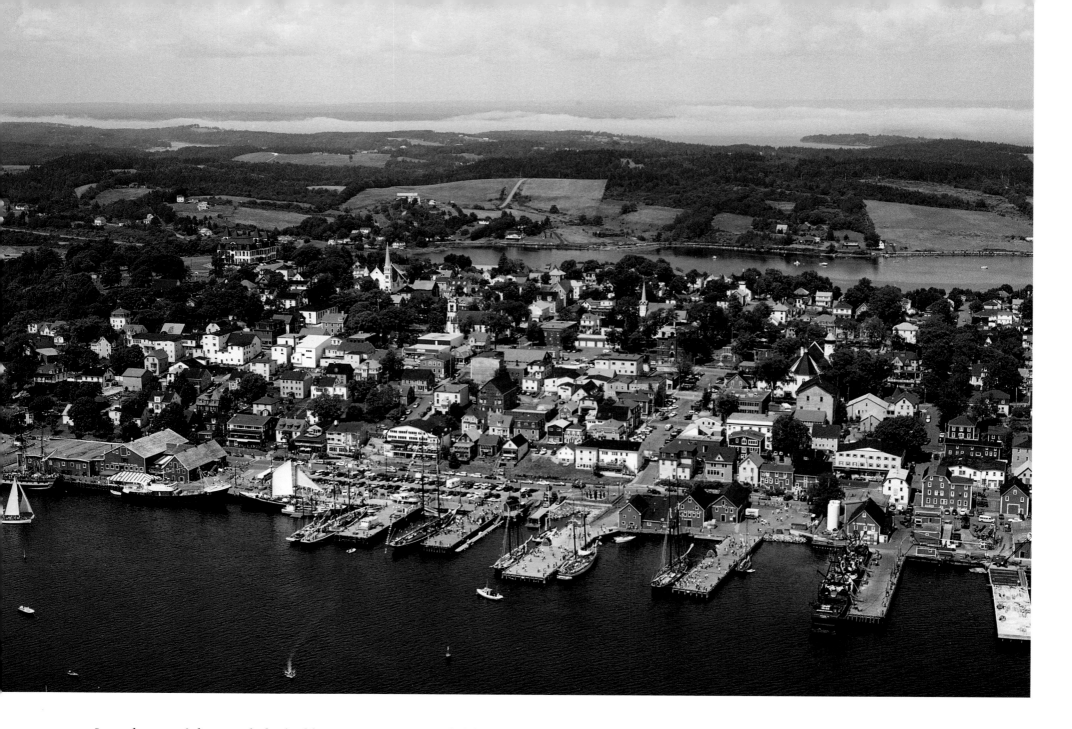

Lunenburg, a fishing and shipbuilding centre, was founded by British forces as a settlement for German and other Foreign Protestants in 1753. Together with Halifax and Savannah, Georgia, it is one of only three places in North America that conforms to its British colonial settlement plans. And of the three, Old Town Lunenburg, with its brightly coloured buildings crammed into narrow streets, has been the least affected by subsequent development. As a result, in 1995, it was declared a UNESCO World Heritage Site.

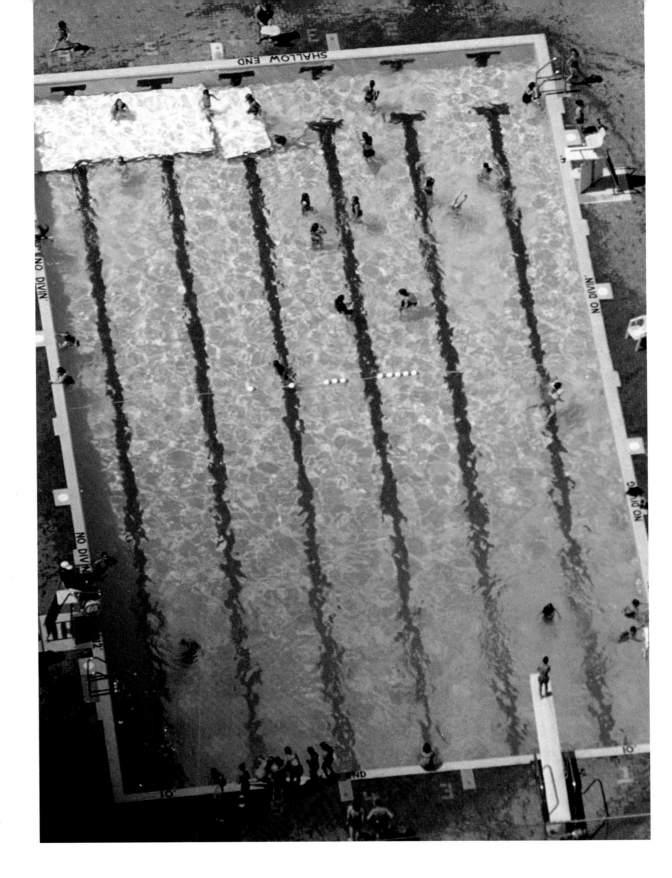

Swimmers enjoy a dip in the Lunenburg and District swimming pool.

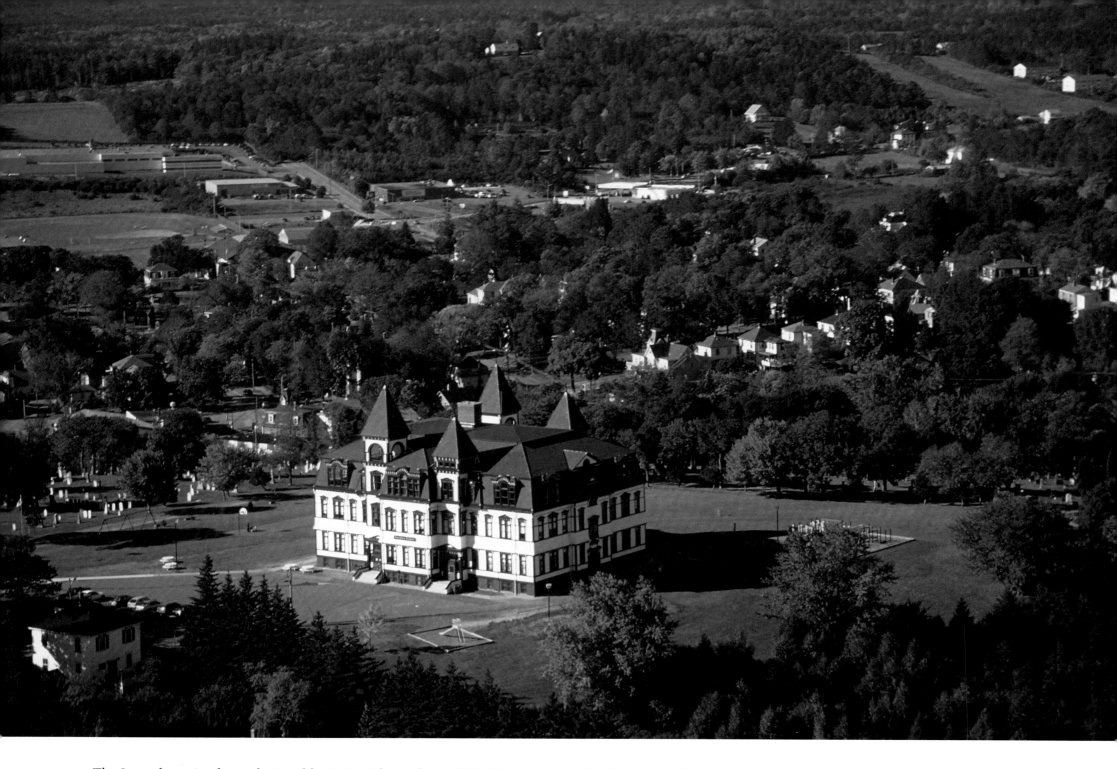

The Lunenburg Academy, designed by Saint John architect H.H. Mott was completed in 1895. This striking heritage building stands on a hill above the town. Today, students in the first six years of their education climb up to the academy. A modern high school has been built in another part of town.

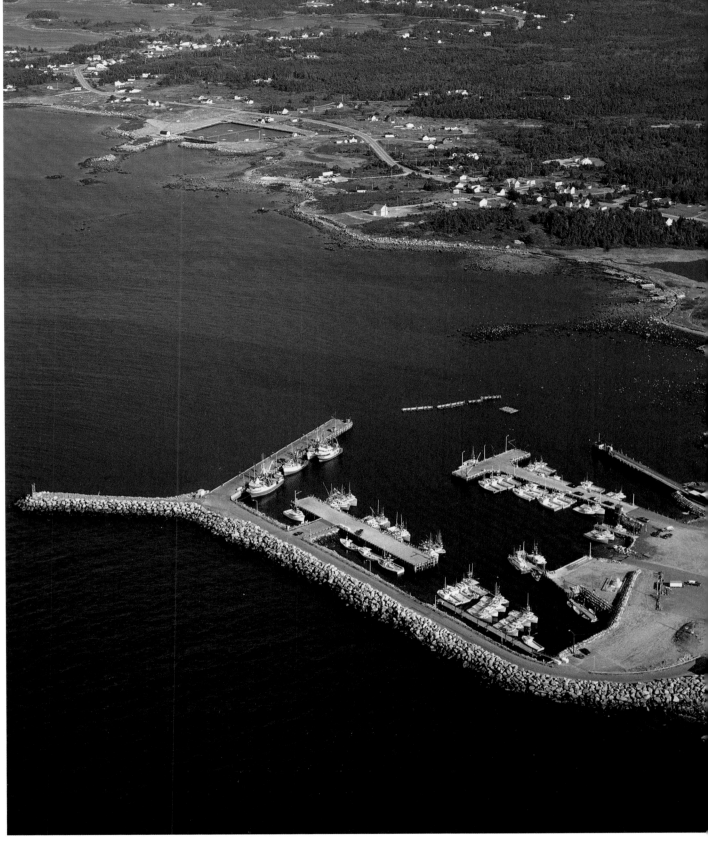

Lobster boats shelter behind a breakwater in West Head, Cape Sable Island. With the decline of the cod stocks along the eastern seaboard, the lobster fishery has become the mainstay of many small communities. There is some dispute about who designed the rugged Cape Islander fishing boat. It seems the credit goes either to Ephraim Atkinson or William A. Kenney, both of Cape Sable Island, and the deed was done in about 1905.

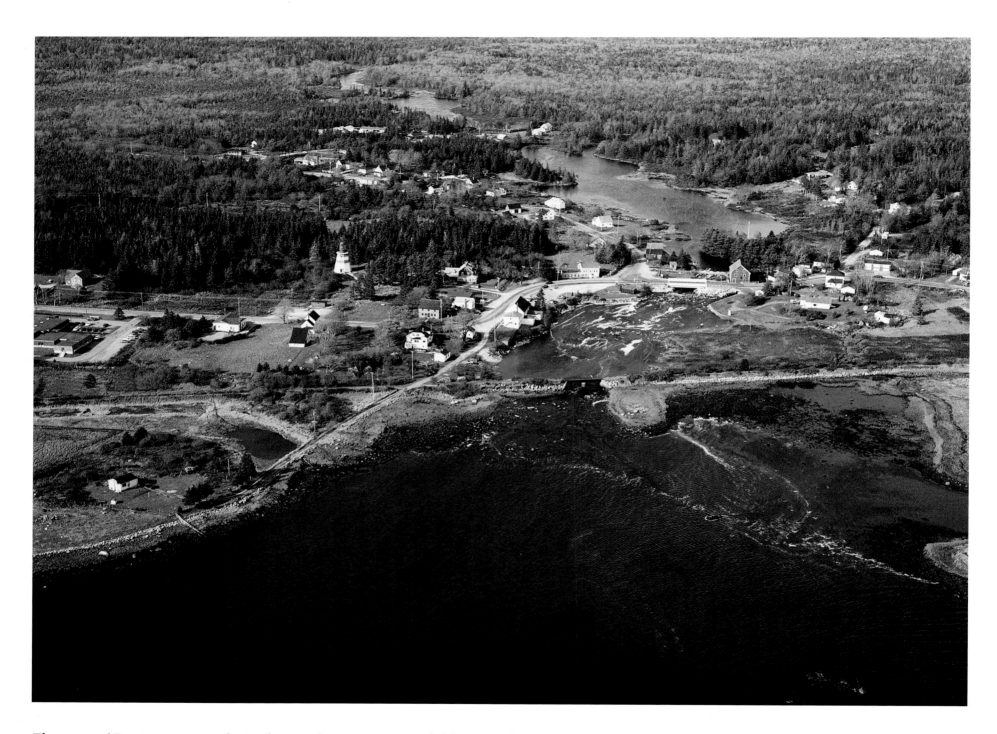

The town of Barrington, an early Acadian settlement, was resettled by United Empire Loyalists. As with many nearby villages, Barrington is a lobster fishing community. It is also home to one of the oldest surviving buildings in English-speaking Canada, a Puritan-style meetinghouse, built in 1765.

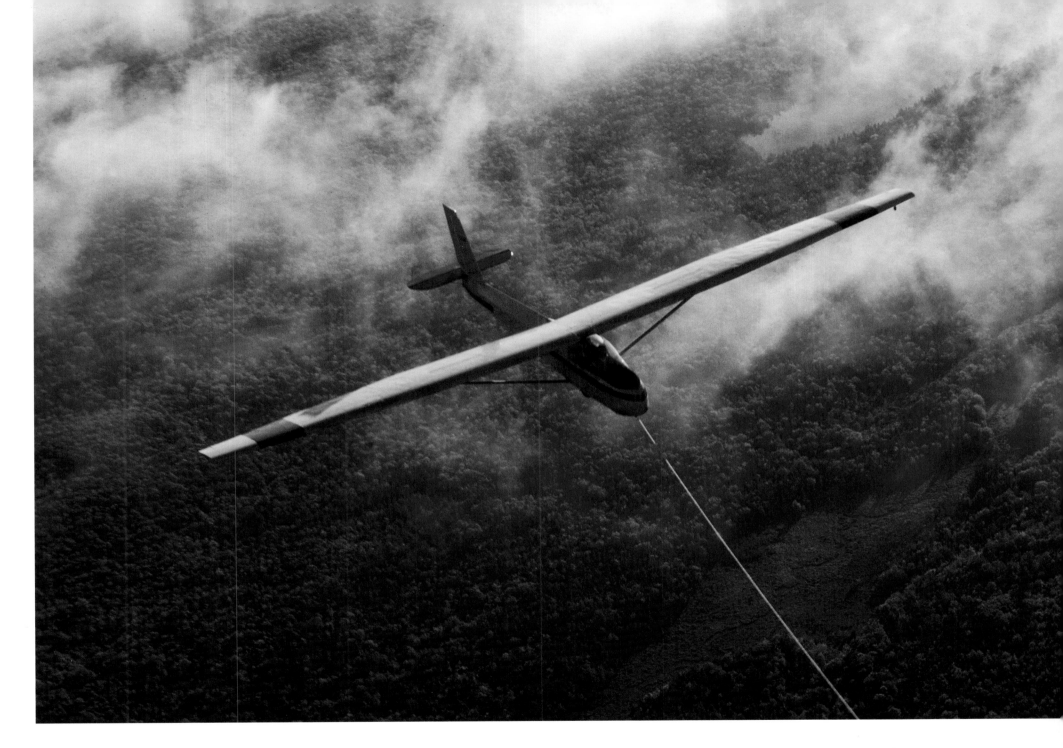

A Royal Canadian Air Cadet Schweizer 2-33 glider is towed over the forests of Yarmouth County on the way to Yarmouth Airport. The Regional Gliding School in Debert offers hundreds of young cadets a chance to fly in a small airplane. There is also a summer program for cadets from Atlantic Canada who want to earn their "wings" and glider pilot's licence.

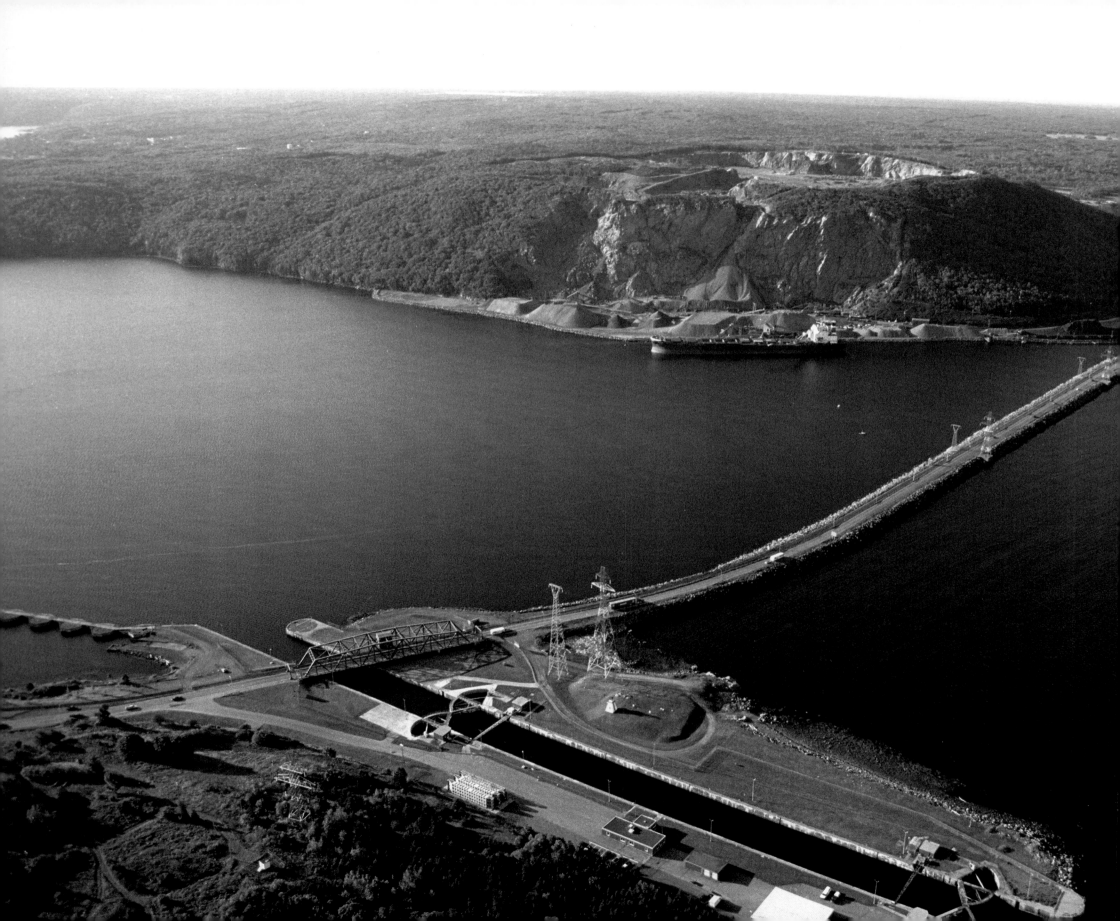

5 CAPE BRETON LAKES AND HIGHLANDS

FLY OVER THE Canso Causeway and it is just a few short kilometres to Bras d'Or Lakes, Cape Breton's inland sea. The lake is connected to the sea through two channels and via the St. Peter's canal. David Williams, captain of the replica of John Cabot's ship, *Matthew,* has said the lake ranks among the best sailing in the world.

Not far from Baddeck, high up a hillside overlooking the lake, is the family estate of Alexander Graham Bell. It was here that Bell's *Silver Dart* took off from the frozen lake in what was the first powered flight in the British Commonwealth.

Towards the northeast, the Cape Breton Highlands loom on the horizon. From the air it looks as if a huge knife has sliced off the mountaintops — the result of thousands of years of erosion. Cars can be seen snaking their way up the twisted ribbon of asphalt to the summit of Cape Smokey.

Left: The 1.6-kilometre causeway connecting the mainland of Nova Scotia with Cape Breton Island was opened in May 1955. On the island side is a 600-metre canal, complete with a swinging bridge to allow ships to pass through the Strait of Canso.

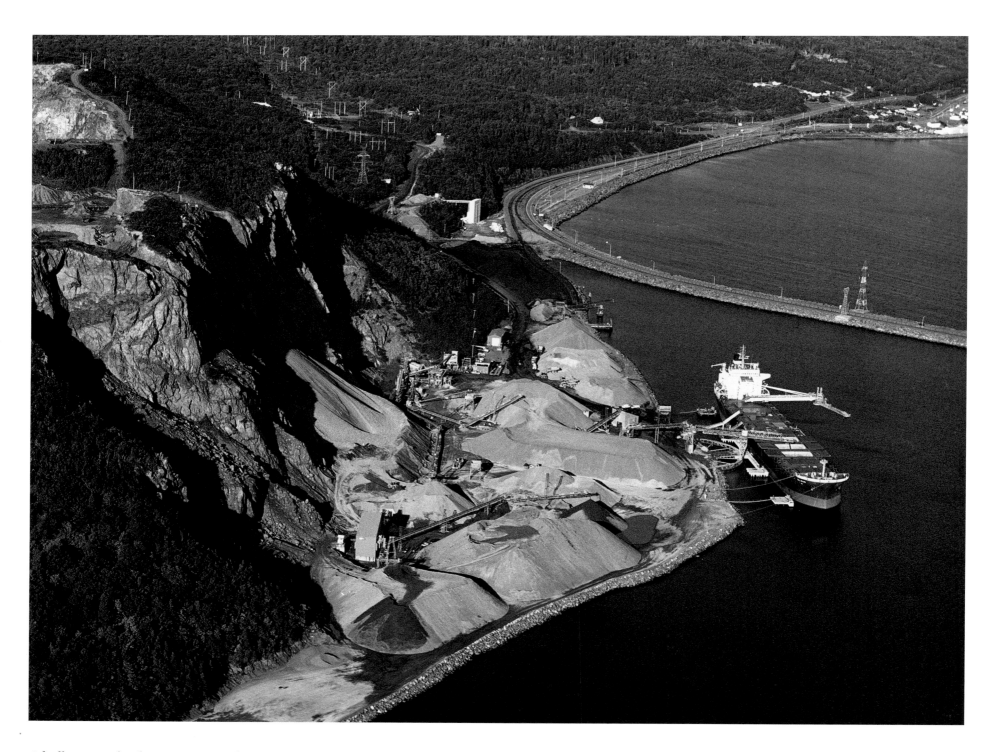

A bulk carrier loads aggregate at the Martin Marietta Materials Canada wharf on the mainland side of the Canso Causeway.

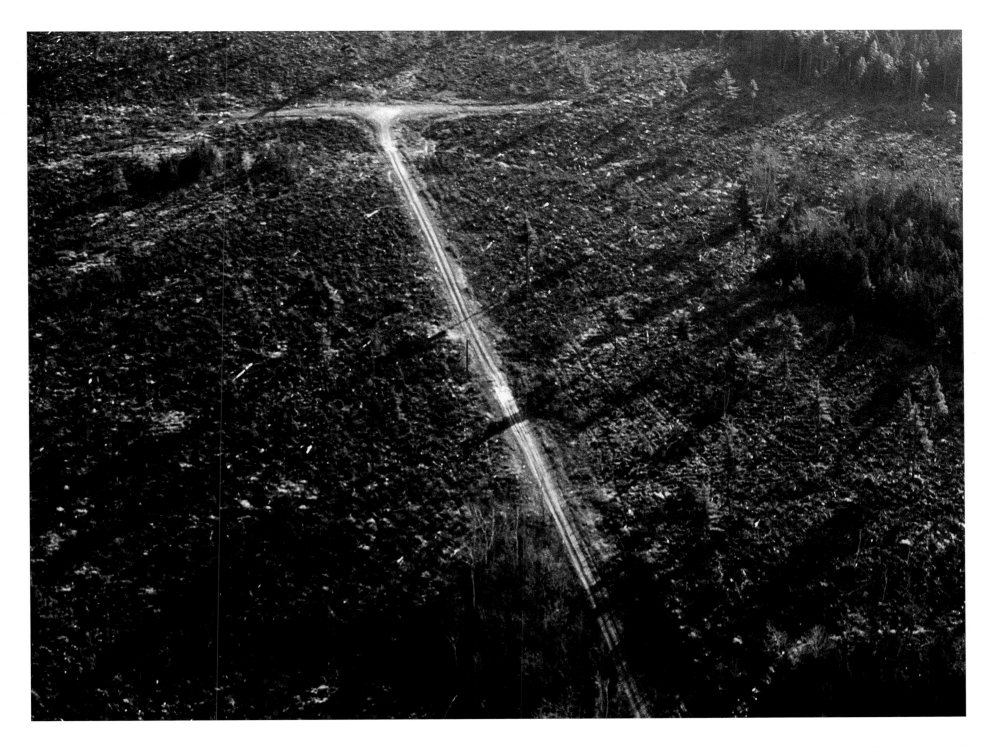

Some call it clear cutting and others call it harvesting, but either way, the complete felling of a stand of trees leaves a scar on the landscape. This method of logging claims over 500 square kilometres of the province's forests every year.

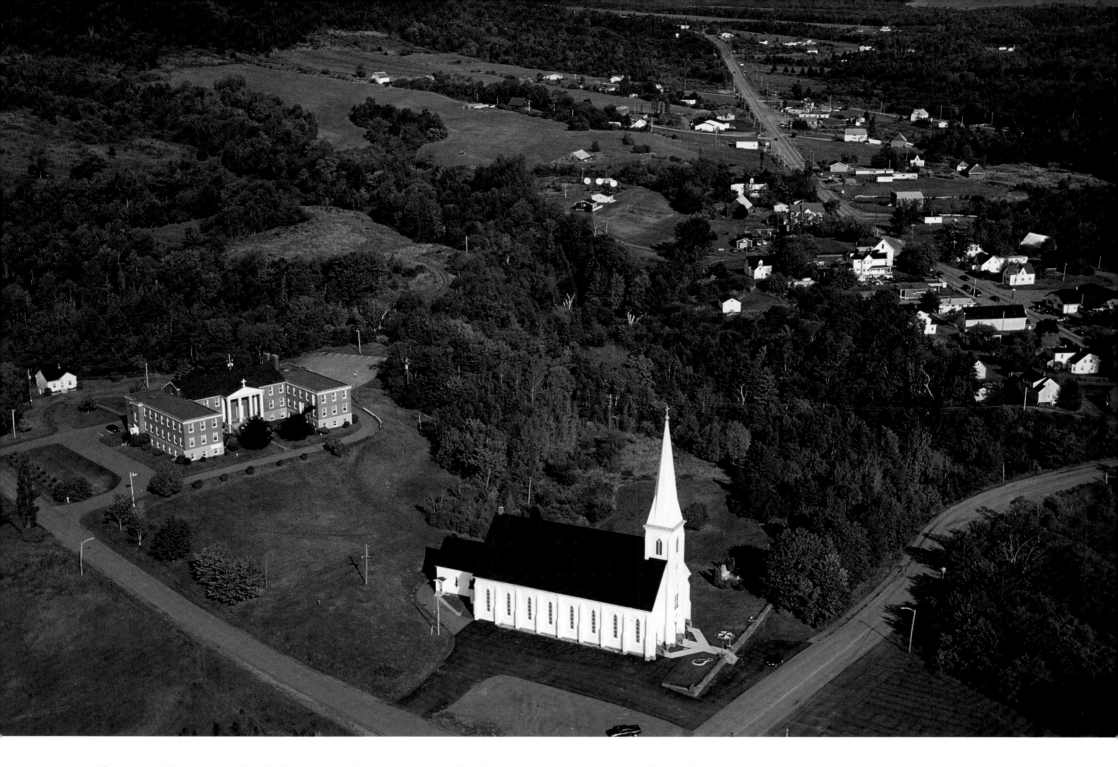

The spire of St. Mary's Church dominates the scenery around Mabou in Inverness County. Behind the church is St. Joseph's Convent and Renewal Centre. Mabou, probably from the Mi'kmaw word *malabokek*, is in a region of fishing and farming and was settled by Highland Scots in the 1800s. The community is home to many celebrated Celtic musicians, most notably the Rankin Family.

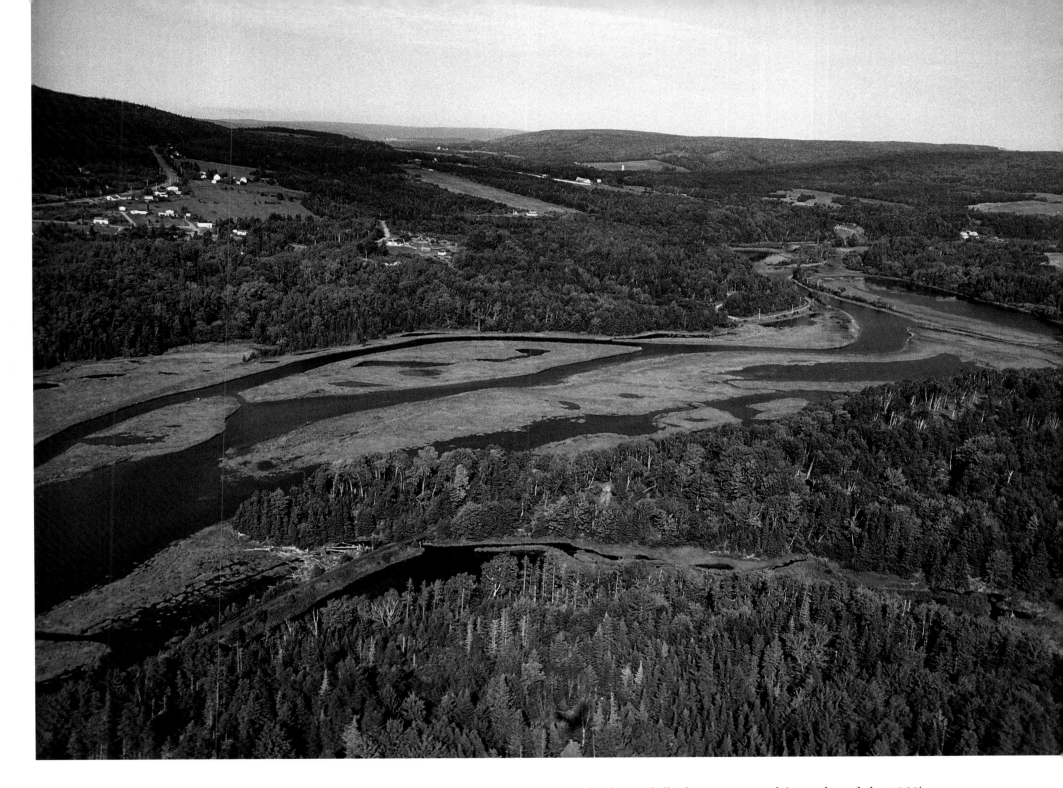

The Mabou River flows between gently sloping hills that were mined for coal until the 1960's.

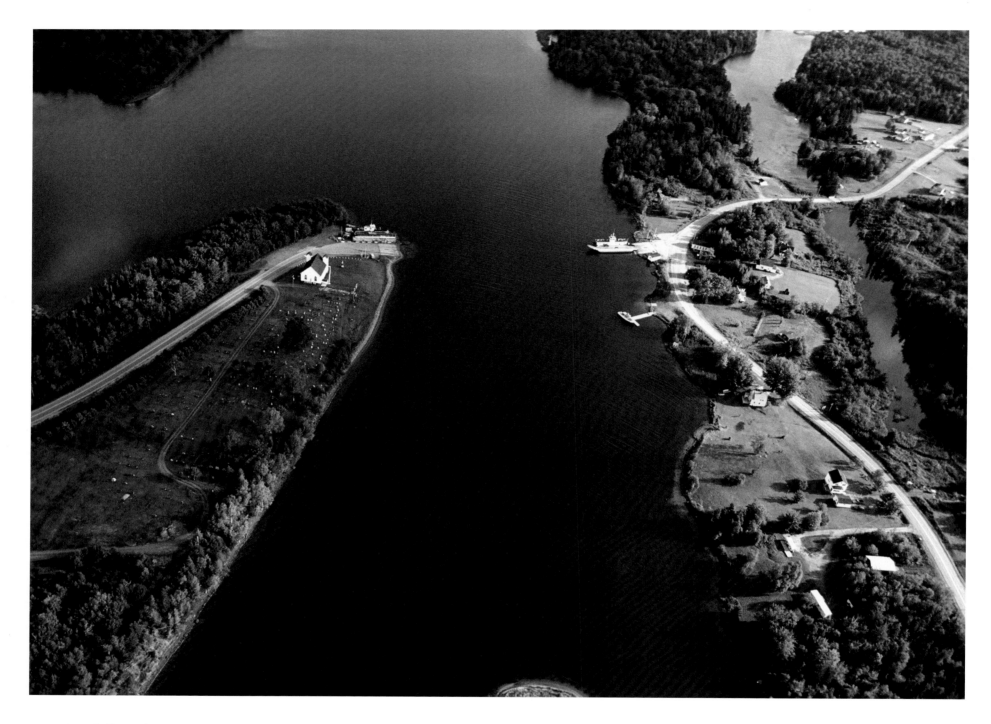

For a few dollars, the *Caolas S'ilas* (Gaelic for Julia's Strait) cable ferry will take cars, trucks, campers and buses across the 200-metre Little Narrows Passage, from Little Narrows to the Iona Peninsula.

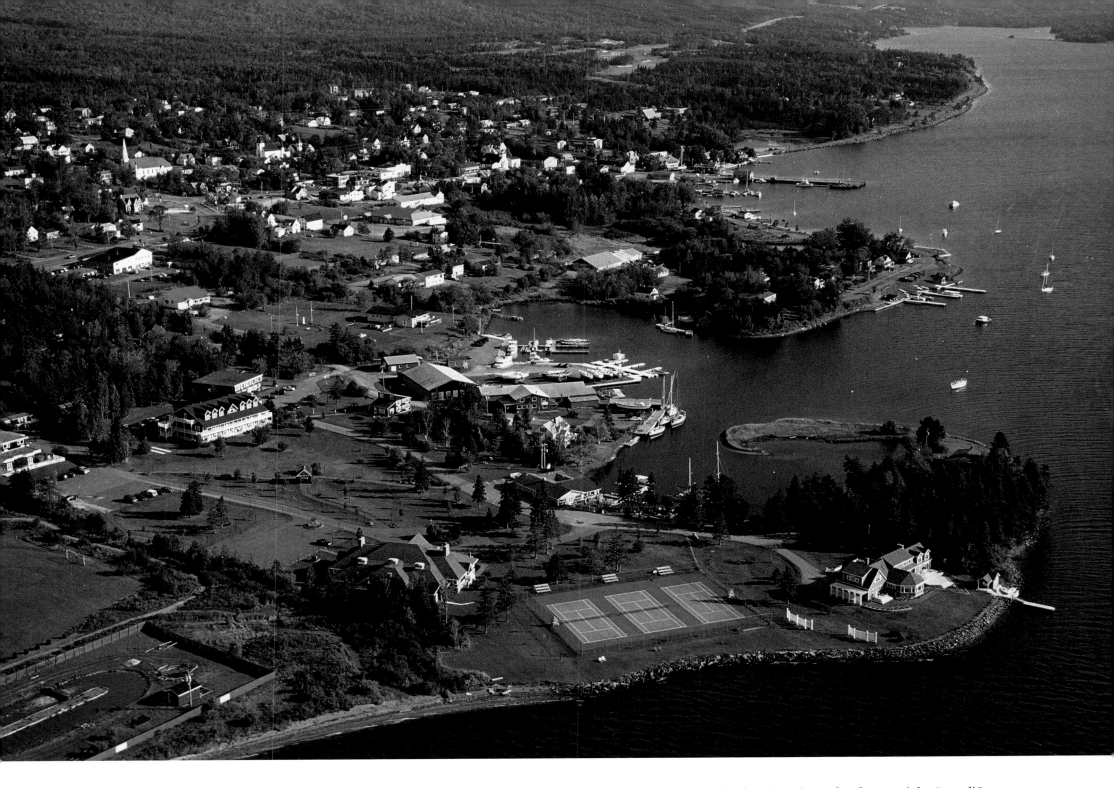

Baddeck, from the Mi'kmaw word *adadak* (place with island near), on the shores of the Bras d'Or, was once rich in game and fish. It was settled by Loyalists following the surrender by the French of the island to the British in the mid-1700s.

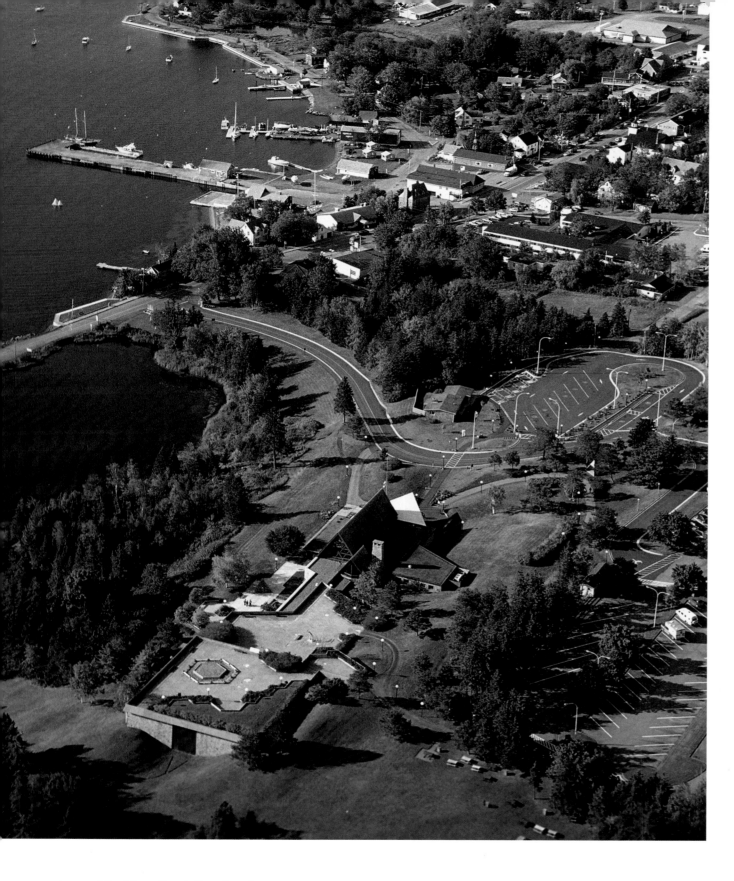

The Alexander Graham Bell National Historic Site is a short drive from the village of Baddeck. Here, one can view the *Silver Dart*, as well as many of Bell's other inventions. He was especially interested in creating devices for the hearing impaired, as his wife, Mabel, was deaf.

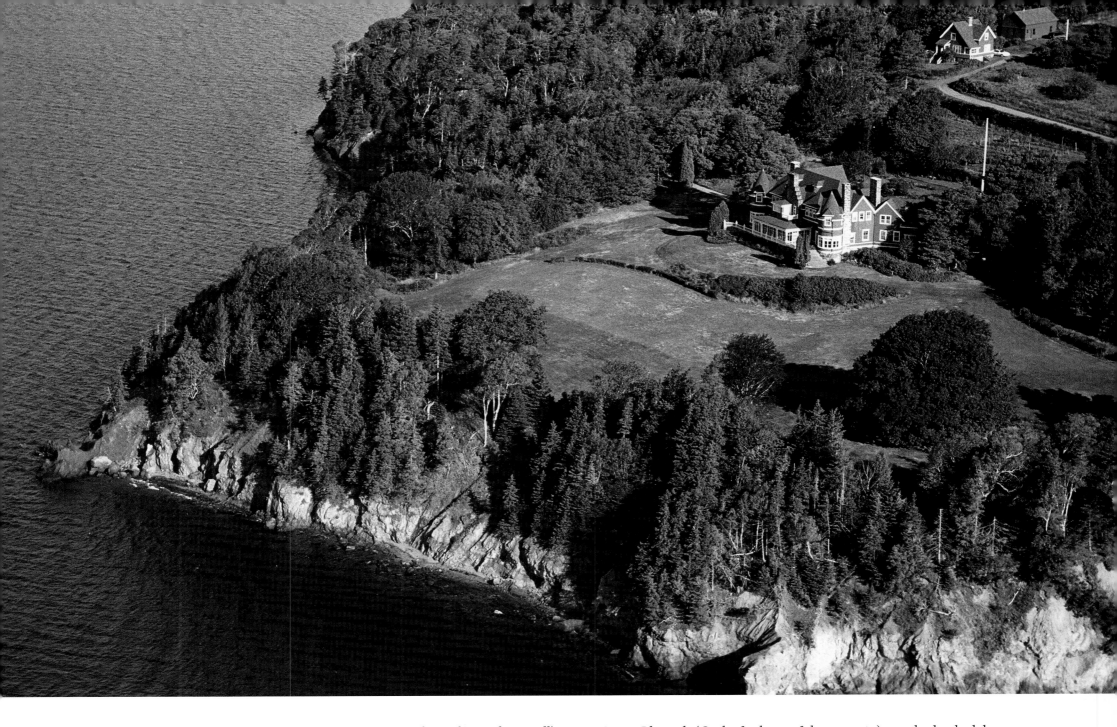

Alexander Graham Bell's estate, Beinn Bhreagh (Gaelic for beautiful mountain), overlooks the lake not far from Baddeck. Bell, best known for the invention of the telephone, built the home in the late 1880s. Here, he conducted many of his experiments, including the flight of the *Silver Dart* in 1909. Bell died in 1922, his wife a year later, and both are buried on grounds of the estate, which is still owned by their descendants.

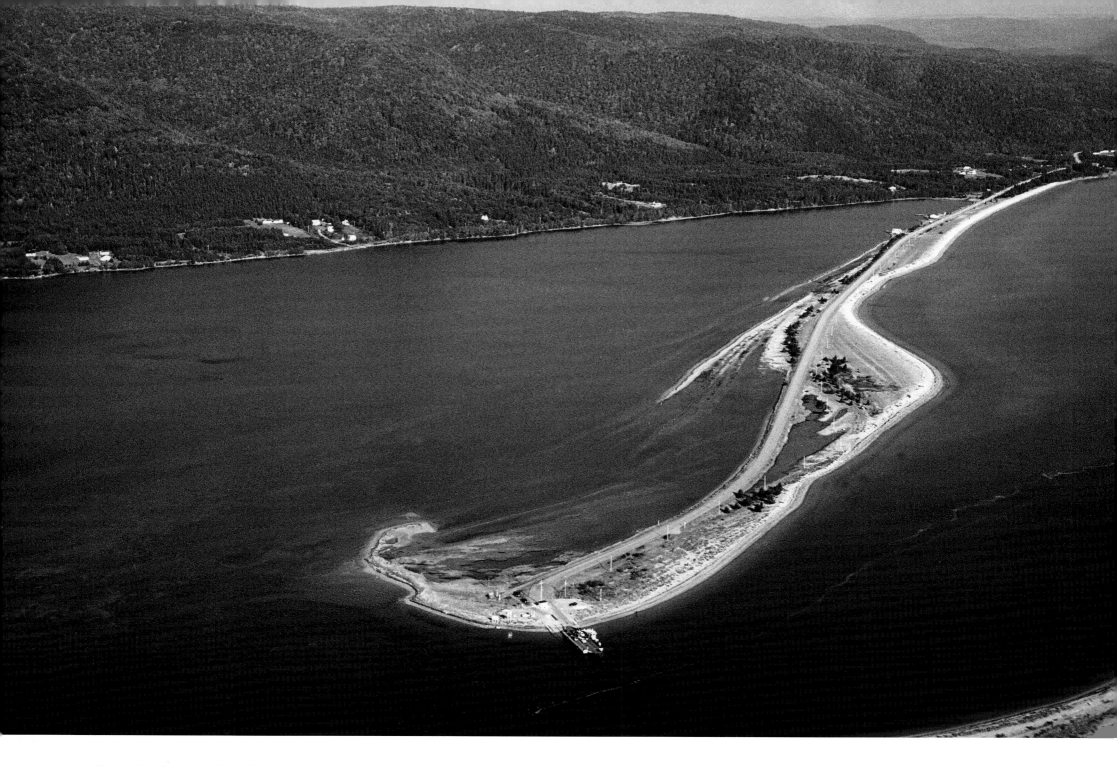

The cable ferry at Englishtown connects with Westport on the Cabot Trail in the Cape Breton Highlands. The tiny village of Englishtown was home to the giant, Angus MacAskill, who was over 2.5 metres tall. He toured with the Barnum and Bailey Circus during the 1880s. A museum, not far from the village, features a statue of MacAskill and oversized artefacts from his life.

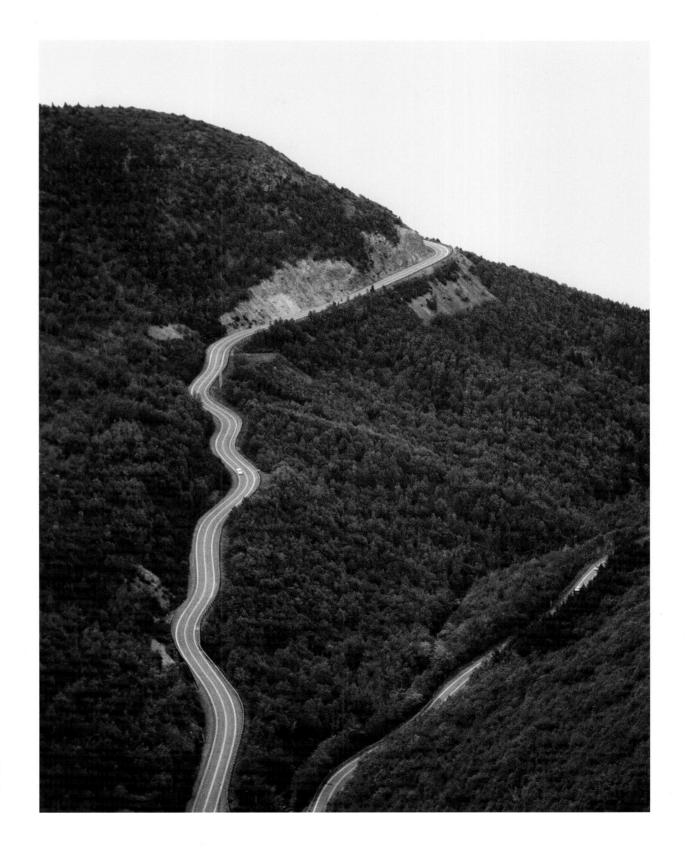

Highway 312 snakes up Cape Smokey, 366 metres above sea level, in the Cape Breton Highlands.

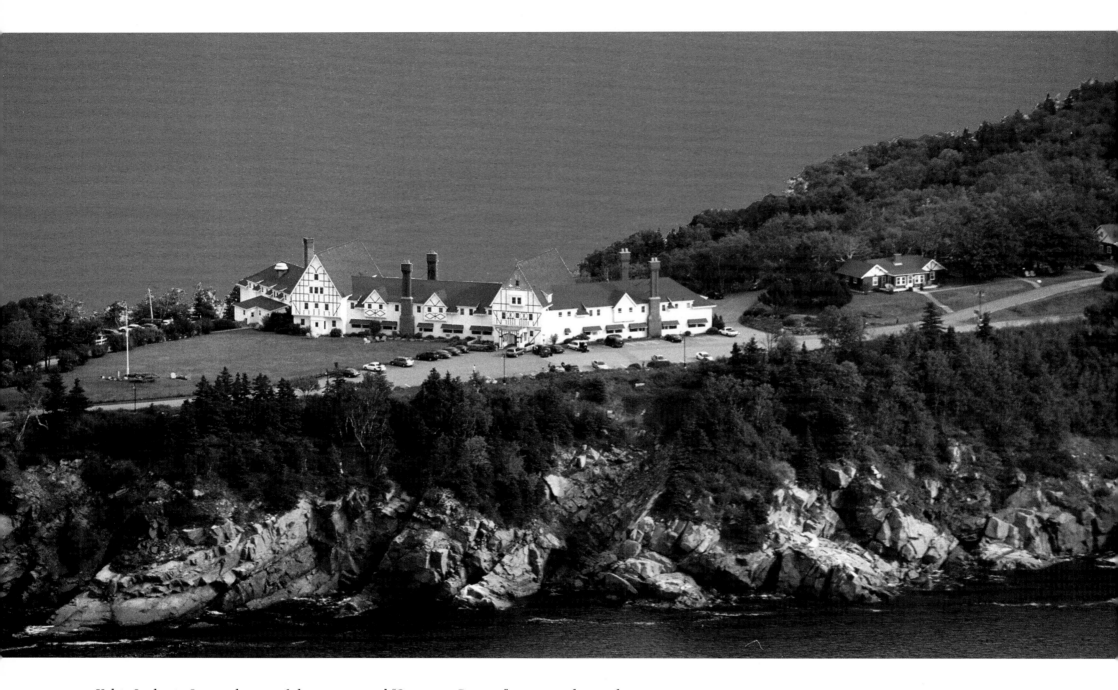

Keltic Lodge in Ingonish, one of three provincial "Signature Resorts", is situated near the entrance to the Cape Breton Highlands National Park. The main lodge opened in 1940 and the rest of the resort was completed in 1972.

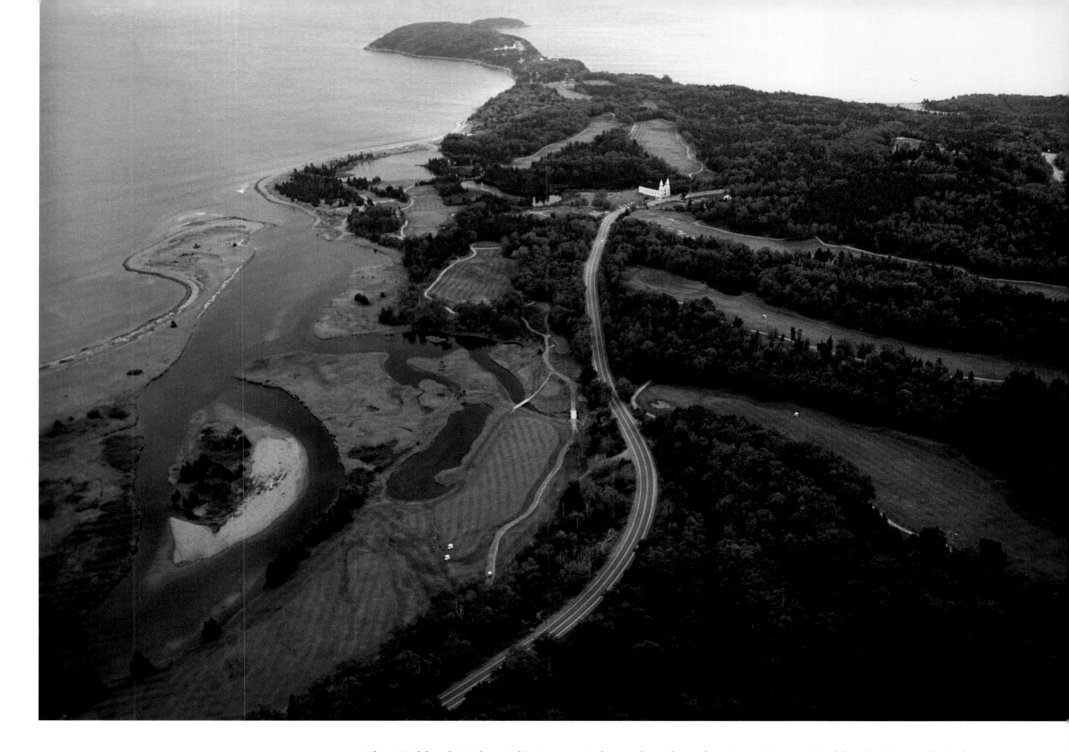

The Highland Links Golf Course is located within the Cape Breton Highlands National Park. Commissioned by Canada's National Park Service in 1939, Stanley Thompson designed and built what he called his "mountains and ocean" course. The course underwent a restoration in 1997 and is ranked 64th in the world.

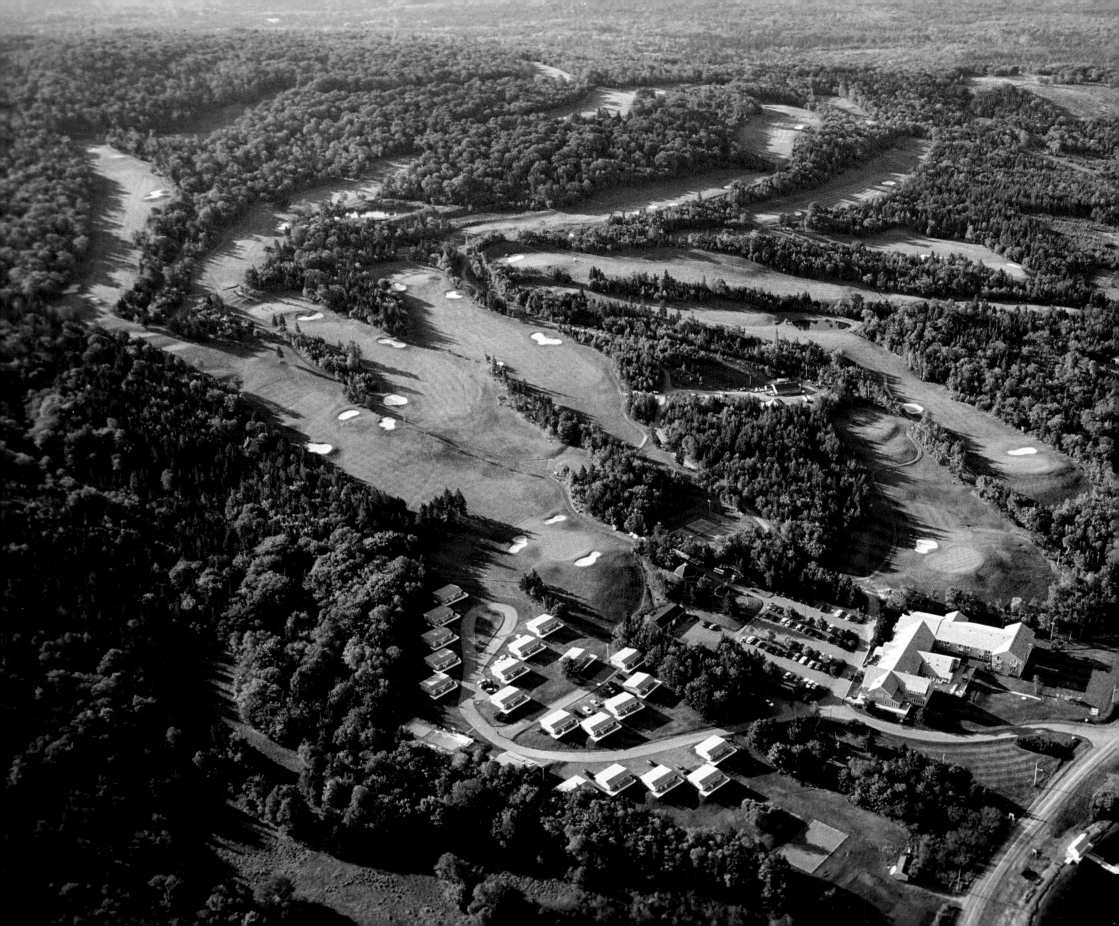

6 ATLANTIC SHORE

FLYING LOW TOWARDS eastern Cape Breton from the Atlantic you cross one of the most pristine parts of the region, the Gabarus Wilderness Area. The landscape features barrier beaches along the southern shore of the island.

Travelling north, the spire over the King's Bastion at Fortress Louisbourg comes into view. The fortress, built in the 1700s, was at the heart of French control of the region, including all shipping in the Gulf. In the 1960s, the Canadian government started what was to be the largest reconstruction project in North America. Viewed from the air, the outlines of houses, roads and walls far from the present site are a testament to the size of the original fortress.

Further along the shoreline are the communities of Glace Bay, Dominion, New Waterford and Whitney Pier. All were once coal-mining towns, with mine shafts that stretched deep beneath the Atlantic Ocean. Today the mines are closed, but the shafts and railway lines are still visible.

Sydney is the heart of industrial Cape Breton. From the air, the Point Aconi power station, at the tip of Boulardarie Island, dominates the skyline. At the south arm of the harbour is the abandoned Sydney Steel Mill. Toxic waste from the plant has collected for decades in the Tar Ponds, which are finally on track for clean-up.

The Dundee Resort at West Bay on Bras d'Or Lake features an 18-hole golf course, a spa and sailing and kayaking.

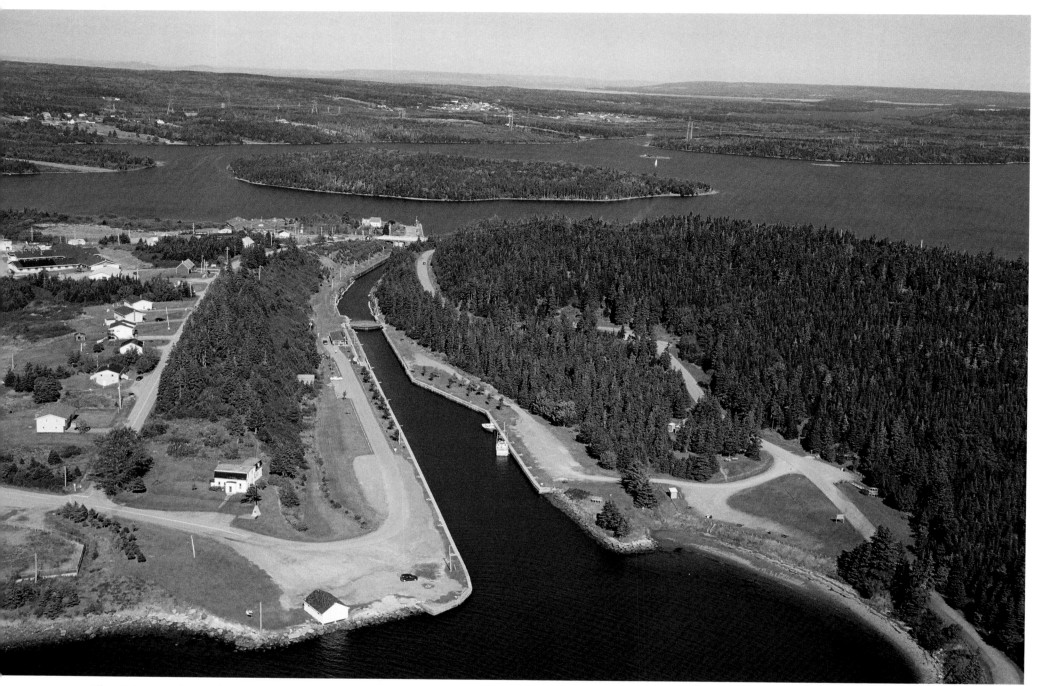

The 91-metre-long St. Peters Canal, completed in 1869, connects the Bras d'Or Lakes with the Atlantic Ocean. Both French and English settlers used the old Mi'kmaw portage trail as a "haulover" road to pull boats across the isthmus to the inland waterway. The area around the canal is now a National Historic Site that features ruins from an early French settlement as well as a later British fort.

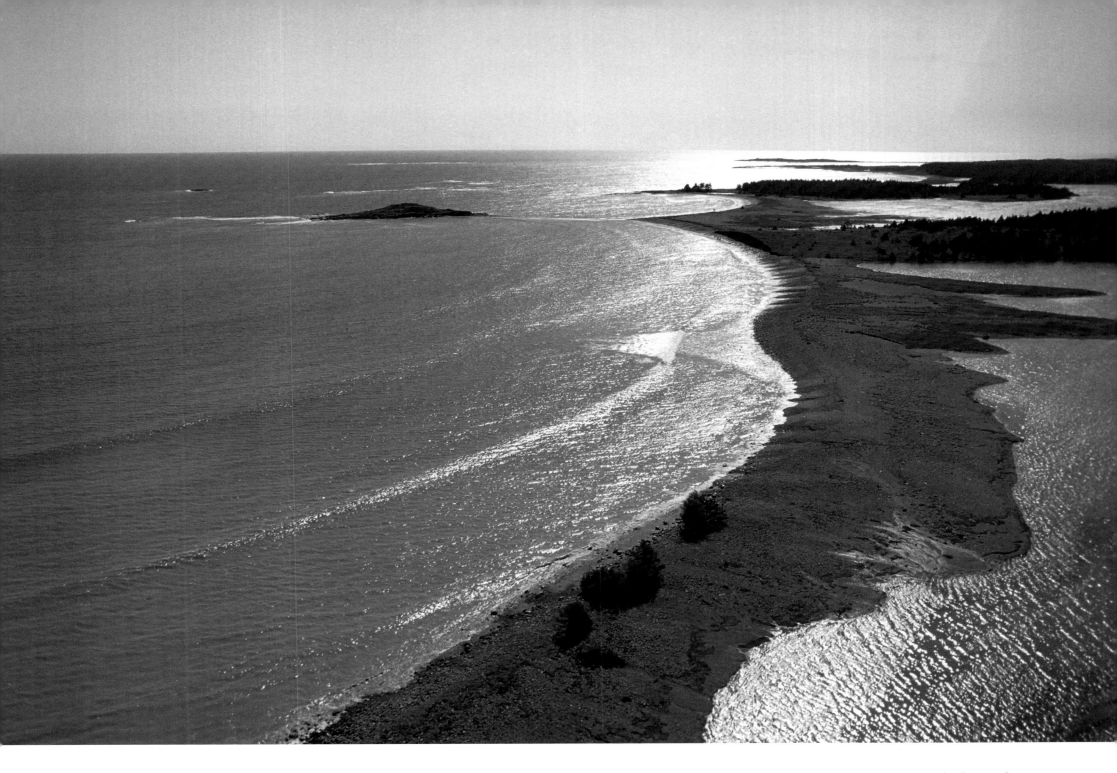

The sea washes a barrier beach in the Gabarus Wilderness Area on Cape Breton's south shore. The 3745-hectare area features hiking trails in a pristine setting, yet abandoned meadows (colonized by white spruce), stone walls and building foundations at nearby Gull Cove mark the remains of a thriving community that once rivalled Sydney in size.

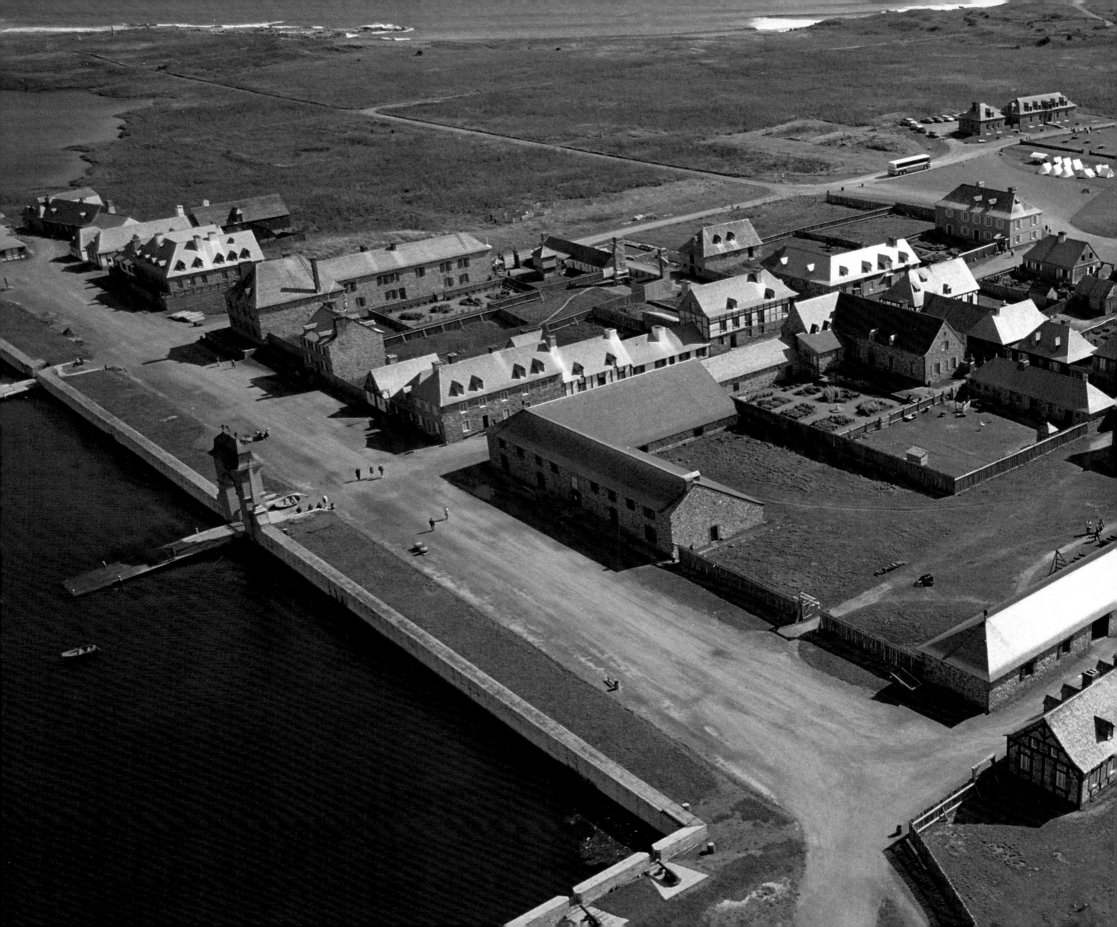

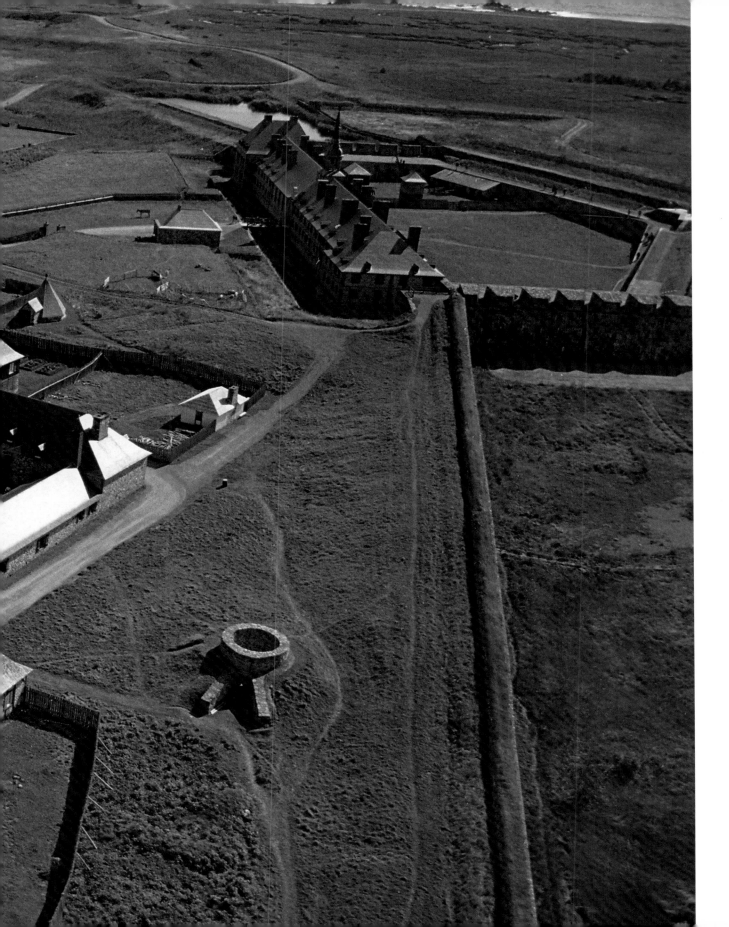

Construction of the original fortress at Louisburg began in 1713 under the direction of King Louis XIV. It was completed some 25 years later at a total cost of more than 30 million livres. Louisbourg guarded French interests in the New World for several years. It was seized in 1745 by New Englanders, then handed back to the French. In 1758 it surrendered to a British force and two years later was razed to the ground.

The reconstruction of Fortress Louisbourg began in 1961 and is still ongoing. Millions of artefacts have been uncovered within the 6700-hectare area. Today, this living-history site offers visitors a taste of life in an eighteenth-century French military outpost.

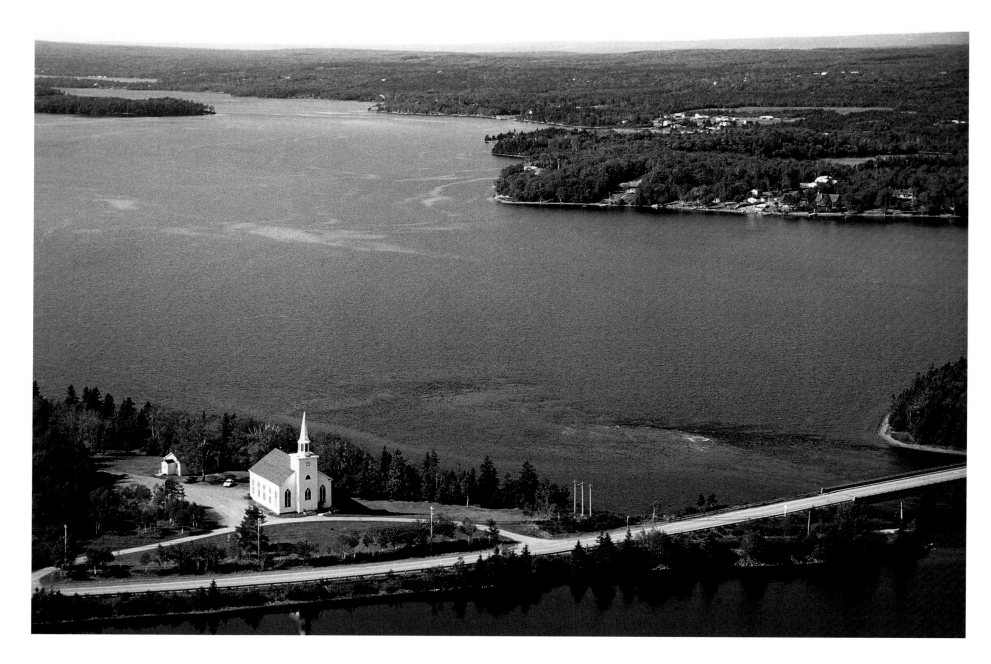

The Mira River flows under Albert Bridge, on the Mira Road between Louisbourg and Sydney. The Union Presbyterian Church is just across the road from the Mira River Provincial Park. In the 1700s, a local brickyard supplied bricks to build the French fortress at Louisbourg on Île Royale (now Cape Breton Island).

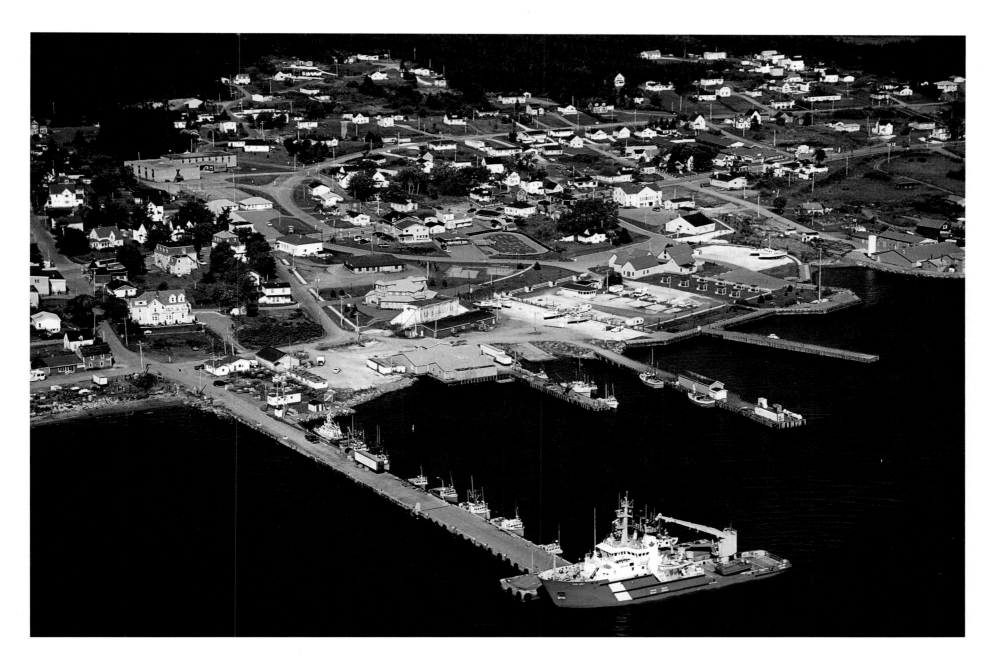

A Canadian Coast Guard ship lies alongside the wharf in Louisbourg Harbour.
The town of 1200 lies in the shadow of the giant fortress that brings thousands of tourists to the area every year. Fishing has been the backbone of the town's economy since its foundation.

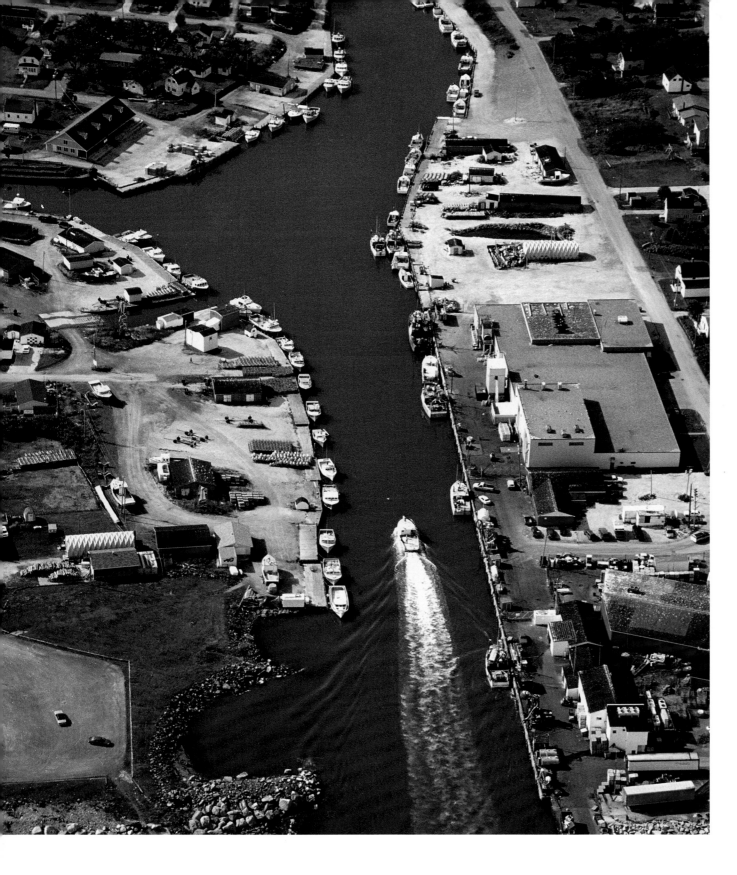

A Cape Islander boat makes its way up Glace Bay Harbour. In 1902, Guglielmo Marconi established the first transatlantic commercial wireless service at Table Head, near Glace Bay. On December 15, 1902, he transmitted a message across the Atlantic, to Poldhu, in Cornwall, England.

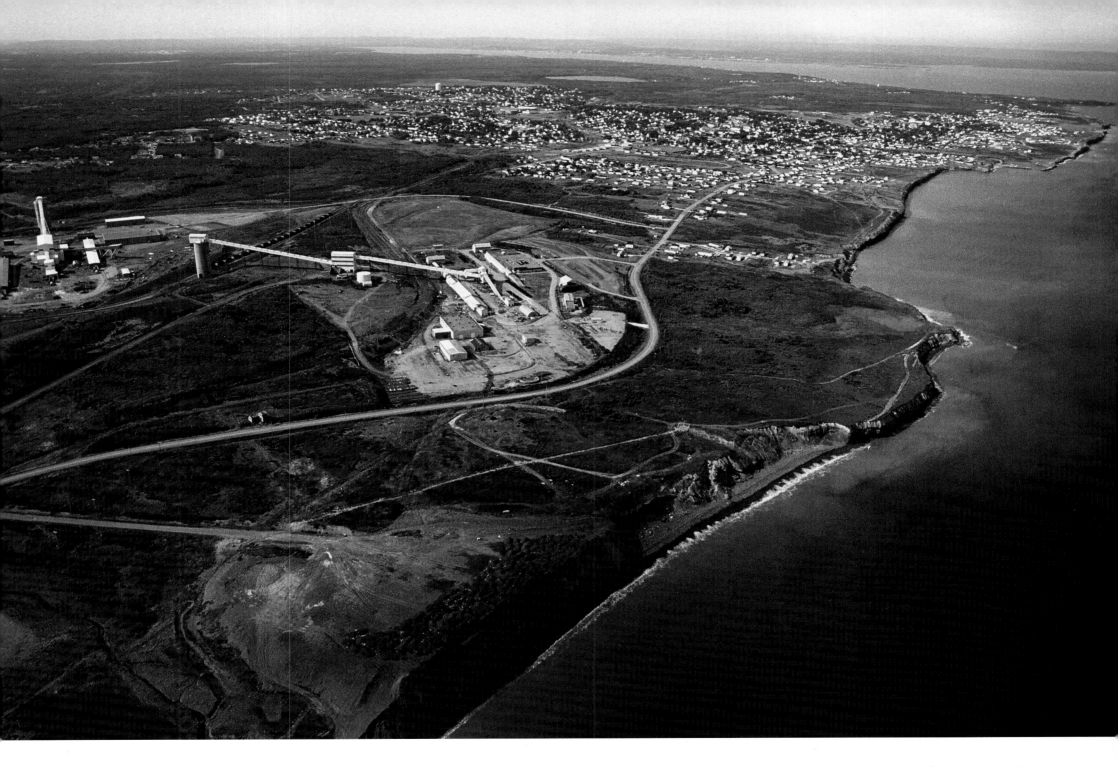

The Lingan-Phalen Mine on the east coast of Cape Breton was an important part of the economy of New Waterford. Coal had been collected in the region by both French and English settlers from the beginning of the eighteenth century, but it was not until the turn of the twentieth century that full-scale mining was undertaken. Lingan Phalen closed in 1999.

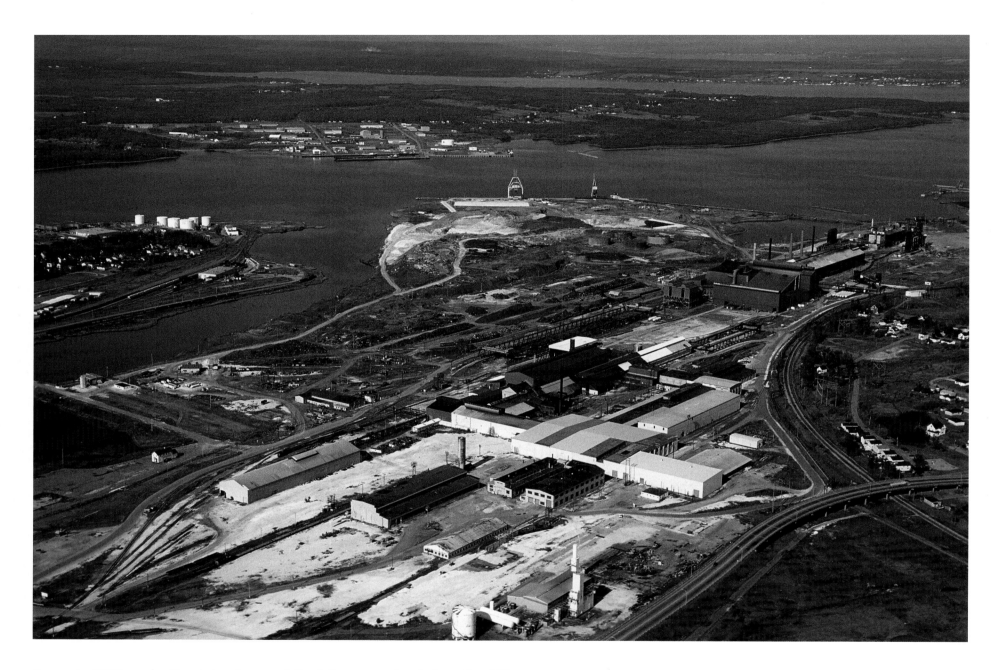

Begun in 1899 as the Dominion Iron and Steel Company, the Sydney Steel Plant was once a major supplier of steel rails and related products. The plant was closed in 2001 by its owner, SYSCO (Sydney Steel Corporation), now charged with duties such as the demolition, clean-up and redevelopment of the site.

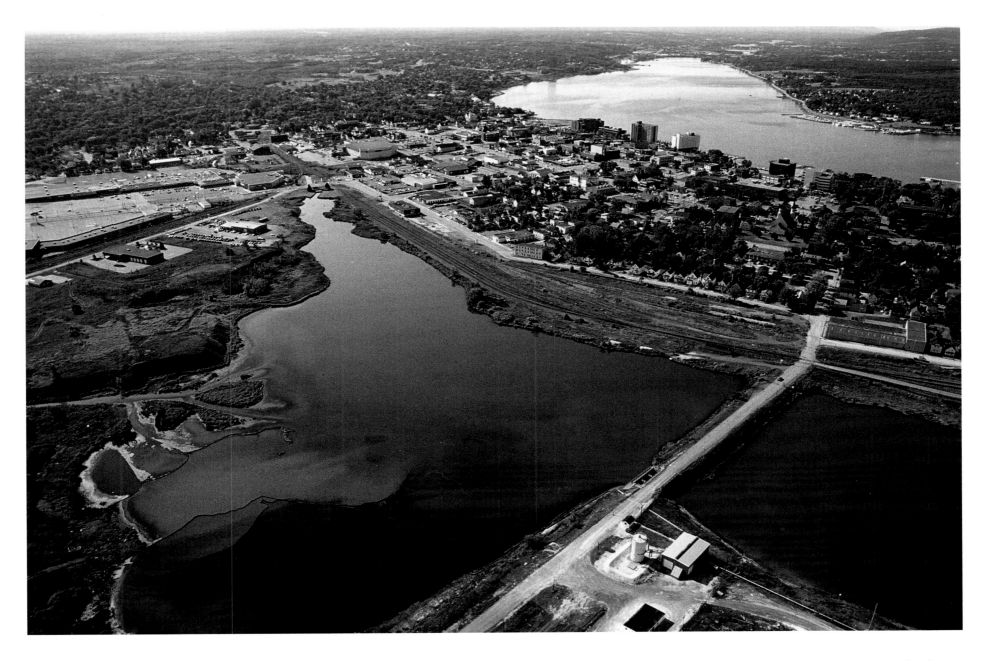

This aerial view of Sydney includes part of the infamous tar ponds, an environmental blight that is the result of decades of steel-making. The water of Muggah Creek flows by the old coking operations before spilling into the tidal estuary. The ponds contain approximately 700 thousand tonnes of toxic sludge, including PAHs, PCBs and other chemicals and metals.

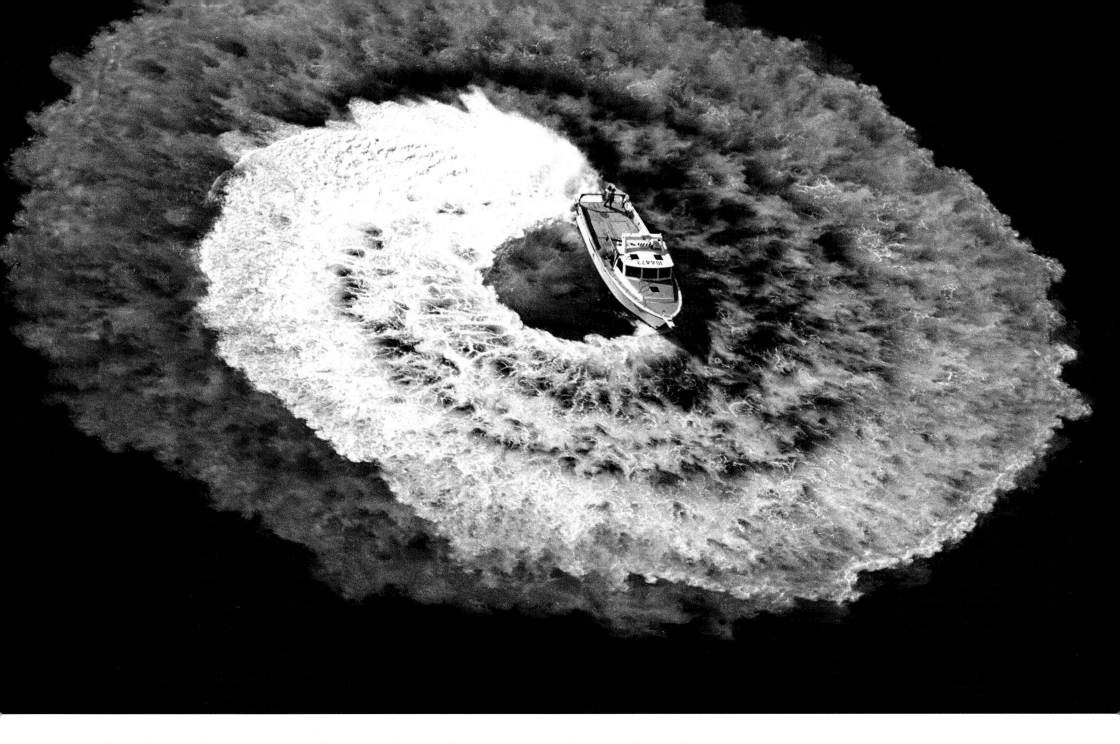

This is the waterborne version of a donut. Out for a test drive, or for fun? Either way it's a thrilling ride for the passenger hanging on in the stern.

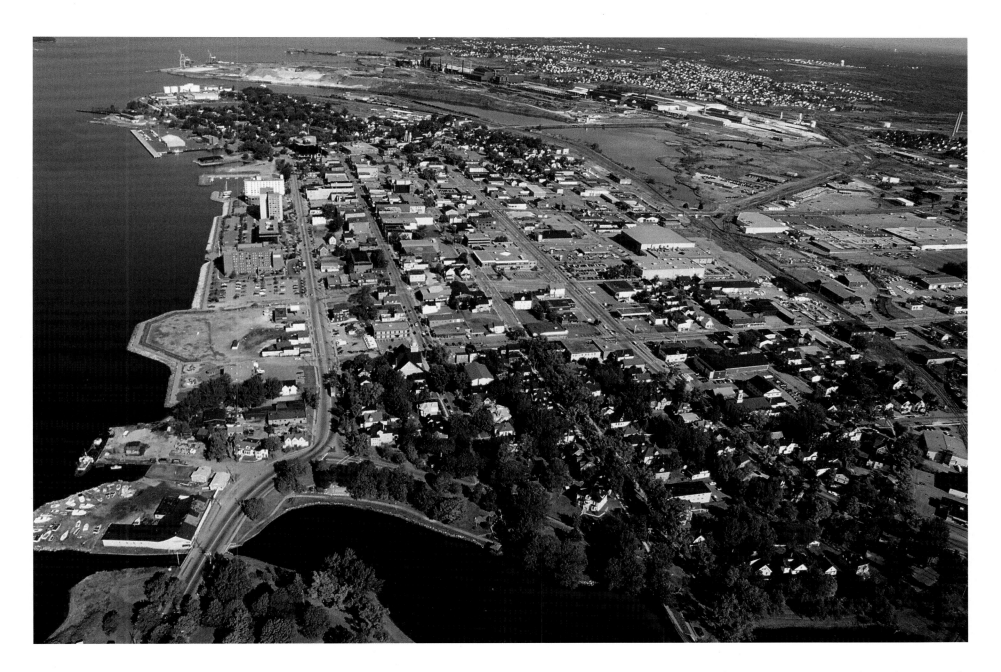

First known to Europeans as Spanish Bay, this area provided safe harbour for Basque fishing vessels during the 1700s. The city of Sydney was founded in 1785 by Loyalists under the purview of Governor Colonel J.F.W. DesBarres, who claimed the area as their colonial capital. Since that time, Sydney has remained an important centre for industry and trade.

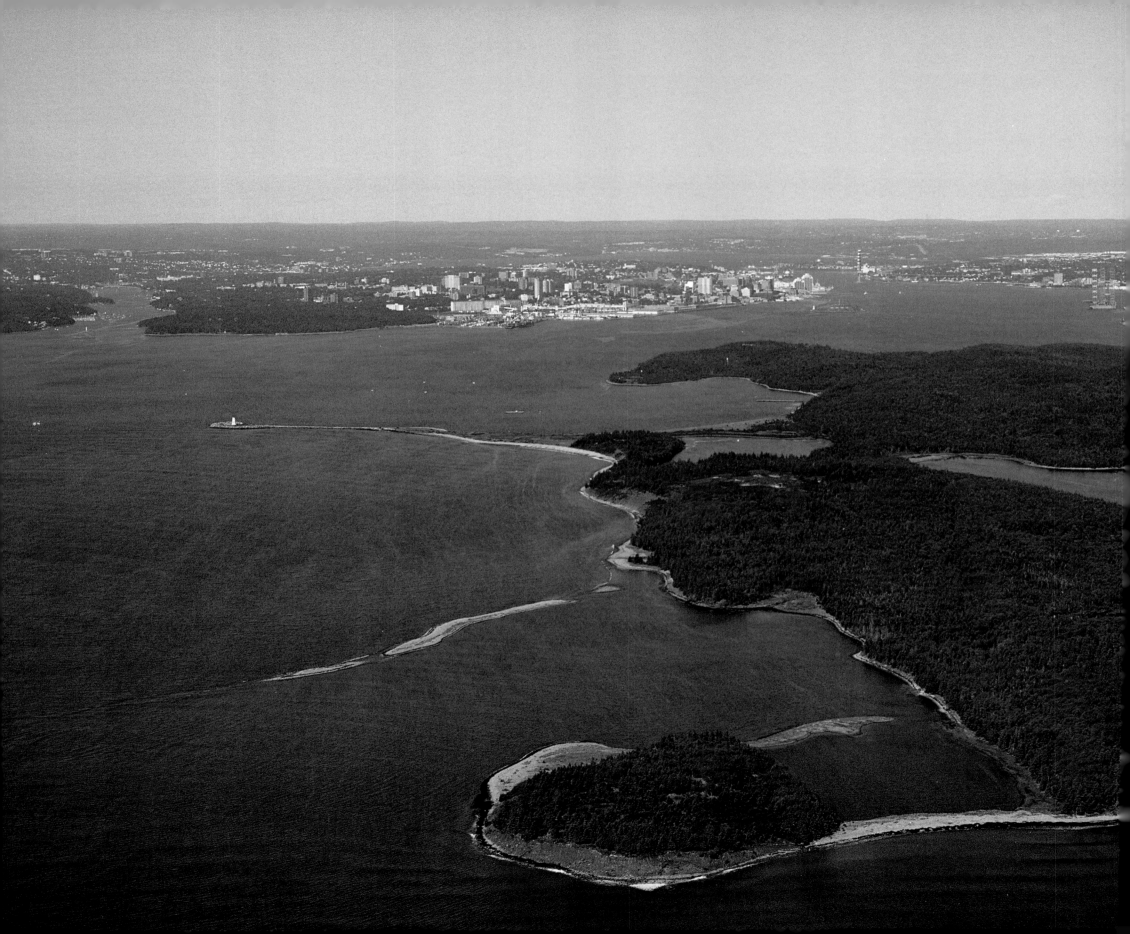

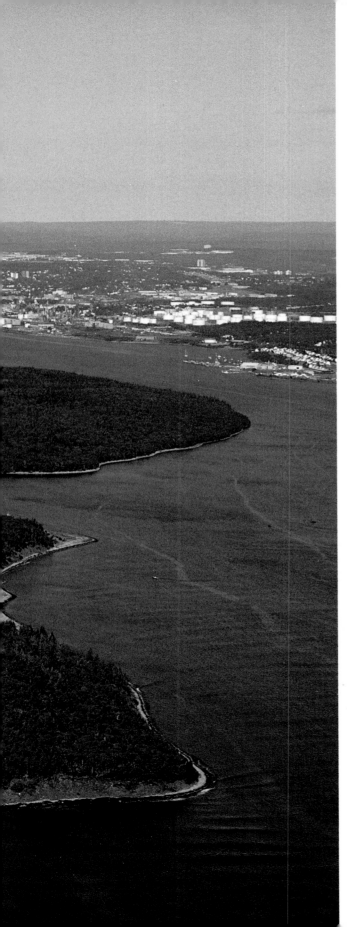

7 HALIFAX HARBOUR

THE URBAN SKYLINE of Halifax dominates the horizon from all directions. At night, the communication towers near Clayton Park, with their flashing white strobes, can be seen shortly after take-off from runways as far away as Waterville in the Annapolis Valley. And on a clear day, the red and white stacks of Tufts Cove Generating Station in Dartmouth provide a navigation beacon for pilots. More than 350 thousand people, nearly 40 percent of all Nova Scotians, live in the Halifax Regional Municipality

The harbour throngs with traffic all day long. Ferries crisscross the stretch between Halifax and Dartmouth. Container ships head towards the terminal in Fairview Cove. Supply ships churn their way to the naval dockyards. And 50,000 commuters a day cross the two bridges.

Look beyond the harbour mouth into Bedford Basin, and it is clear why this area was chosen for European settlement. The huge, ice-free harbour can handle large volumes of traffic, which was proven during both world wars, when massive convoys were staged here before heading across the Atlantic.

Big Thrumcap, at the southern tip of MacNabs Island, has greeted sailors entering Halifax Harbour for 250 years. The island, once the site of Mi'kmaw fishing camps, was used by European settlers as a source of timber, as a convenient location for drying fish and as a relatively safe haven for their livestock. Through much of the late nineteenth and early twentieth centuries, local residents flocked to the island to listen to bands, watch sporting events and enjoy Findlay's Pleasure Grounds.

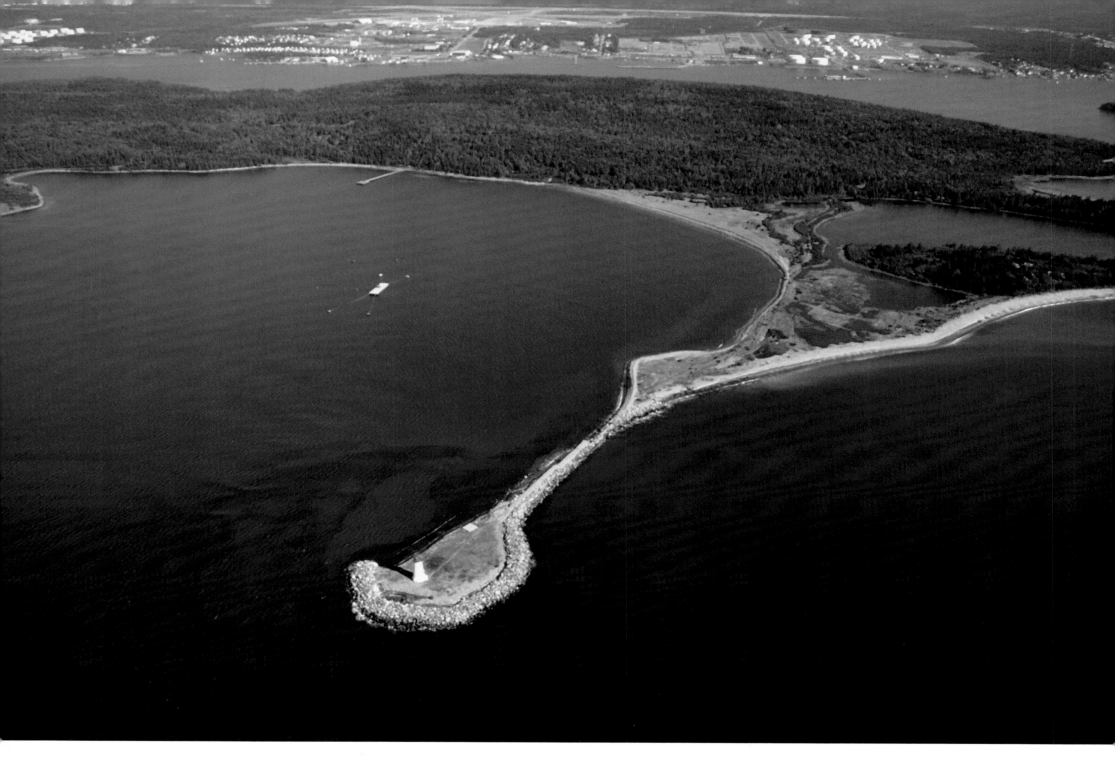

A lighthouse at Maugher's Beach has helped ships navigate the approach to Halifax Harbour since the early 1800s. To the right of the breakwater is Hangman's Beach, where deserters were given their final cruel punishment and left as a warning to other sailors entering and leaving the harbour.

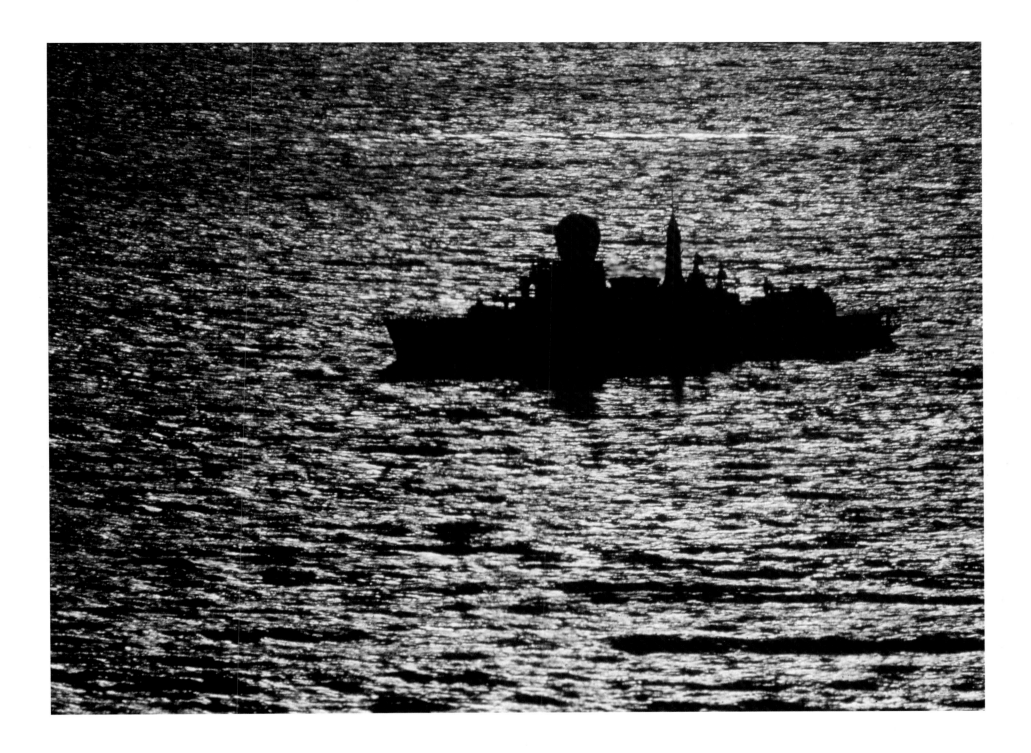

A European ship, part of the North Atlantic Treaty Organization (NATO) fleet, conducts exercises off the coast of Nova Scotia. Canada was a founding member of NATO, which was formed in 1949 to act as a deterrent to Warsaw Pact countries.

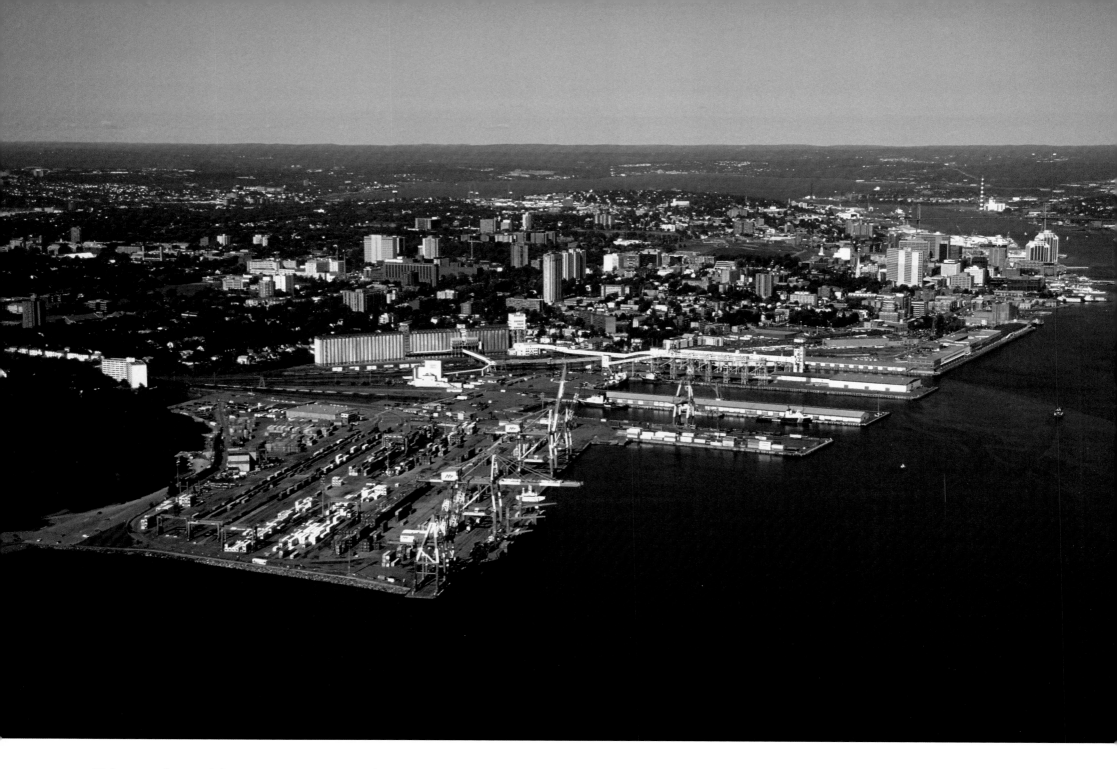

Halterm is the port's largest container terminal. It was built in the south end of Halifax in the 1960s. As the harbour is ice-free, container ships can unload year round. CN railway lines connect Halterm with cities in eastern and central Canada and the United States.

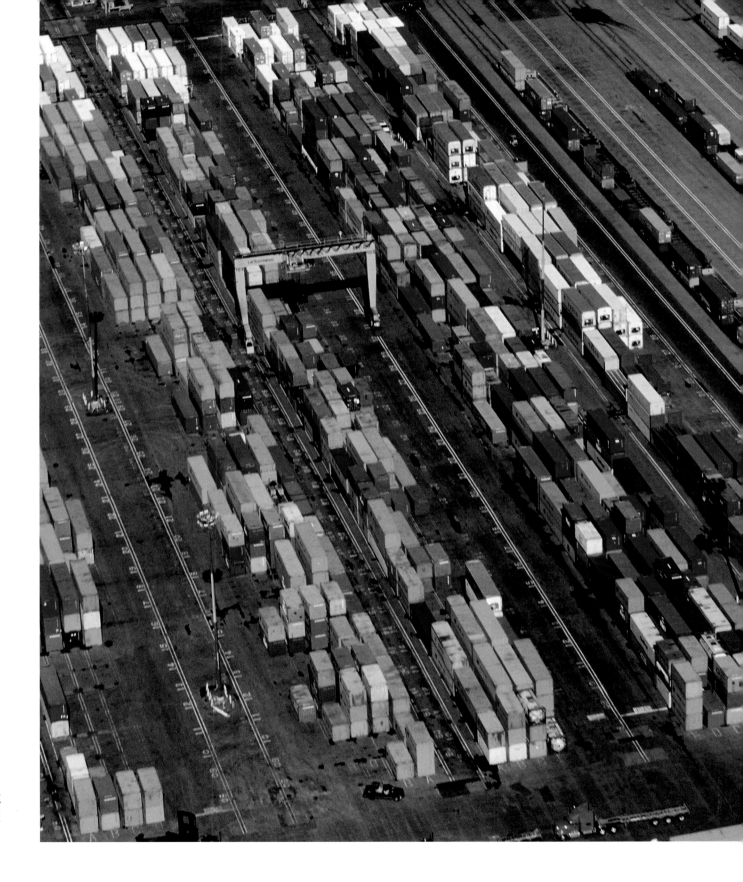

Like toy trucks waiting for Lego blocks, tractor-trailers line up near a container ship being unloaded at the Ceres Fairview Cove Terminal on the shore of Bedford Basin.

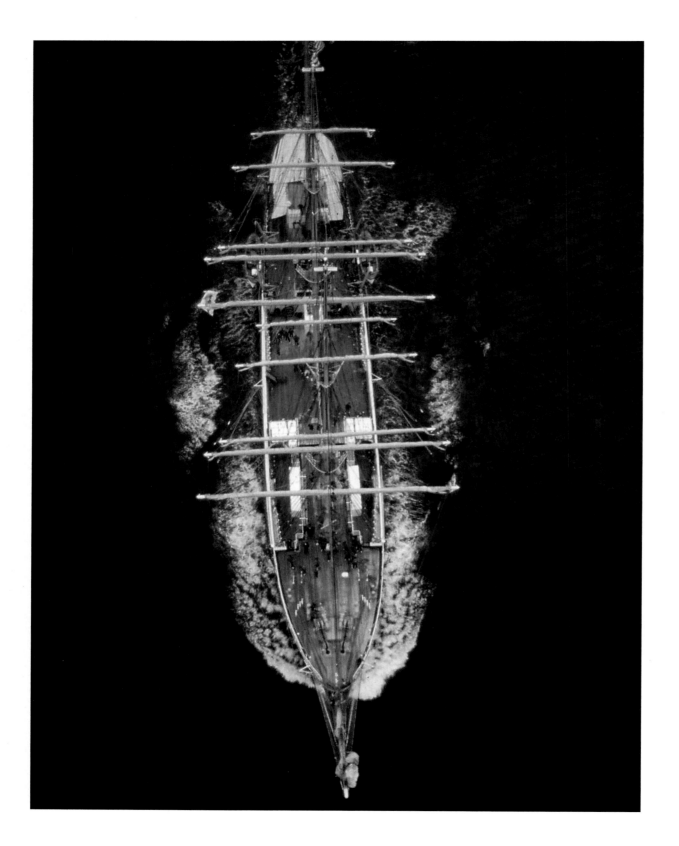

The United States Coast Guard *Eagle*, based in London, Connecticut, enters Halifax Harbour. The square-rigged vessel, now used as a training ship, was built in Germany in 1936 but captured by American forces during World War II. The *Eagle* has been a frequent visitor to Nova Scotia, both solo and as part of the Tall Ship, Parade of Sail.

The stone and earthen works of Fort Charlotte on Georges Island are part of a former harbour defence system. The island, named for King George II, is a small drumlin (hill formed by glacial debris) and was a military post for over 200 years. The military declared the fortifications surplus in 1960, and five years later, Georges Island was declared a National Historic Site. Today the island is home to thousands of garter snakes, old military fortifications and a lighthouse.

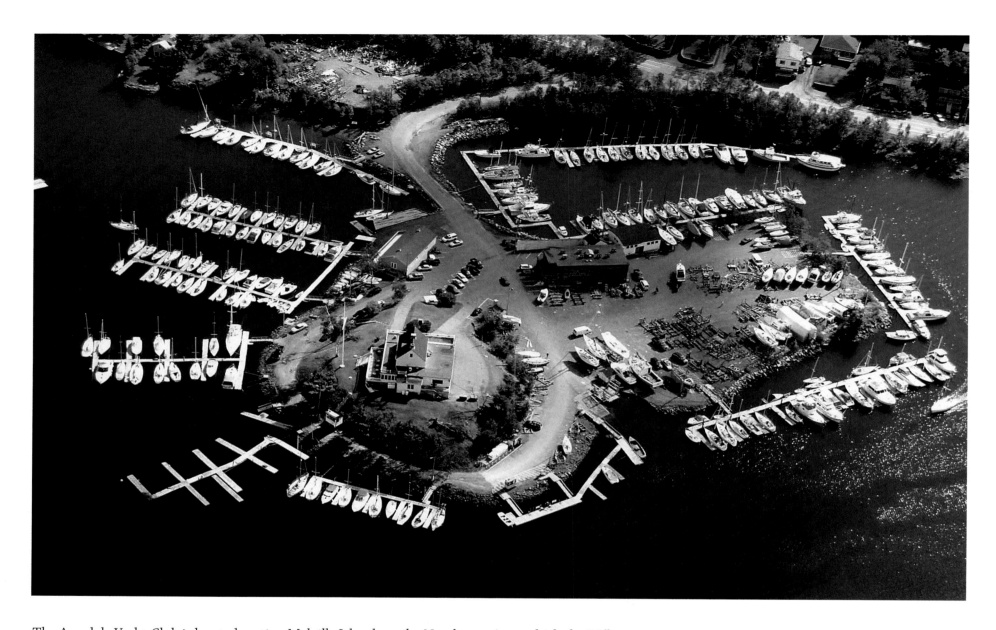

The Armdale Yacht Club is located on tiny Melville Island, on the Northwest Arm, which the Mi'kmaq called Waegwoltic, meaning deep river or end of bay. The island was formerly the site of a hospital, a prison and an ammunition depot.

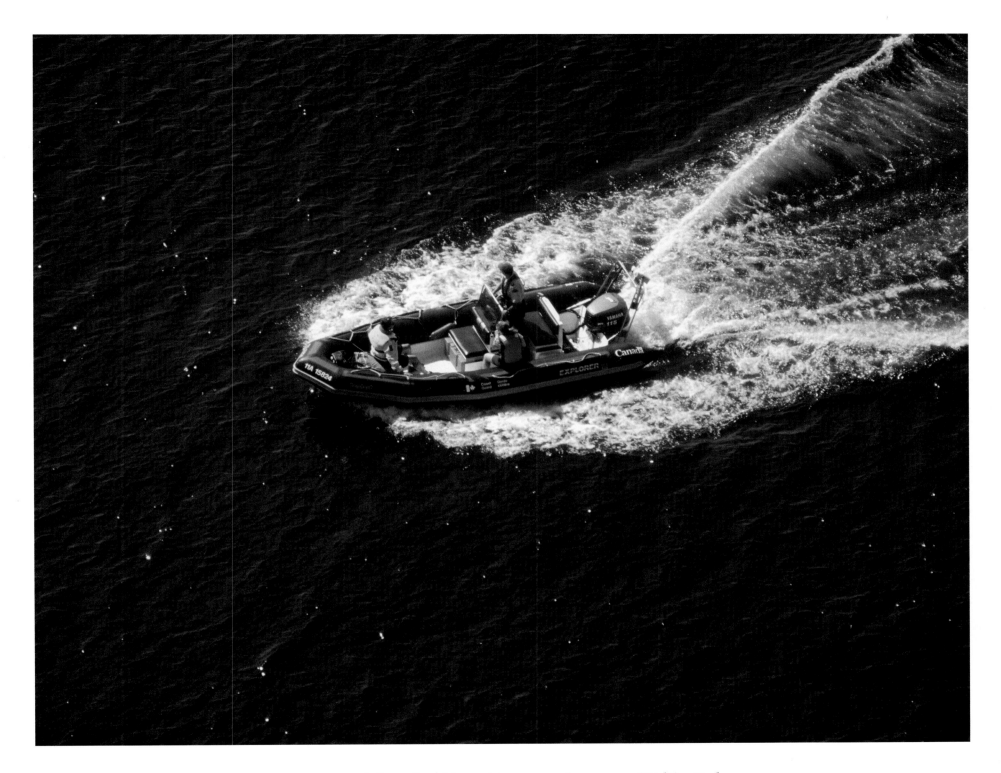

A Coast Guard boat skims across the waters of Halifax Harbour.

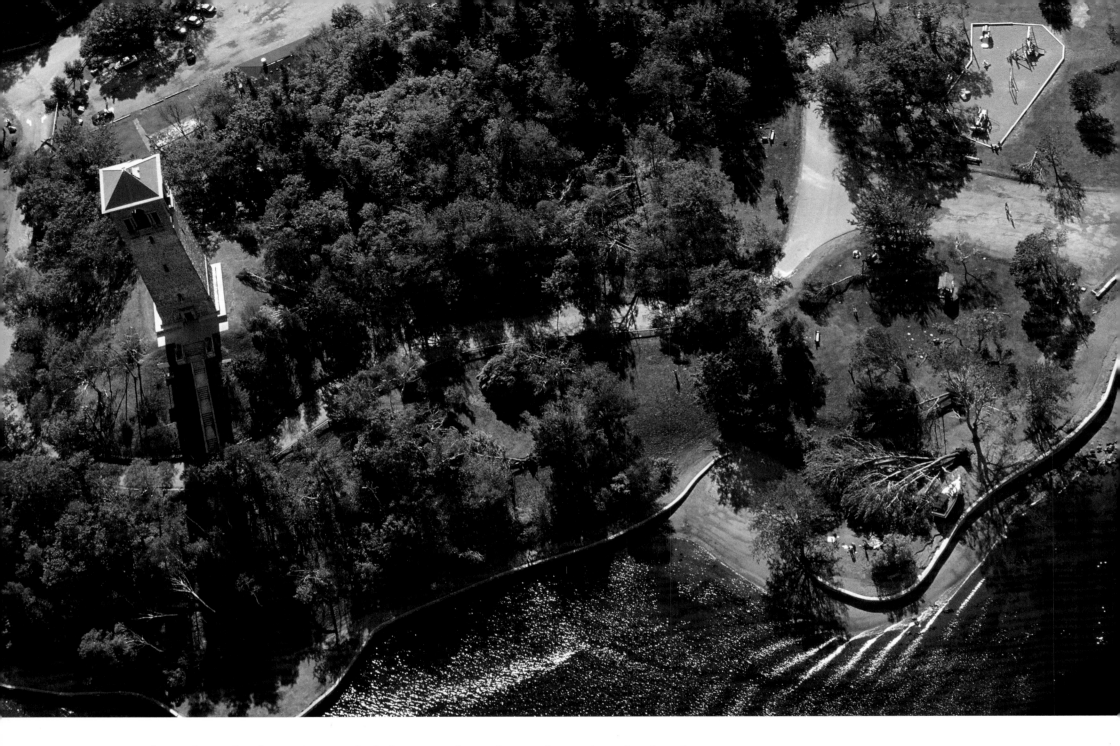

Boats and trees litter the shore of Sir Sanford Fleming Park, on the Northwest Arm, the day after Hurricane Juan ripped through the province on September 29, 2003. The 95-acre park was donated by Fleming, an engineer with the Canadian Pacific Railway and inventor of standard time zones, to commemorate the 150th anniversary of representative government in Nova Scotia. The park was opened in 1908 and the Memorial Tower, known as the Dingle Tower, was completed four years later.

Soccer game at Saint Mary's University Stadium.

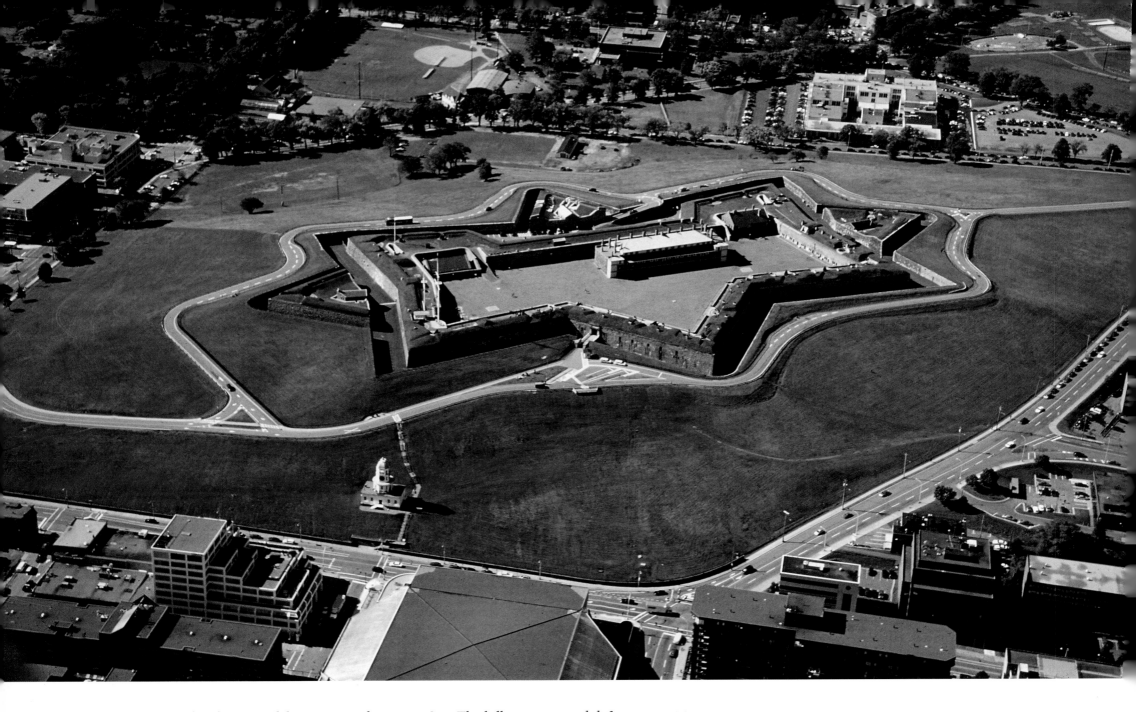

The star-shaped Halifax Citadel is a National Historic Site. The hill was a natural defensive position, with its commanding view of the harbour. Today, the hill is some 12 to 22 metres lower than its original height, thanks to construction of four forts over the eighteenth and nineteenth centuries. The present fort, the only one constructed of stone, was finished in 1856. The site is a living museum but it also contains two museums; one that reflects Canada's military history and the other a look at Halifax's past. Every day, at the stroke of noon, a cannon is fired from the ramparts.

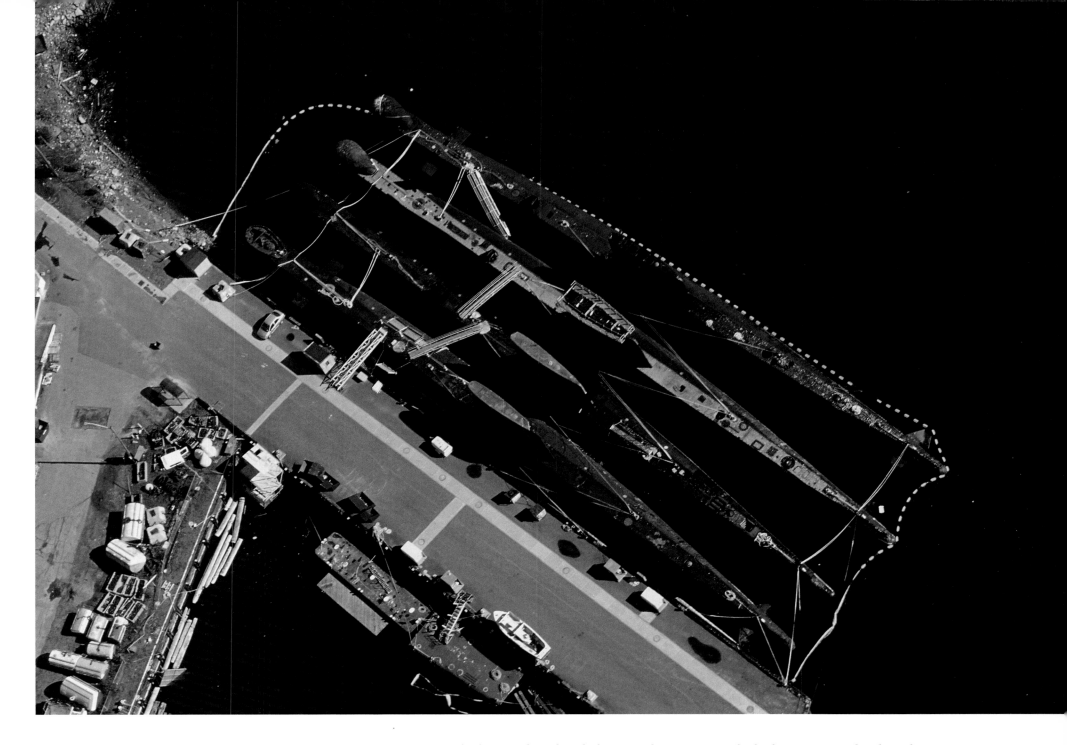

Decommissioned Oberon Class diesel-electric submarines are docked in Dartmouth. The submarines, in service for over 30 years, were retired when Canada bought four Victoria Class (formerly called Upholder) submarines from Britain.

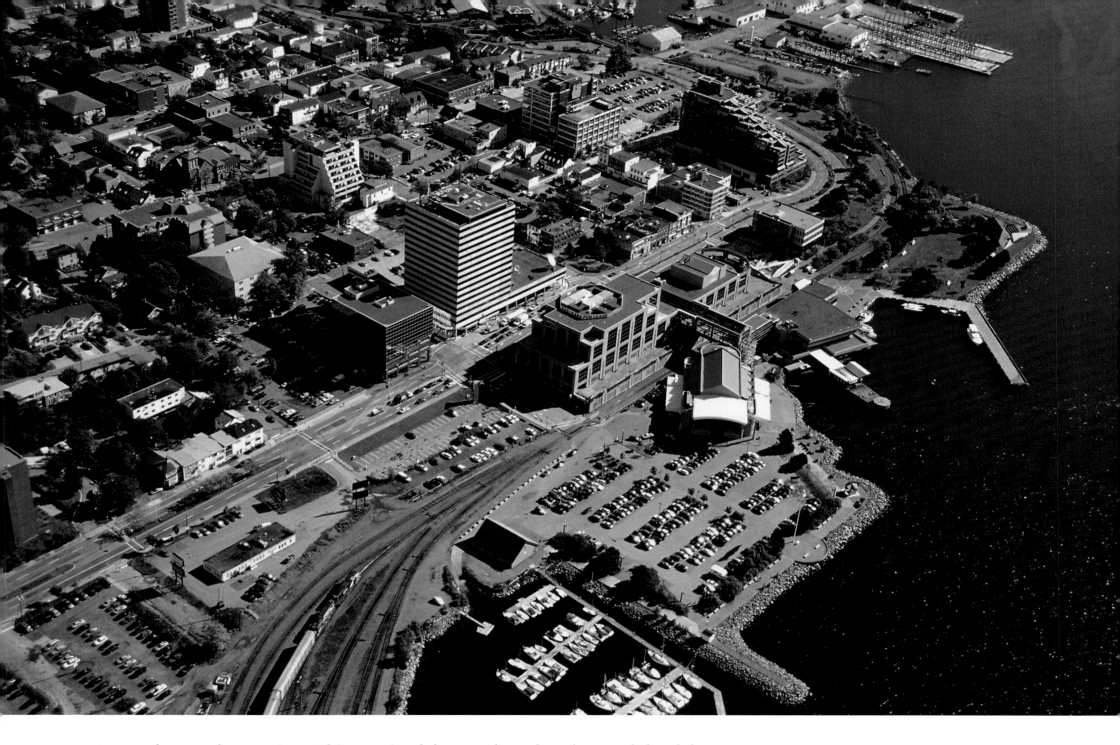

Dartmouth, across the water from Halifax, was founded in 1750 by settlers who arrived aboard the *Alderney*. The two cities have always been intricately linked, and in 1996, together with the rest of Halifax County, Halifax and Dartmouth were amalgamated into the Halifax Regional Municipality (HRM).

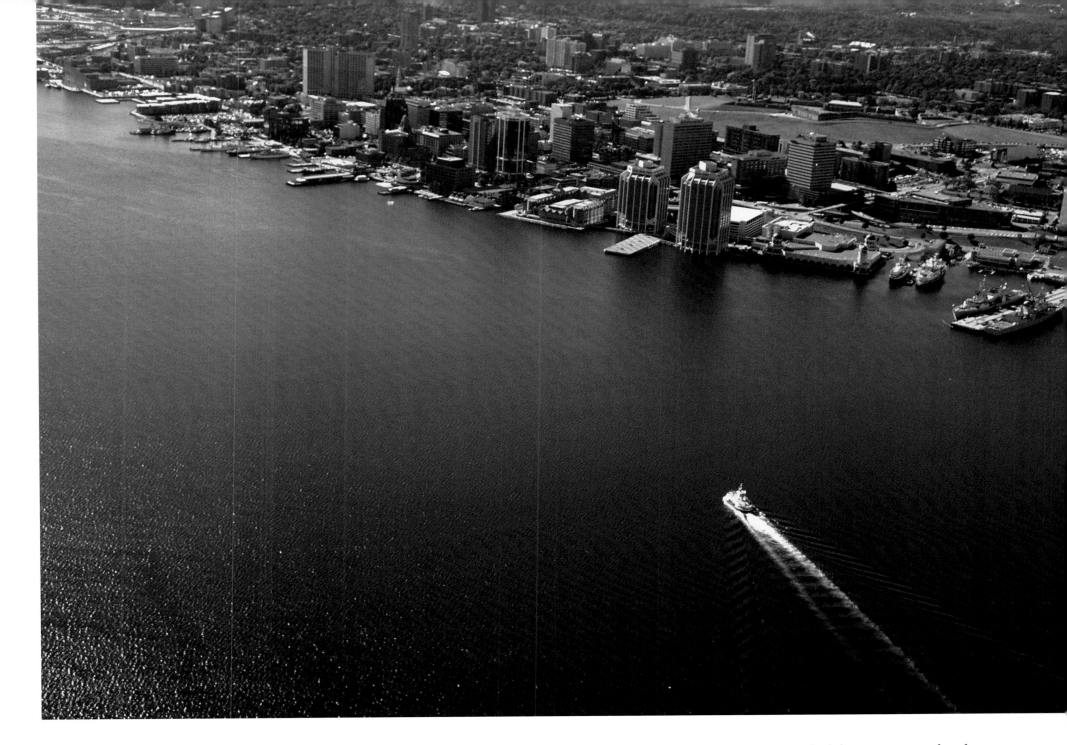

A ferry takes commuters from Dartmouth to Halifax. The ferry service, which began in 1752, shortly after the establishment of the twin cities, is said to be the oldest running salt-water ferry in North America. Early Dartmouth settlers used the ferry to transport produce and ice to the garrison town across the harbour. It continued as the only quick link between the two cities until 1955, when the Angus L. MacDonald Bridge was opened.

ACKNOWLEDGEMENTS

When I first started this project, I turned to Rob Francis, a friend I learned to fly with when we were both about 14. Rob takes time away from his family and his vacation days to jump in planes and take me where I need to go. His enthusiasm and helpfulness in getting the plane at the right angle at the right time have been invaluable.

Ideas are a dime a dozen and lots of people want to publish books. I want to thank Elizabeth Eve and Jim Lorimer of Formac Publishing for their support and guidance to make it happen.

Bob Guscott is a friend and an employee of the Department of Natural Resources who has helped pinpoint difficult locations. Bob's knowledge of our province helped me identify mountains that went by at 120 kph.

Deborah Skilliter, Curator of Geology, Nova Scotia Museum of Natural History, has helped me identify the province geological history.

Dave Thompson of the Nova Scotia Community College taught me photography and how to "bleed for the art." Over the years, his friendship has been unwavering. Dave and his wife Alexa have helped many a young photography student over the years and Alexa helped me with the research and writing of the text for this book.

Thanks, Ma, for giving me my first camera.